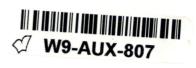
A MARITIME ALBUM

A MARITIME ALBUM

100 *Photographs and Their Stories*

Photograph selection & introduction by

John Szarkowski

Essays by

Richard Benson

The Mariners' Museum · Newport News, Virginia

Yale University Press · New Haven & London

Design and composition by John Gambell, New Haven, Connecticut

Set in Adobe Minion typefaces

Printed in Hong Kong

A catalogue record for this book is available from the British Library.

Library of Congress Cataloging-in-Publication Data

Mariners' Museum (Newport News, Va.)
A maritime album : 100 photographs and their stories / from the Archives of the Mariners' Museum :
introduction by John Szarkowski : essays by Richard Benson
p. cm.
ISBN 0-300-07342-9 (cloth : alk. paper) — ISBN 0-300-07399-2
(pbk.). — ISBN 0-917376-48-x (Mariners' Museum : pbk.)
1. Photography of ships. 2. Mariners' Museum (Newport News, Va.) — Photograph collections.
3. Photograph collections — Virginia — Newport News. I. Benson, Richard, 1943 – . II. Title.
TR670.5.M37 1997
779' .37 — DC21 97 – 22154
 CIP

The paper in this book meets the guidelines for permanence and durability of the Committee
on Production Guidelines for Book Longevity of the Council on Library Resources.

10 9 8 7 6 5 4 3 2 1

CONTENTS

7

FOREWORD

9

ACKNOWLEDGMENTS

11

INTRODUCTION

17

A MARITIME ALBUM

219

CHECKLIST AND SUPPLEMENTARY NOTES

FOREWORD

The Mariners' Museum has long prided itself on its sizable collections of maritime objects, archives, and library holdings. It is, however, one thing to have in storage an archive of 600,000 photographic images and quite another to ignite the life they once captured. For John Szarkowski and Richard Benson, photographs are more than exact depictions of fleeting moments made visually permanent. They are adventures in which the human stories that surround and are contained in them can be rekindled and relived.

A Maritime Album: 100 Photographs and Their Stories is at first glance a book of photographs, all of which relate to our relationship with the sea in ways that occupy us primarily for work yet also for pleasure. It is Richard Benson's words that illuminate these pictures with knowledge, observation, and an easy familiarity born of growing up along the water's edge. The combination of Szarkowski's selection and Benson's comment strikes a series of optic and verbal notes on perfect pitch.

It is not surprising that it does. Each collaborator on this volume is an extraordinarily distinguished contributor to the field of photography. Szarkowski's seminal books *Looking at Photographs* (1975) and *Photography Until Now* (1989) are considered by many to be the most important works on photography ever published. Benson is renowned for creating a process of print reproduction of photographs that set a new standard, both technological and artistic. Their delight in discovering these photographs in the early months of 1996 was intoxicating for those lucky enough to be nearby. From the depths of file boxes to the pages of this album, we are grateful to John Szarkowski and Richard Benson for inviting us to look with them through these windows on history.

John B. Hightower
President and CEO, The Mariners' Museum

ACKNOWLEDGMENTS

Most of the work that made this book possible was done by the curatorial, library, and support staffs of The Mariners' Museum. Literally scores of the Museum's people contributed to it professionally, substantially, and cheerfully. A few of those must be thanked by name: Without Tom Moore, Curator of Photography, I would never have found my way through the labyrinthine complexities of the Museum's photography collections. In addition his taste and understanding have surely colored my choice. When I found a picture that I especially liked, Alan Frazer, Senior Curator, told me what the subject was, and, with the limits of my capacity, how it worked. Benn Trask, head of the Museum's superb research library, and his staff (especially Tom Crew, Charlotte Valentine, and Heather Friedle) worked selflessly and with, I hope, some success at filling, or at least bridging, the lacunae in the maritime education of one who was raised more than six hundred miles from the nearest salt water — which was Hudson's Bay. The Museum's chief photographer, John Pemberton, and his staff solved with alacrity and precision a wide range of challenging technical problems.

In a larger sense, those to whom I am most grateful are the long line of curators, collectors, and *amateurs* who have formed the Museum's collections, and those friends of the Museum who have supported the institution's passion, even on those days when it may have seemed exaggerated.

From a personal point of view, my deepest gratitude must go to the President of the Museum, John Hightower, who asked me into his great treasury of wonders.

John Szarkowski

This is a book that could only have been written from the basis of experience, and I was lucky enough to have spent a childhood around the sea and its tools. While actually writing I found that a few current friends and a small group of others from the past were my advisors, and that their good words, along with my memories, provided the primary sources for the writing. Four people stand out among the many who made the book possible through lessons they gave me years ago. These are Edward W. Smith, Jr., who gave me my first boat; Thomas Benson, who taught me the irrational nature of quality; Rutherford Elliot, who put up with

me in his small machine shop in Newport, Rhode Island; and Frank Fletcher, who first demonstrated to me the nature of a broadly engaged mind. Among current friends, my wife Barbara and brother John each helped and advised throughout the writing, and these brief essays would be much less good without their considerate and wise counsel. In the course of the writing there were many specific points that neither memory nor references could make clear, and for these I was able to turn to seven current friends for advice. These were Jon Powers, Harry Sherman, Brown Beezer, Pete Randall, George Mendonsa, Tod Papageorge and John Hegnauer.

The book itself would not exist if The Mariners' Museum had not persevered through the years and taken in and cared for such a rich collection of maritime artifacts. Tom Moore and John Pemberton supplied every need from their various departments, and Beverly McMillan, the Museum's Publications Director, made my long and wordy text usable; these colleagues have been instrumental in making the book what it is. Judy Metro at Yale University Press supported the book with great enthusiasm, and her impulse pushed us all to completion, so the book has reached its reading public well before we could have managed without her aid. John Gambell, the designer, has superbly adapted the form of John Szarkowski's *Looking at Photographs* to this publication, so this earlier inspiring book has been a visual as well as intellectual model for what is contained here. John Gambell has also spent his share of time greasy and wet, and so along with design has come much good advice about the book's content. Of course, without the inspiration of John Hightower, the Museum's director, and the great eye and energy of John Szarkowski, who selected and sequenced the pictures, there would be no book at all.

Richard Benson

INTRODUCTION

If we consider that Thomas Jefferson never saw a railroad, and that Warren Harding never flew in an airplane, it will help us put those remarkable and relatively recent developments in transportation technology in an appropriate perspective. The railroad is, of course, a tool of very great importance; it carries great loads over long hauls. But a railroad car does not cross an ocean, or even a Great Lake, except when carried by a vessel. The cargos of airplanes, on the other hand, are lightweight even when lethal. Planes carry bombs, or tourists, but they do not carry the stuff that most needs transporting, such as small grains, paper, Portland cement, wine, and oil.

Oil is carried in ships. When the oil is all gone, and if battery operated airplanes prove impractical, it would seem that aviation might be given up entirely with little fundamental revision of modern life. In any case it seems very unlikely that airplanes will significantly increase their current, minor contribution to the hard work of the world.

During Thomas Jefferson's time one could travel by land at a rate of perhaps twenty-five miles a day. A person in good physical condition could do this on foot or on horseback; if one pushed the horse much farther on a daily basis it would not last long. At this rate one could in theory walk from New York to San Francisco in about five months, resting on Sundays, if it had been possible to walk in a straight line on a level path. In practice it took longer. It took Lewis and Clark—experts, and in excellent shape—eighteen months to get from St. Louis to the mouth of the Columbia, and they paddled part of the way. Jefferson had sent them on their epic voyage largely in the hope that they might find a passage by water, through the continent, to the Pacific. Three centuries after Columbus found his destination blocked by what came to be called the Americas, and more than a century after the death of the great René-Robert Cavelier, Sieur de La Salle (who would have found the Northwest Passage if it had been there to find) Jefferson was still hoping for it, because walking was too slow, and a horse could not carry even as much as a very small canoe.

Lewis and Clark found no Northwest Passage, but in partial compensation the designers of sailing ships made them faster. In 1854 the *Flying Cloud* sailed from New York to San Francisco, around the tip of South America, past the terrifying storms of Cape Horn, and made the journey in eighty-nine days. The straight-line distance for the *Flying Cloud*—forgetting the true tacking and beating distance—was more than fifteen thousand miles: six times the over-

11

land, crow-flight distance between the two points. She averaged one hundred and seventy straight-line nautical miles per day; God only knows how fast she actually moved in a favorable wind.

The point is that the best way to move something heavy from here to there was and is to float it there. This truth is as true now as it was in the days of Homer.

* * * * *

The history of the technology of the sea, and the politics and sociology and poetry of the sea, would comprise almost a history of man. (It is only recently, relatively speaking, and cautiously, that we have moved far from the oceans, to places like Siberia, or Nebraska, and it is by no means clear that places so far removed from the sea are viable in the long term.) The present book might be thought of as a sketch for one essay in a great maritime cyclopædia. It is concerned with that brief moment in the history of our relationship to the sea that coincides with the brief and callow history of photography.

It is true that some of the very best photographs describe the Great Pyramids, and other fossils that existed centuries before photography was invented; but for the most part the pictures gathered here describe the living, contemporary world of the moments of their making, during the brief period that begins with photography and the steamship, and extends to now.

There is a nice correspondence between the story of the steamship and that of photography. In 1835 William Henry Fox Talbot made his first tiny photographs of images formed by cameras. In the same year the young engineer Isambard Kingdom Brunel proposed to the Great Western railway that they extend their track to Bristol, and build there a great steamship, the *Great Western*, to sail to New York. It was the first steamship to make scheduled voyages across the Atlantic. By the time Brunel was fifty-one years old, photography was so well advanced that Robert Howlett could make his perfect portrait of Brunel, standing before the launching chains of his heroic disaster the *Great Eastern*, wondering, perhaps, where things had begun to go wrong.

Photography describes only a thin chronological slice of the story of man and the sea, but that slice represents a period extraordinarily rich with the overlapping of old and revised and radically new technologies. The rise of steam surely encouraged the marvelous nineteenth-century advances in sailing technology, and even in the 1920s, (even after the invention of the Leica camera) the wind still carried a substantial part of the world's freight. And the people of the tribes of the Algonquian nation did not abandon their beautiful, ephemeral, birch-bark canoes until the early years of this century, when they adopted the new (perhaps equally beautiful) cedar plank and canvas canoes, built in small factories by Yankees and Canadians. In 1839, when photography was first announced to the world, a significant part of the world's population was still unknown to the West, and the second age of exploration was only well started. In the West itself, some of the astonishing changes of the next hundred years would

not have been possible without the new pictorial system, which made available to every biol-ogist and astronomer precisely replicable and apparently disinterested pictures of what other scientists had seen in their microscopes and telescopes.

It was the perfect time for photography to have been invented. Without it we might be almost as ignorant of the look of many things described in this book as we are of the face of England's William IV—Victoria's predecessor, who died in 1837, two years before the publica-tion of Daguerre's miraculous new invention.

* * * * *

The photographs reproduced here were taken by a highly various assortment of photogra-phers, amateur and professional. Some were peripatetic free-lances, as footloose as sailors on liberty, and some, like family doctors, worked the same county all their lives long. Some were company men, who went to the same shop every day and photographed the shipbuilding industry nut by nut and bolt by bolt. The best of those learned the character of the light in their factories like a river pilot learns the current of his stream, and made photographs that were described in a scale of grays as lovely and smooth as the inside of an oyster shell. Some thought of themselves as reporters, some as shopkeepers, or adventurers, or historians, or technicians. A few doubtless thought of themselves as scholars, and a few as artists, and doubt-less some of them served many of these roles, serially or simultaneously. It is tempting to believe that some of them led wonderful if unsung lives, like that of David Barry, who in the 1880s did portraits of the Sioux, in what was still Dakota Territory, and in his old age was good enough to do, in Superior, Wisconsin, what might be the most stylish group portrait of ship-yard workers done so far, in that or any other town. (pl. 68)

If I could choose for myself the life of one of these photographers, I think it would be that of H.C. Mann, (pls. 25, 26, 66) who seems to have known his part of the tidewater with the easy and trusting familiarity with which most men know only their dogs. His pictures—like most of the very best photographs—seem to have been less made than given, as a reward for patient, close, intelligent, sympathetic observation. On the basis of the evidence it is clear that some of the photographers represented here were better than fine, and that others made an occasional superior picture because they were hard working and tenacious. Still others, for reasons beyond their ken or ours, were granted one silver bullet. We should of course be grateful for the pictures of those who earned their successes by the application of high talent and high ambition, but should we be less grateful for knowledge given to us by grace of luck?

All of us interested in the history of our own species are in debt to the photographers who made these pictures; and also to the amateurs, enthusiasts, corporations, and magpies who first saved them from the almost certain destruction that has been the photograph's normal lot; and we are indebted most of all to The Mariners' Museum for having made the conscious and continuing decision to collect and preserve these fragile fingerprints of our past, at the

cost of never-ending attention; and we are indebted to the Museum now for its decision to publish a thin slice of this collection.

The Museum's collection of photographs is an irreplaceable resource, providing a stratum of evidence that speaks not only of ships and rigging but of our own history as explorers, traders, fishermen, warriors, and weekend adventurers. Such a collection might be compared to a lumberyard, which offers materials from which different builders will make very different buildings; or to the contents of a very old desk, crammed with shopping lists, laundry lists, fragments of love letters, midnight complaints, postcards with illegible postmarks, etc., out of which no two scholars will infer exactly the same life.

To select one hundred photographs from a collection of more than half a million is an exercise that might conceivably be approached in the spirit of measured scientific inquiry, but that path did not seem inviting, and it was not followed here. These pictures were chosen because they are, in a variety of ways, good to look at. Horatio Greenough's formulation held that beauty was the promise of function; in those terms these pictures are good to look at — beautiful, if not always elegant — because they promise to enlarge our comprehension, or our apprehension, of our world, if we attend them carefully.

It is easier to analyze the success or failure of a text than of a picture, for writers work from a shared catalog of standard parts, arranged in alphabetical order in any dictionary. These parts can be combined in a finite number of ways, whereas the number of vantage points from which to view a simple subject is infinite.

Thus we can say of H.C. Mann's *South Mills* (pl. 25) only that the picture persuades us that Mann was there at the right moment on the right day, and that he stood in precisely the right place, and positioned his camera so that the edges of his plate corresponded exactly with the edges of the picture in his head. Then he exposed and developed his plate so that the print might be as seamless and invisible as a sheet of glass — so that it might seem a window opening onto the world, a piece of paper that from corner to corner hid its true nature, and disguised itself as sky and water and wooden artifacts. But we will never know what was just outside Mann's frame.

* * * * *

With so much to be thankful for it is perhaps churlish to sigh for what seems to be missing. Nevertheless, some observers, including this one, think they see a certain attenuation, during the past generation, in the body of photography that describes our essential, quotidian life, including our life with the sea. The reasons for this decline are not clear, but an explanation might begin with the recognition that professional photographers like H.C. Mann and David Barry and many others included here no longer exist. Their professional lives were defined in terms of service to specific communities — geographical or cultural — that no longer exist. Professional photographers today, much reduced in numbers, work for larger, more homogenous

markets, and often for clients they have not met. Photographers are for the most part creatures of their environment, and it would be unreasonable to criticize them for having so often failed, in recent decades, to photograph what we would have wished, and for having instead made endless numbers of virtually indistinguishable photographs of generic love goddesses, or of fringe royalty holding wine glasses, or of politicians shaking hands, or of the displaced young, attempting to look simultaneously uninvolved and avant. There is no end of such stuff, but good photographs of commercial fishing (or wheat farming, logging, mining, teaching, keeping house, keeping books, etc.) are distressingly rare. This is partly because photographs of such subjects are more difficult to make, but it is also true that there has lately been little economic incentive to photograph anything except those subjects that are potentially interesting to everyone. Such subjects tend to produce photographs that are not very interesting to anyone.

Under the circumstances the photographing of ordinary life has been left to amateurs, who have for the most part declined the challenge, or to an occasional professional who worked as an amateur, like O. Winston Link, who for the love of it photographed the railroads doing what they did every day, rather than wait for a spectacular derailment.

Mann and Barry represent the last generation of professional photographers who practiced their trade as a local cottage industry. By the time of World War II such photographers were dead or old, and they were not replaced. Their role had been made obsolete by technological and cultural changes that need not be detailed here. Suffice it to say that those changes still belonged to the old industrial revolution of heavy muscle and physical connections, which (for example) enabled the printing industry to produce eight million fat copies of *Life* magazine in a twenty-four-hour day (5,555 copies per minute).

We are now engaged in a new industrial revolution, characterized by magnetism and electronic connections. Some of its prophets have suggested that this new technology (light on its feet, quick reflexes, enormously pliant) might make it again possible to publish work of serious ambition (including photographs) for audiences no larger than a company of infantry, or a symphony orchestra. If this should prove the case, then photographers might stop dreaming of a universal audience, and try again to describe the life on their own street. Or on their own river.

John Szarkowski

A MARITIME ALBUM

100 Photographs and Their Stories

HULKS ON THE NORTH LANDING RIVER

JOHN LOCHHEAD American 1909–1991

And so we begin with an ending. Tucked away in the tidal water of the North Landing River lies a group of hulks, as the marine world refers to the worn-out and abandoned remains of its ships. Even when a vessel is small it can be difficult to get rid of, as the backyards of coastal America show, but when the victim of age is a ship, too large for a simple neglectful end, then disposal can be a real problem. These hulls have been run up the lower reaches of the river where a high tide has allowed them to be brought in and pervasive mud has held them firmly in place; the marshy shores are not particularly good places for people to live, and so there were no neighbors to complain as the old ships were nudged into their final resting places.

Nineteenth-century ships, of which these are the likely remains, were especially difficult things to get rid of. They were very long lived, and had the habit of rotting away just enough to become dangerous, leaving the hapless owner with the carcass but not the useful servant. They floated, being made of wood, and because most carried no ballast, sinking was out of the question without loading many tons of sand on board. If this was attempted, the resentful hulk could almost be depended upon to sink in the wrong place, such as a harbor mouth, while on its way to the deep water, and so entail a removal that could bankrupt most small enterprises. An old ship could not be let loose, either, as a one-hundred-foot-long construction of oak and pine could wreak terrible havoc in a storm in the wrong place. When ship construction shifted to iron, and then steel, recycling became practical, as a large hull held many tons of material for the furnaces of the time. Because of this persistent disposal problem the marine junkyard has evolved, usually starting innocently enough, like the incipient one pictured here. Often these aggregates of dead ships covered acres of shoreline as space after space became filled with the massive and immovable remains of the seagoing world.

The tranquil waters of the river mouth are pierced by the vertical ribs of the hulls. These hardwood frames persist longer than the softer skin of the planking, and so the ships gradually turn into skeletons, as we all do in our inevitable return to the earth. These protruding bones have become a symbol of earlier times, and along our coasts there lies a repertory of frame and rib, some jutting from an innocent-appearing beach, and others lying as flooring in dirty and overused harbors. All of them remind us that even giants have a brief life before becoming worn out and obsolete in the face of age and change.

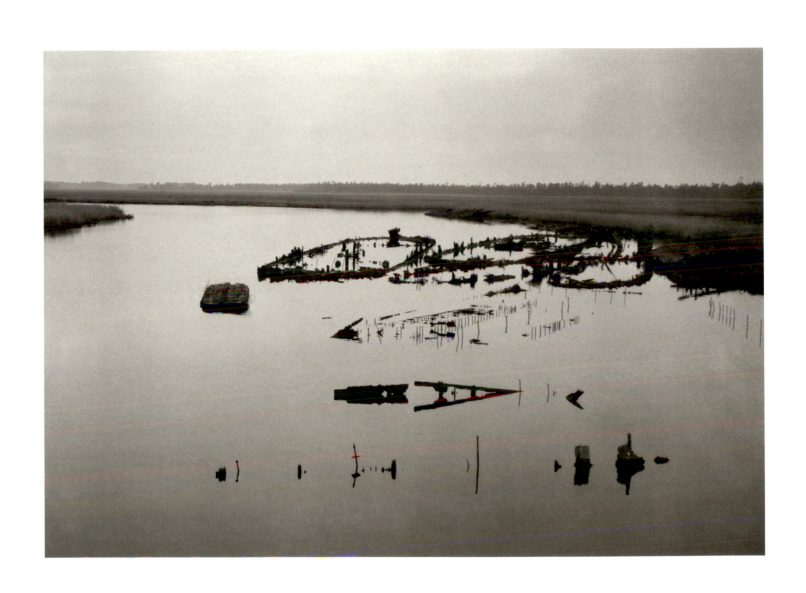

FISHING CRAFT ON THE NILE

PHOTOGRAPHER UNKNOWN

Boats come in all types and sizes. This is because they are an ancient invention that has had the chance to evolve into distinct models that suit specific commerce and its location. If we work out an evolutionary tree of these many forms, then the most basic division might be whether a vessel was created for use on the open seas or within the protected water of rivers and bays. These two places have generated radically different hull forms: oceangoing ships must plunge deep into the water, seeking out with their hull shape the more stable realm where wind does not create the turmoil found at the surface, while river craft need to be shallow to move over sand bars and beach themselves on gradually inclining shores. One way to think about this difference is to imagine the hull of a boat to be like a flat plank, and to understand that success in deep and rough water depends upon this plank floating vertically on edge, whereas in calmer locations the plank can be flat on its side, in the attitude it would take if thrown into the water. The plank-on-edge boat requires ballast or low weight to maintain it in that position, and this seemingly odd idea of partially sinking a boat in search of stability rewards the builder with a form that ignores the water's surface confusion but responds instead to the deeper and more dependable rhythmic movement of the sea itself.

Nile River boats such as these blended their types in the Mediterranean Sea, and we find the lateen rig there, fitted onto seaworthy, deep-running hulls. The Mediterranean region is a giant melting pot of nautical types, and every imaginable hull and rig finds its home there. The water is of moderate temperature, and so is a pleasant place to be; the shores hold every type of human being, and the rivers and open stretches experience every sort of weather. Here in America, so justly proud of our short history, we often lose sight of the millennia-long fermentation of invention that this great inland sea supported, out of which many of our ships evolved.

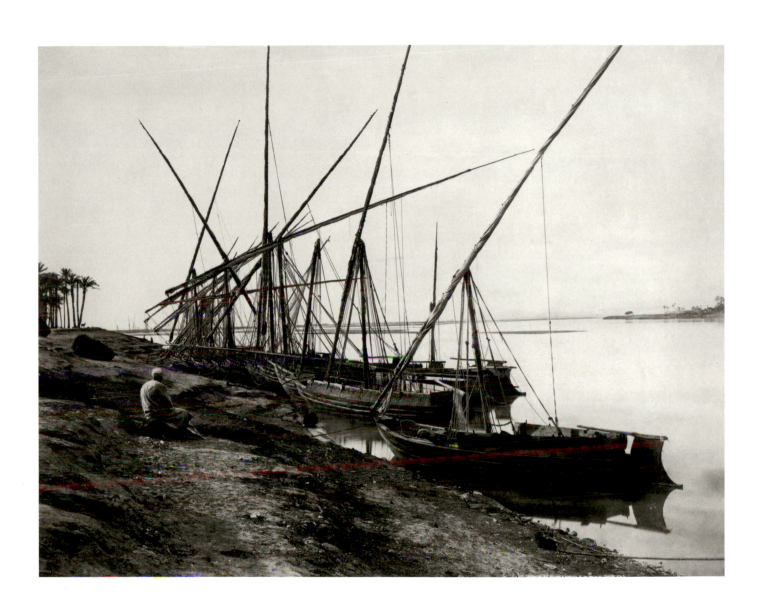

ALGONQUIN CANOE

PHOTOGRAPHER UNKNOWN

On a globe we can see that the top of North America explodes into a mass of islands, rivers, and bays. It is almost possible to travel from the East to West Coast along the U.S.–Canada border without ever leaving the water, because the lakes, streams, ponds, and inlets form a network of highways throughout the wilderness. The boat in this picture is a birch bark canoe, a versatile and highly developed craft that evolved only in North America, where it made travel across the continent feasible.

These small boats were lightweight, so they could be carried short distances, and they were made in different styles, according to maker and function. One might have been put together in an afternoon, for the single use of a specific river crossing, while others were constructed with great care and refinement to permit years of working life. We do not know how long these small boats have been around, but their intricate construction and extreme refinement speak of an ancient craft. The modern aluminum canoe and the beautiful canvas-covered Maine canoe are simplified derivations of the perfect craft we see in this photograph.

John McPhee wrote a marvelous short book in the 1970s called *The Survival of the Bark Canoe.* It describes the disappearance of canoe builders by mid-century and the efforts of a New Hampshire native, Henri Vallaincourt, to relearn the craft. After building early versions based on examples he had seen, Vallaincourt heard of *The Bark Canoes and Skin Boats of North America* by the great nautical scholar Howard I. Chapelle, a curator at the Smithsonian Institution in Washington, D.C. Chapelle, it turns out, wrote the book because he stumbled on a vast and encyclopedic archive of information, collected toward the end of the nineteenth century, about every detail of the form and construction of the bark canoe. This life work of data collection was done by Edwin Adney, who was obsessed with the canoe. Adney caught up in his net of curious dedication every scrap of knowledge that remained about this dying indigenous American craft. Adney's notebooks, photographs, and detailed drawings reside at The Mariners' Museum in Virginia, and this photograph comes from a glass plate in that collection.

Through centuries of hard work, knowledge such as that embodied by this canoe can reach a stable and usable form. The disruptive technology and population growth of our time can wipe away such an achievement in a few generations. This is why we have museums; they can catch the falling pieces of our history and set them aside for us to view, so we may better understand the future that's been so long in the making.

4

OUTRIGGER CANOE, YARUTO ISLANDS
PHOTOGRAPHER UNKNOWN

This little picture from a traveler's album shows a small outrigger canoe skipping across the water like a bug walking on the surface of a pond. The canoe is a highly developed form of boat called a proa, which was made for inter-island passages in the South Pacific. The proa is a double-ender, with two stems and no stern; the direction of this odd craft could be reversed by shifting the sail and rudder but not turning the boat. To go home, the rig was reconfigured to drive the canoe backward, and the sailors simply moved to face the other direction.

The outrigger design allowed a small boat to be stable while sailing, yet not have to depend on a deep keel for resistance to the force of the wind. The many islands where boats such as this were used had few deepwater piers, so the beach was the normal place to come ashore, and the shallow draft and light weight of a canoe made landing easy. Since the proa traveled back and forth but did not turn around, she only needed a pontoon on one side. When present-day boatbuilders try to achieve record speeds under sail they often build proas, since the practical issues of changing direction and traveling at different points of sail don't enter into speed trials along a measured course. Like other extreme boats, the fastest modern racing proas easily exceed the speed of the wind, and they move so rapidly that the sail is sheeted in to utilize a new wind direction created by the combination of air and boat speed–the "apparent wind." This new and rapidly moving breeze can form a taut and efficient airfoil out of the sail, and the boat is pulled along by the pressure differential this shape can generate. All modern rigs use this principle, but racing sails behave more like airplane wings than the older sheets of canvas that both pushed and pulled a boat across the water.

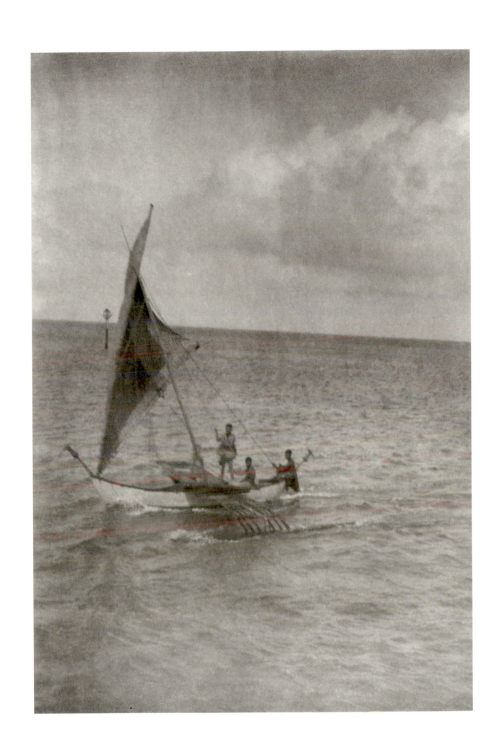

THE *JOSEPH CONRAD*
PHOTOGRAPHER UNKNOWN

If we asked the ship to pose for an idealized portrait she couldn't do a better job than this. The light is that moving afternoon sort, when the sun breaks out to illuminate the foreground against a dark and cloudy sky; movie folks call it the magic hour. The ship leans to a fine breeze, but somehow moves high out of the water across a relatively flat sea, so her full hull can be seen, with the chainplates clear against the dark iron of her sides. Every sail draws to perfection, and even the main course obliges with its triangular shape, so we can see the perfect foresail beyond and ahead of it, curving against the solid wind. The skipper wears black, his nautical hat and proper coat silhouetted against the canvas. The two whaleboats are painted a contrasting white, so they stand out against the gray of the sky.

If there is a certain unreality about this picture, it derives in part from the fact that this was a training ship, built and run for the specific job of defining the manhood of young men who had chosen a life at sea. Sailing before the mast was doomed by the advent of steam power, and it was impossible for mature sailors to imagine a new generation of mariners who didn't know the craft and hardships of sail. Training ships were built in all countries having merchant or military fleets, and these continue in use today, far past the time of the last commercial sailing ships. Because they were created for educational purposes, these boats existed outside the brutal economic restraints that dominated the commercial world. They had a relatively comfortable budget on which to run, and used large and obedient crews to make sure every line and painted surface was in perfect order. No dirty or corrosive cargo gets loaded here, and no shells or cannonballs would ever touch the painted topsides.

The *Joseph Conrad* was built in Denmark as the *Georg Stage*, and she is afloat today under her new name at Mystic Seaport. The *Conrad* was not always on the right side of the surface, however, for in 1905 she was rammed by a steamer and sank with the loss of twenty-six young men. The sinking was rapid and fatal in part because the ship had no watertight bulkheads, such as the ones that kept the destroyer USS *Shaw* afloat (plate 67). When she was raised and rebuilt, these lifesaving improvements were added, and so this small, full-rigged ship was able to keep doing her job of preparing new generations for a life at sea.

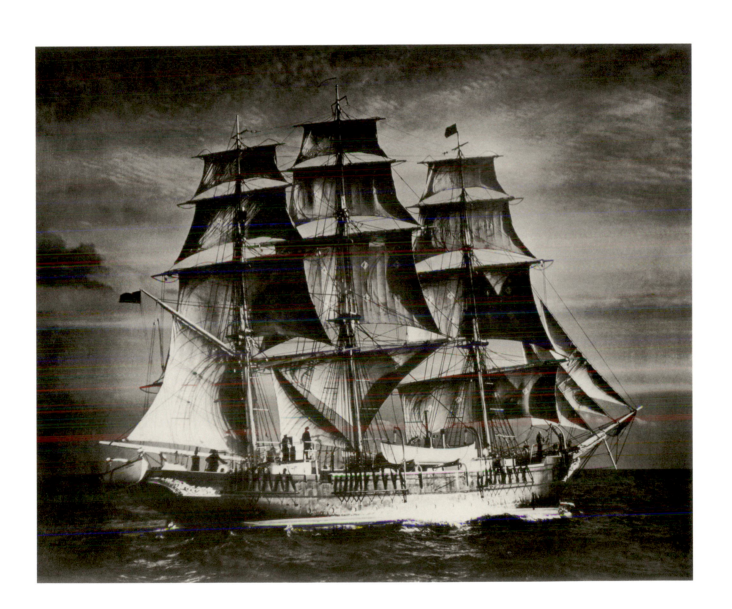

6

USRC *BEAR* ANCHORED TO AN ICE FLOE

JOHN JUSTICE

This picture shows the United States Revenue Cutter *Bear* moored somewhere in the Arctic. By the time this picture was made, the heroic early days of northern exploration were ended and the *Bear* had settled into a long and arduous life of repeated trips into freezing waters. The ship ran on both wind and steam and she was built in Scotland as a sealer in 1874, not entering government service until ten years later. She was purchased then by the United States Navy to be part of a successful rescue team sent north to find Lieutenant A.W. Greeley, whose expedition had become marooned while trying to travel farther north than anyone had ever gone.

When the technology-obsessed travelers from Europe and the United States came into the Arctic, they did so for three reasons: to pursue the whale, to search for a transcontinental sea passage above North America, and to rescue those lost explorers looking for this same North-west Passage. The whalemen went into the ice first because the value of bone and oil that made up a whale could justify huge risk; the very fat that protected these mammals by insulating them from the cold of the sea was the source of the oil that made their slaughter inevitable. If the price was a steady loss of ships and men, then this was simply an acceptable cost of doing business. The explorers were daring but often foolhardy men, who approached the natural barriers of the North with that particular arrogance that our belief in science and technology so consistently breeds. They saw no reason why the ice shouldn't fall to their superior minds and tools, and death came with a vengeance because of their inability to adapt to the realities of a frozen climate. As these travelers pushed their way through the North, a complex society of local inhabitants lived their normal lives there, and looked on in bemused wonder at the tragedies that so regularly befell the strangers.

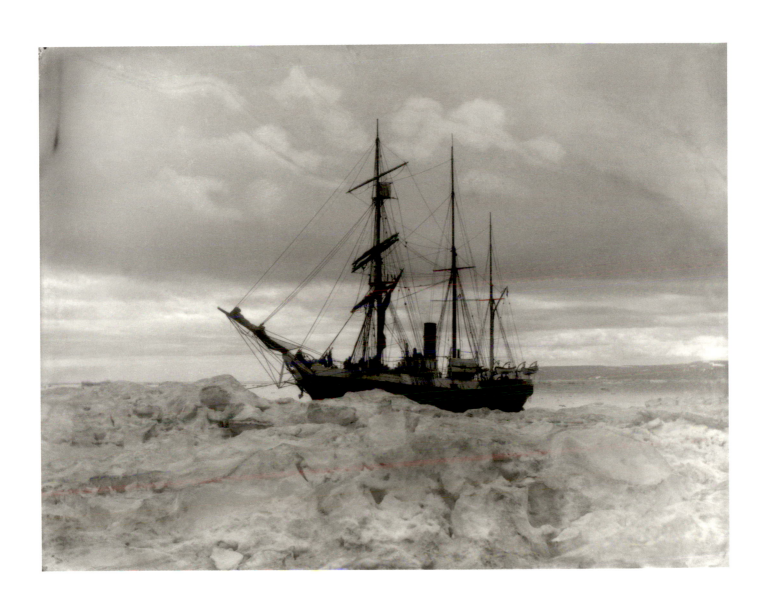

SPERM WHALE ON *CALIFORNIA*

MARIAN SMITH American, active 1901

The whale is huge and the man is tiny. The great marine mammal we see here on the deck of a whaling ship is actually much bigger than the photograph implies, because the picture shows just part of her massive head, called the "junk," that remains after the lower jaw is cut away. How does the man come to be at sea, with his intricate tools and cooperative tribal effort, hunting this extraordinary animal?

It all happens because different kinds of whales, cut to pieces or boiled down, turned into the commodities of baleen, bone, oil and spermaceti. Baleen and bone would go into corsets and umbrellas, collar stays and cane handles. Women made their husbands shirts with buttons of whalebone; sailors brought home yarn spinners of this tough white stuff, and penknives were bound in its smooth grip. The oil found its way into tiny bottles that came with every sewing machine, as sperm whale oil proved to be the finest lubricant ever known. It even went into jars with fancy labels, hawked by quacks in covered wagons selling magical cures to an unsuspecting public. One of nature's more astonishing productions, whale oil has only recently been replaced as we have finally learned to make comparable materials from oil that comes from ground-based wells.

As petroleum and modern chemical miracles reduced the demand for whale oil and bone, the fishing industry that depended upon the whale cast about for new uses for its catch. Whale became a delicacy for the dining tables of some countries, and ground-up and processed whale protein became feed for domesticated animals in the complex human food chain. The whale became another victim of rampant human consumption, and only now, through the efforts of conservationists and the economic realities of disappearing stocks, is the hunt dying off. Soon there will be no more whaling ships, but whether the whale itself will survive beyond them is a question only time can answer.

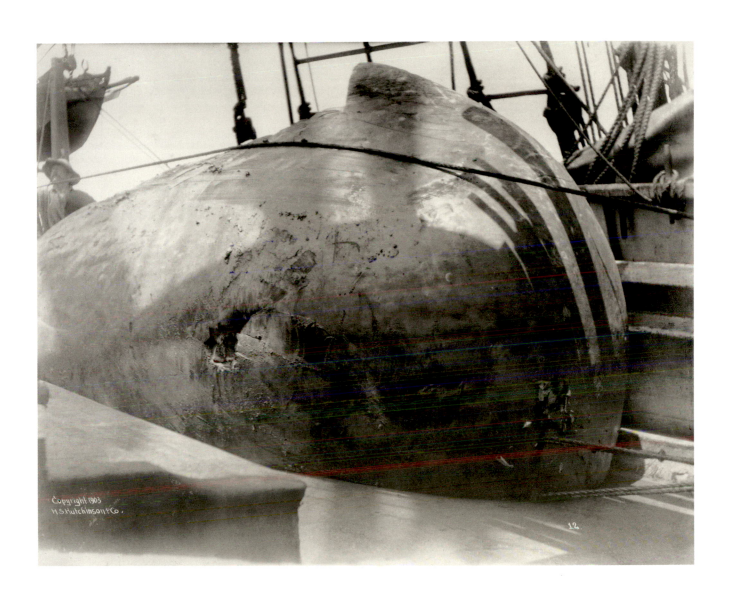

12.

WHALEMEN, NEW BEDFORD

PHOTOGRAPHER UNKNOWN

Winter clothing is something we have had to invent. In the brief time that humanity has been around, the species has not lived in icy climates long enough, nor been adequately isolated there, to genetically evolve protection from the cold. We are born naked, and for most of our tenure on earth we have walked around that way, so the notion of wearing clothing at all is a relatively new one. The travelers we see in this beautiful old blueprint, whalers returned to New Bedford, are wearing protective clothing made from the skins of animals who lived in the North.

Our own skin, with little hair and vital blood running just below the surface, offers almost no resistance to truly cold weather. Cold-adapted animals, however, have two protective devices that we lack: insulating layers of fat, and thick coverings of hair. It is impractical to peel off coats of blubber from a dead creature and try to wear them (although distance swimmers have traditionally greased themselves down before a long trip), but skinning an animal and preserving its hide and coat have been among our oldest crafts. These sailors wear complex and refined clothes that were developed by the long-time residents of the North. The man on the left wears his outfit with the hair side turned in, while the others have it out, facing the weather. Both these clothing types are efficient, because the insulating nature of hair, which retains a layer of still air, can work well in both cases. Whether in or out, the most serious problem to be faced is that of the clothes becoming wet. If the hair is out, then the dampness comes from the weather; if the hair is in, then it is even worse, coming from the condensation of the wearer's body moisture.

The basic function of clothing that protects us from the cold is to handle the transition of temperature from our warm skin down to that of the much cooler air outside. Insulating clothing creates a gradual thermal incline over which temperature decreases as the distance from the skin increases. A problem arises because relative humidity, a measure of the moisture content of the air, is intimately tied to temperature; as any enclosed volume of air cools, it reaches a point where its water vapor condenses into liquid. Therefore, wetness from condensation, fed by water in our sweat, develops within the garment, and it is just as persistent and difficult to handle as a steady rain from the outside. The solution is to make clothing that holds insulating air, and yet allows enough circulation so that condensation does not become a problem. The animals who worked out these skins in the first place consistently wear them hair-side out, which allows condensed moisture to evaporate. People, always messing around with the natural order of things, tried them both ways, and the marvelous comfort of being wrapped in a pelt hair-side in was often irresistible.

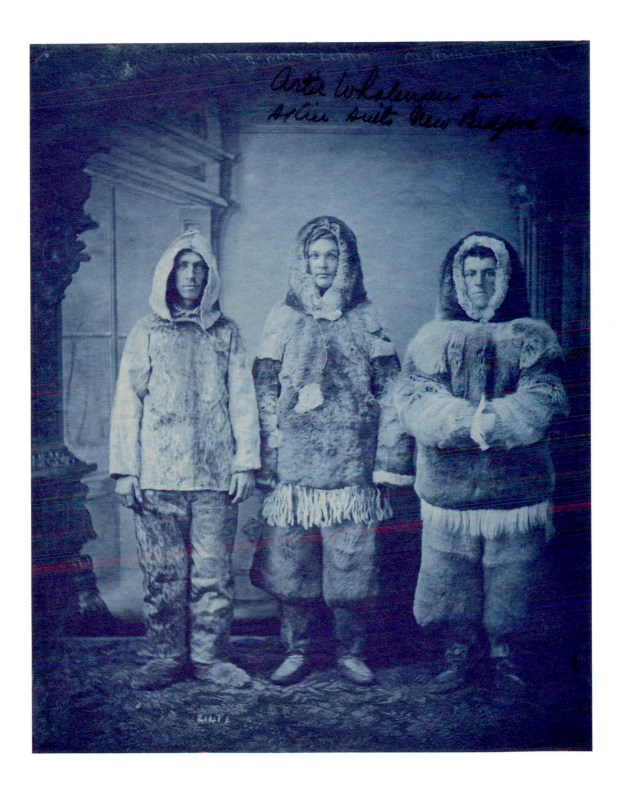

Artic Whalemen in
Artic Suits New Bedford 1884

COMMODORE MORRIS, WHALER

PHOTOGRAPHER UNKNOWN

The *Commodore Morris* is probably at the end of her days, and the tiny precise figurehead will never again plunge into a warm Pacific swell. The jibboom is withdrawn, lying on top of the massive bowsprit, and the stumps of the masts are accompanied by the rough lowered top-masts holding up what remains of her rigging. Chained to New Bedford's stone wharf, she and her companion have become the large, ungainly leftovers of an earlier time. It was not always so.

Commodore Morris (bark)
Built at Falmouth Mass, 1841 · 338 tons, 107 feet overall, 28 feet beam, 18 feet draft
Owned by Oliver C. Swift, Falmouth Mass.

Sailed Nov. 30, 1841	Pacific Ocean	Returned May 13, 1845
	1450 bbls sperm oil, 40 bbls whale oil	
Sailed July 9, 1845	Pacific Ocean	Returned April 1, 1849
	2450 bbls sperm oil, 100 bbls whale oil	
	sent home 90 additional casks sperm oil	
	lost whale boat and crew off Chile, 1846	
Sailed August 13, 1849	Pacific Ocean	Returned August 19, 1853
	1860 bbls sperm oil	
Sailed December 7, 1853	Pacific Ocean	Returned October 17, 1858
	1098 bbls sperm oil	
Sailed July 13, 1859	Pacific Ocean	Returned June 19, 1864
	931 bbls sperm oil, 232 bbls whale oil, 1700 lbs bone	

Sold to Swift & Perry, New Bedford, Mass.

Sailed May 10, 1865	North Pacific Ocean	Returned December 10, 1867
	850 bbls sperm oil, 70 bbls whale oil	
	sent home 1810 additional casks sperm oil, 30 casks whale oil	
Sailed May 12, 1868	Atlantic Ocean	Returned December 3, 1869
	759 bbls sperm oil, 43 bbls whale oil	
	sent home 164 additional casks sperm oil	
Sailed April 27, 1870	Atlantic Ocean	Returned May 24, 1873
	610 bbls sperm oil	
	sent home 1215 additional casks sperm oil	
Sailed July 29, 1873	Atlantic Ocean	Returned September 24, 1876
	2930 bbls sperm oil	

USRC *BEAR* WITH CARIBOU

JOHN JUSTICE

Life in the North is not the same as it is farther south. If we were to pinpoint the single biggest difference, it would be the lack of agriculture above the Arctic Circle. People living there have become clever at building shelter and developing clothing to fight the cold, but the inability to grow food has meant that animal life alone has become the basis of their diet. The whale, seal, bear, musk ox, and caribou are the large mammals living in the coldest northern regions and they have been hunted and eaten since the first human migrations into their territory. Along with fish and birds, these animals are prized by the Inuit for the living storehouses of protein that are their bodies, and hunting for sustenance is the chief activity of anyone who lives at the top of the world.

European travelers in the Arctic were terrified by the lack of visible food, and they assumed that stores had to be brought with them onto the ice. Time after time, we read about the back-breaking labor of pulling sledges loaded with sugar, tea, pemmican, and cooking oil for hundreds of miles across the barren terrain, yet all the while native populations were living off what they could catch. The freezing temperatures refrigerate, so a few hundred pounds of seal meat wouldn't spoil as it was eaten, and the local hunters had long since accepted that food would be found when it was needed. The first white traveler to understand this fully was Vilhjalmur Stefansson from Minnesota, who repeatedly claimed that his hometown winters were worse than those of the Arctic. Stefansson studied the northern cultures, taught himself their hunting skills, and adopted their belief that the land held a plentiful food supply. In 1913 he stepped off the northern shore onto the ice of the polar cap carrying hunting equipment instead of stocks of food, and proved his point by living vigorously in the North for five years before returning.

Many northern animals migrate, moving in broad patterns that reflect seasonal changes as well as the realities of the ice. Occasionally a herd of reindeer or musk oxen would fail to appear at its expected location, and the inevitable result would be starvation and death for families, or even entire villages, waiting for them. The USRC *Bear* is in the background of this photograph, and she has unloaded the reindeer waiting on the rocky shore as part of a relief mission. Perhaps this saved some lives, but it may also have caused the death of people waiting in vain for these same animals to arrive at some distant location.

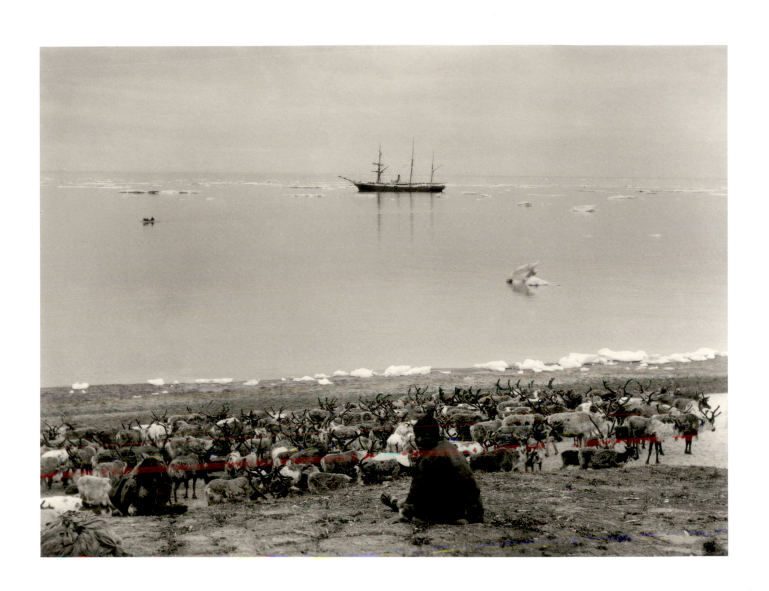

MINOT'S LEDGE LIGHT

PHOTOGRAPHER UNKNOWN

Because lighthouses live in the tumultuous and changing locale of the seashore, they must be built to forms unlike the ship or the house. Waves and tide assault the shore and tear down any structure built there, and when the building must be tall, as the lighthouse need be, then the problems faced by architect and builder are great.

The tower of the Minots Ledge light is cylindrical — one practical shape for a lighthouse. The wind and sea, both of which will strike the house, can come from any direction, and the form of the building must offer the least resistance to their attack. If we knew that waves would only arrive from a single point of the compass, then we could build a knife-edged house facing that way, like the Swiss buildings in avalanche country which present an acutely angled edge to the rising slopes upon which they are built. The sea, however, is unpredictable, and her assault can come from north, south, or any direction in between. Only with a cylindrical shape can we know that the building will handle an onslaught best, no matter from which direction it comes.

These blocks are held together with mortar, the glue of the mason's world, and the flat horizontal surfaces are mated with a wide joint of cement, to hold the chunks together to form a single massive structure. While the mortar helps, the chief binding force of the building is gravity, and this tall tower is actually just a highly refined pile of rock. Another of these carefully finished and tall rock piles is the Washington Monument, which often adorns postcards from our nation's capitol. These two shaftlike buildings, one round and the other of square cross section, depend upon the density of stone in the grip of gravity to achieve their strength and stability.

The stones are being pulled up to their final resting places by a gin pole. This simple and ancient lifting device consists of an angled pole that leans out from its pivot to a point beyond the building's edge. From its tip is suspended a block and fall that can reach down to the ground and lift each successive block. The gin pole is strong and light, and as the building grows this crane rises with it. The little stick and its lines, that we see here at the top of the partially constructed lighthouse, are thus the precursor of the steel cranes that dot the landscape of all large cities today, as they grow up into the sky to keep above the working surface of the buildings that they are steadily creating.

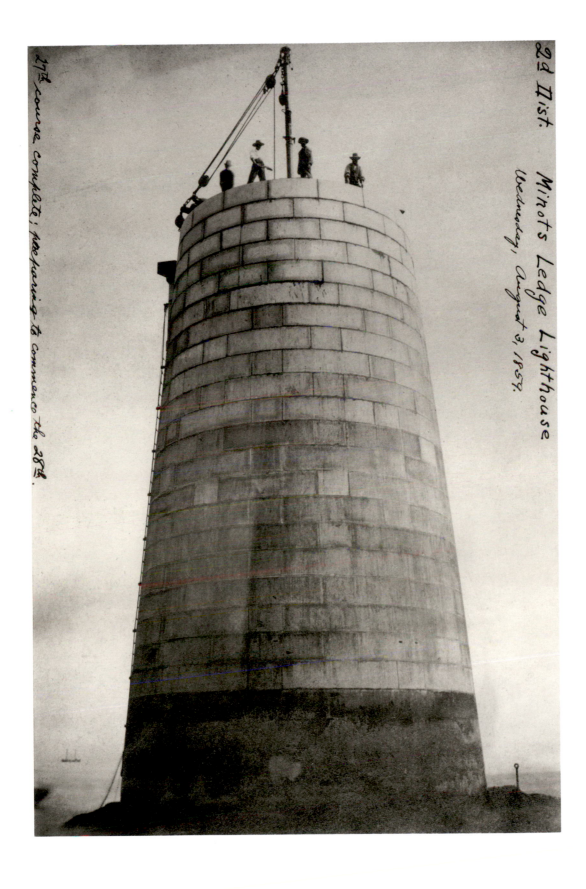

Minot's Ledge Lighthouse

Wednesday, August 3, 1857.

17th course complete; preparing to commence the 28th.

WRECK OF THE *ADLER*

PHOTOGRAPHER UNKNOWN

Even a construction as massive as this fighting ship is puny compared to the forces of nature, and all it takes is one good storm to strip a machine like the *Adler* of her rigging and armament. The intricate ship has been reduced to a beaten lump on the expanse of coral, and the natural order of things has been restored: the ship is a fragile passing fancy, built by upstart men, and only the old beachhead, built by billions of tiny animals, has withstood the tropical storm.

We can see how her structure has been blown, beaten, and scraped until the hull alone is intact, but the astonishing thing about this photograph is that it shows just how far out of the water the ship has been carried by the storm. During the blow, the sea must have been high enough to float her here, because even a 150-mile-per-hour wind doesn't pick up 400 tons of ship and toss it through the air. The rising water level that accompanies a tropical storm is one of its most destructive characteristics, and we often forget about this phenomenon because the wind and violent waves are so much more easily envisioned.

Heat from the sun falls steadily on the planet, warming the air and sea and driving the engine of Earth's weather. When a gas is warmed, it expands, and any given volume then becomes lighter and so will rise. This is the simplest description of how wind is created, because the rising air demands a replacement flow below it, and so circulation is set up and the wind blows. In the eighteenth century the physicist Bernoulli wrote a theorem about the behavior of fluids in regard to velocity and pressure. His work demonstrated that when a fluid such as air moves smoothly in any direction, (as in a breeze), its pressure drops. This reduction of pressure is why the *Adler* sits so high upon the coral. The planet's skin of water is wrapped in the gaseous atmosphere that holds the winds, and the contour of the water's surface follows the squeeze of its encompassing air. When the wind blows strongly in one region the air pressure there falls, and the sea rises up, pushed by the surrounding higher pressure of calmer regions.

Storms carry with them a risen plateau of water produced according to Bernoulli's law, and this destructive mass lets the wind and waves do their damage. Anchors lose their flat angle of attack to the sea bottom, and so pull out; ships come down on top of rocks and piers, and water attacks constructions far from its normal shore. The *Adler* was lifted many feet above her usual location and then dropped brutally on the coral reef, to let us know, once again, who is the strongest player in this game.

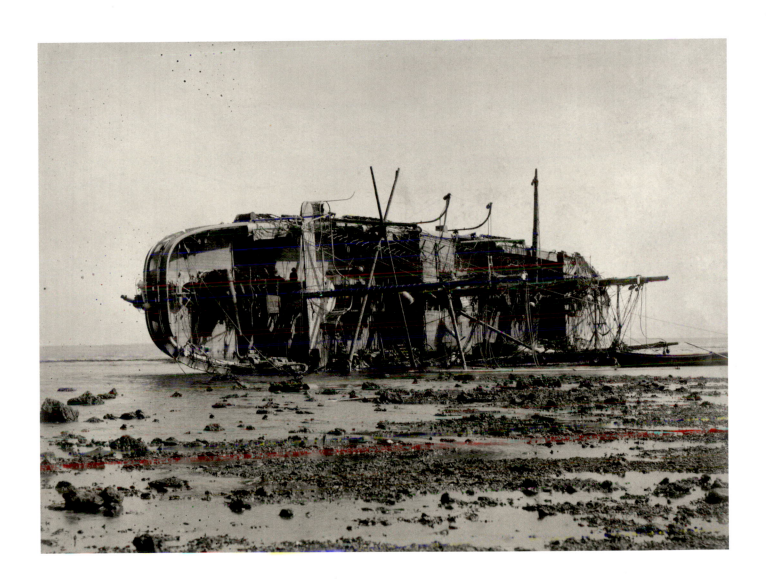

13

THE USS *CONSTITUTION* ON THE WAYS

PHOTOGRAPHER UNKNOWN

This photograph shows the USS *Constitution* being rebuilt on the ways in 1874. Old Ironsides, as she was dubbed after British cannonballs bounced off her hull during the War of 1812, is as much a part of United States history as the Liberty Bell or the Declaration of Independence. While these two other artifacts have been easy to preserve, needing only to be protected from the weather, this sailing ship has required constant rebuilding through the years. Not counting continual refitting, she has received major overhauls about every forty or fifty years; this picture probably dates from the middle of her second rebuilding. We can see how her surface skin has been peeled away so bad wood can be replaced, and it is reassuring that the life of an individual ship can continue in spite of such extensive repair, where so much of the hull is replaced that we really don't know if any original wood remains. Today she is the oldest ship on the naval list and floats, freshly rebuilt, in Boston Harbor only a short distance from the site of her launching two hundred years earlier.

The *Constitution*'s record reads like a history of the United States. Ordered up by Congress in 1794, she was launched in 1797. Her creation expressed young America's struggle to become a first-rate sea power at the end of the eighteenth century. By winning the Revolutionary War, the United States had rattled England's self-confidence and when the *Constitution* sank two of her warships, the *Guerrière* in 1809 and the *Java* in 1812, many felt that Britain's days as an imperial power were over.

Old Ironsides spent much of the nineteenth century carrying officials around the world, acting as a flagship, training young seamen, and in general strutting America's stuff for the world to see. As late as 1930 she went to sea, by this time a hallowed piece of our past, touring the coasts to rekindle national feeling among her subjects. Millions of school children and tourists have walked upon these decks, and her only movement nowadays is a periodic turn at the dock, so the eroding forces of sunlight can work on her port and starboard sides equally, eating away at the planks where earlier iron shot could do no harm.

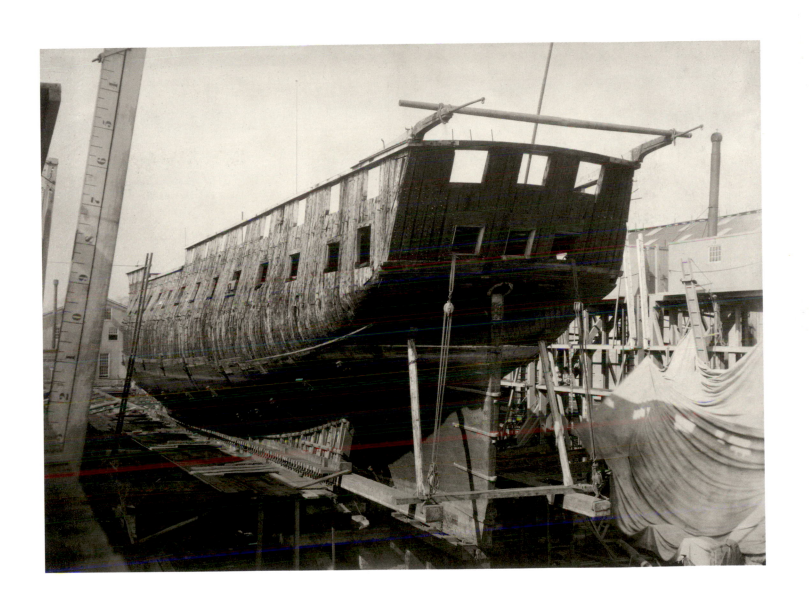

RIGGING OF THE USS *CONSTITUTION*

PHOTOGRAPHER UNKNOWN

Here is the almost unbelievable complexity of rigging in a large square-sailed frigate. The photograph has been carefully made with the large negative of a view camera, perched up high so we see the lines and spars from a height equal to their own. The surreal clarity of the picture is confirmed by the postcardlike silhouettes of the seamen painting and wiping down the rigging, keeping this web of lines and sticks in perfect order. There is something a bit suspicious about the photograph, and this is confirmed when we understand that this is the ancient *Constitution*, a national relic, and yet the men have that unmistakable look of the twentieth century about them.

Even if some overzealous conservator of our national heritage might have added a few extra lines and given them a perfection that a working ship could never have, we must recognize that manpower was the key to running a vessel like this. As the nautical world runs round the clock but people need their sleep, two full complements of seamen were required. Gun crews, marines, bosuns, cooks, and carpenters also packed the ship, so hundreds lived and worked together in its pitching confines. Toward the end of the nineteenth century, one hundred years after this ship was built and thirty years before this picture was taken, the square rigger had grown to huge proportions, made for commercial hauling all around the globe. On these later ships the sails grew bigger and the rigs taller, yet they ran with crews only a fraction of the size of the military ones; perhaps only fifty men would handle 3,000 square feet of canvas. There has been a steady increase in the value, in monetary terms, of human labor through the years, a fact that the declining numbers in a sailing crew reflected.

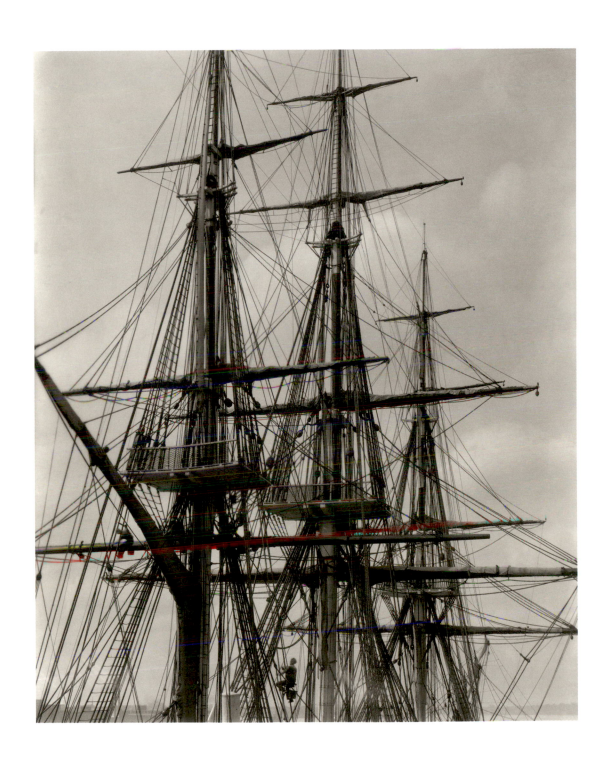

DONALD MACKAY

ALBERT SANDS SOUTHWORTH American 1811–1894

JOSIAH JOHNSON HAWES American 1808–1901

This is a photograph of Donald MacKay, the builder of the best and fastest clipper ships of his or any other time. What a picture and what a man. How does the innocent child become a creature of such confidence and force of will, that even through the scratched image on a copper plate over one hundred years old, he is able to move us so. Maybe it is the hands, ready to heave aside any obstruction to his desires, the hard set mouth that needn't speak to let us know disapproval, or the piercing eyes that see so much more than we do. Wherever he came from, or whatever forces made him, we can be glad to have never stood in this man's way.

The simple fact of moving materials, whether raw or manufactured, has often been the root of great wealth. MacKay didn't achieve such riches, because he was too interesting a character, more obsessed with the means of transportation than the rewards it could earn. When he built the great clippers, speed had become a factor in commerce, and the slow pace of eons was being overturned by the frantic nature of man the builder, harried by his understanding of time and its fleeting pace. There turned out to be a clear relationship between the speed with which a ship could run across the thousands of miles of her route and the size of the cargo this same ship could carry; the larger the load the slower she went. The interlocked nature of speed and capacity were part of an intricate formula that included underwriters' fees, reckless sailing, and changing technology and tastes, and which led to the development of the clipper ship. She could carry a moderate load at a lightning pace, sailing beautifully even through the wildest seas, and from about 1840 until the full-blown age of steam there was a worldwide excitement about these refined and beautiful cargo ships. Donald MacKay created some of the most extraordinary: *Staghound, Sovereign of the Seas, Great Republic, Glory of the Seas,* and *Flying Cloud.* Their names ring with excitement now as then, and they remind us of a time when the United States was still young and restless, not staid and dull as she so often seems by comparison today.

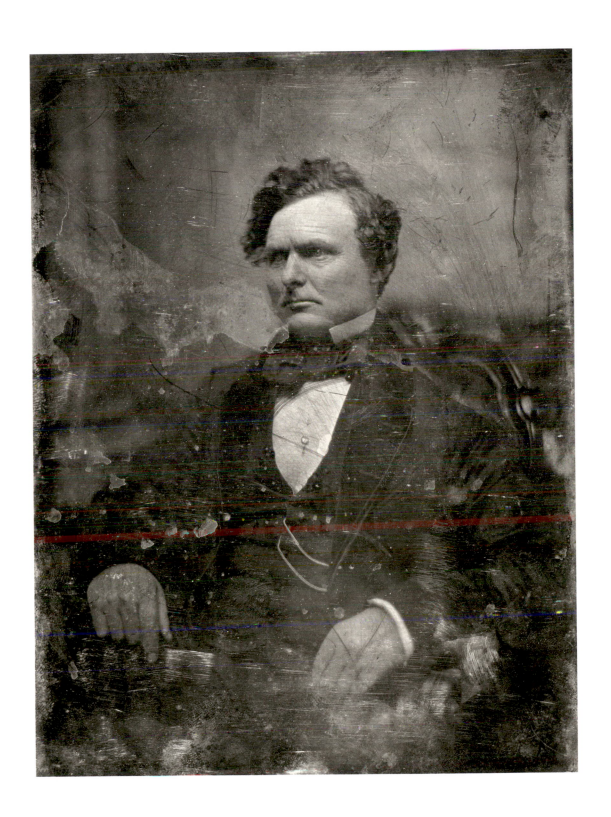

THOMAS W. LAWSON
PHOTOGRAPHER UNKNOWN

The square-rigged ship ruled the high seas during the years of sail, but a completely different type of vessel handled the coastal trade. Near shore the daily cycle of changing heat of the land and sea creates foul winds at all the wrong times. In response to this, and also in need of a simpler and less labor-intensive plan, the coasters grew up using the more familiar modern "fore and aft" rig that we see here. The sails on these ships could be drawn close in to the hull, parallel to the ship's length, and the bellying canvas then formed an airfoil with its low pressure side pulling the ship along in a direction that could be much closer to the wind's source than a square sail could manage.

Coasters started out small and gradually became long, of great capacity, and multimasted. These ships tried to compete with the square riggers, but did not fare well in seas like the Southern Ocean, the unobstructed belt of water that circles the globe below Cape Horn and the Cape of Good Hope. There, the trough of a storm-driven wave could be so deep that the short-masted coaster was literally becalmed while low in the wave's cycle and slammed mercilessly while on the crest. The tall rig of the clipper reached above this variable air, keeping the ship in a comparatively steady state through all the turmoil; the many yards and sails could be set in more varied combinations to suit specific conditions.

This schooner is the only seven-master ever constructed and the largest sailing ship ever built. She was made of steel, which finally cured the old problem of these hard-working boats sagging out of shape due to low buoyancy at stem and stern. She carried coal in the beginning, and was capable of loading over 9,000 tons, but later on she was fitted out with internal tanks for oil. Only when deeply loaded would she sail properly, but when full of cargo her draft exceeded that of almost all harbors where this same cargo was needed. The *Lawson* really was a failure: she worked for only five years before being lost on the rocks off England in 1907.

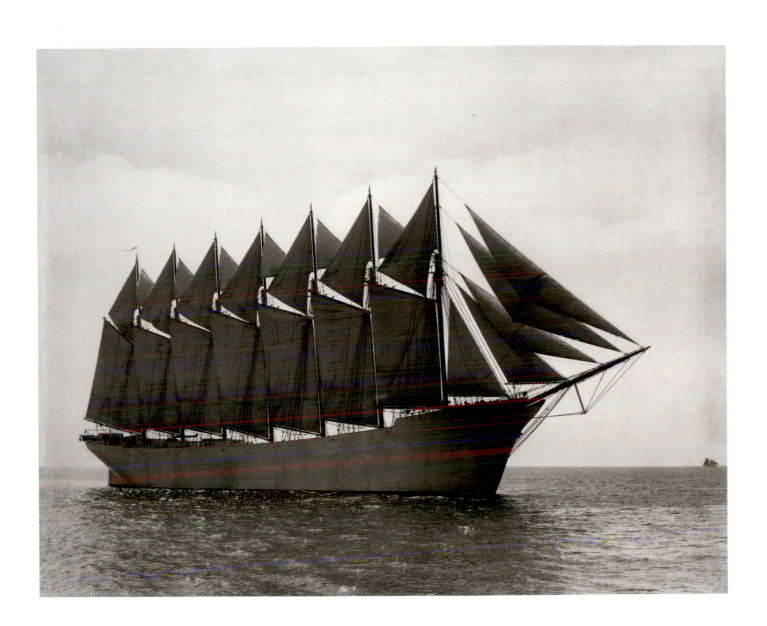

JUAN SEBASTIAN DE ELCANO

CLIFTON GUTHRIE

The white ship whose figurehead we see is a trainer, built by Spain for the betterment of her young seafaring officer candidates. These ships sail about, not really going anywhere, and when the men are not up in the rigging learning fear and respect for the sea they can be found employed in the three activities shown here. First is the pastime of leaning back in some nook of the ship, with a companion, and passing the long days peering about and commenting on wharfside life. Second is carrying on the constant battle to prevent the ship from rusting away; this is what the man suspended in the rope bosun's chair is doing. Whether scraping or painting, the crew of any steel or iron ship must continually fight rust caused by the corrosive salt water in which the ship lives. Third is the ceremony of dressing up in fine clothes, complete with gold buttons and stripes of rank, that all military men must do to display their human version of the ruffled feathers or raised antlers that adorn so many creatures that fight.

The flattening structure of the photograph, which puts the four men and the ornate figurehead all on the same picture plane, binds the people up in a linear web. Most of this visual network is drawn by strands of wire rope, or cable, but common rope — or line as it is called at sea — is visible as well, holding our sailor suspended in his chair. The most surprising line of all in the picture is the white, featureless bobstay that runs diagonally from lower right to upper left. This is a solid shaft that reaches to the end of the bowsprit from its anchor point low down on the stem of the ship, and it counteracts the immense upward pull that the bowsprit must sustain from the forestays that support the ship's masts and headsails. By matching the tension of the cables that reach up to the masthead, this rod ensures that the bowsprit is in compression only, so the wood supports a load that can be easily handled, in the same way that a structural column holds up the weight of a heavy floor or lintel. The white rod is acting like another piece of line — it could just as well be a length of massive cable — but because of its forward location half in the water, this structural element is subject to corrosion of the worst sort. The twisted fine wires of a cable would suffer from destructive rust that would be hard to see or prevent; the use of a smooth, round shaft instead, which can be painted and easily examined, avoids the potential catastrophe of a failure in the most highly tensioned point in the ship's rig.

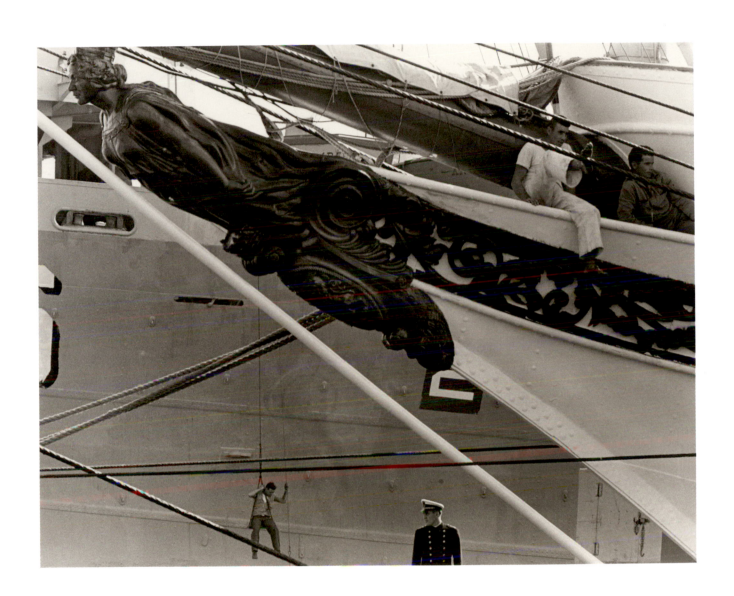

HIGGINS AND GIFFORD BOATYARD
GLOUCESTER, MASSACHUSETTS
PHOTOGRAPHER UNKNOWN

The photographer must be standing on a pier that faces the granite dock with its disorganized group of buildings. Farthest to the left is someone's home, complete with Victorian shutters on the windows, and to the right of it is the boat shop with its late addition stuck on the back. All the way to the right is a three-storey building that most likely has apartments on the upper two floors, and shops that smell of fish or tar on the first. Whatever their variable uses, this complex of buildings has cropped up over time without a plan. First the land was created by the granite wall that could hold fill, to eliminate the useless slope of the natural shore, then a house was built on one spot, a shop on another, and before long the group found its form as recorded in the photograph.

This haphazard evolution was not the case with the boats in the foreground of the picture. They embody a completely different approach to construction; each of the eighteen white double-enders was built to a single plan, to produce a group of objects as identical to each other as possible. The reason for this repetition is that the boats will all be used for the same job out on the water. When the future of our creations can be foreseen, and we understand that multiple units of any object will be needed, then we toss off the old casual patterns by which we make things, like the group of houses, and instead take up the modern idea of efficient repetition in manufacturing.

These boats were made to a single design, one that experience refined over the years. The boat shop doubtless holds the set of forms over which the identical hulls are built, and the workers making each piece of each boat have made earlier examples of the same parts before, and so make them with an efficiency that only the suppression of imagination and the acceptance of duplication as a methodology can produce. The boats will each be painted with the same color, each be trimmed with a pair of identical half-round rub rails, and each receive the same wooden pump that shows above the gunwale. This is the modern way, this idea of many things being the same and so becoming powerful. Our photograph shows beautiful hand-made boats, appearing to belong to an earlier era, that demonstrate the impersonal strength that repeated invention can give to man the maker.

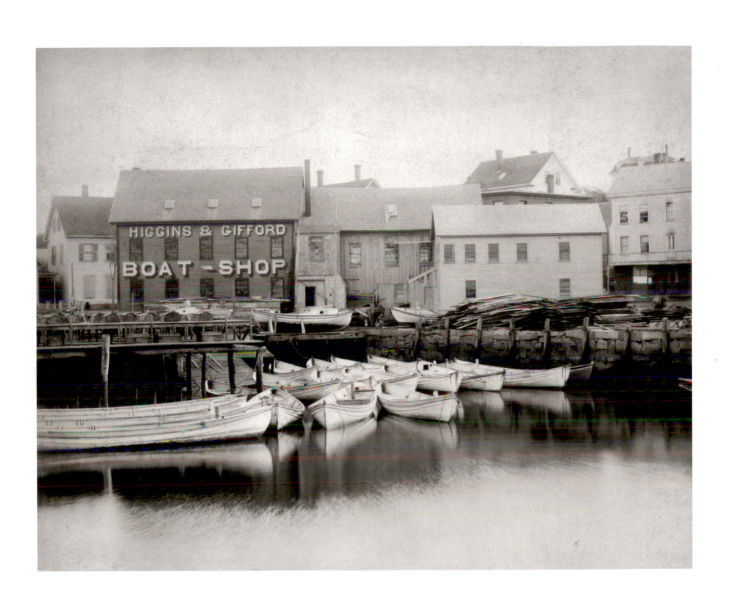

IRISH CLAM DIGGERS
PHOTOGRAPHER UNKNOWN

Someone has written the title of this picture in pencil on the front of this beautiful old blueprint. Such titles are not always reliable, but this one is acceptable because the figures strike a familiar chord that confirms who the title says they are. There was a huge migration from Ireland to the States in the late nineteenth century when blight all but destroyed the monolithic potato crop which fed Ireland's population. The people in this photograph have likely found their way to the plentiful shores of America, where food could still be gotten through the simple old expedient of hard physical labor. The ground out of which these workers dig their crop is wet and unplowed, but the clam and the spud both hold convenient, fist-sized nuggets of sustenance that can be harvested into bushel containers and brought to market.

The large tub in the center was built with hoops of sinewy green wood, instead of the iron used in traditional casks. We tend to forget that the cask—tough, waterproof, and stackable—could hold water or goods in its tapered interior. These containers swell when wet; they seal and become more watertight the wetter they get because the wood in their staves expands and each mates more firmly with its partners within the restrictive grip of the surrounding hoop. The picture also shows boxes, rectilinear and perfectly stackable, that gradually replaced the cask and became the shipping container of choice in the commercial world. A box can be machine-made, assembled out of pieces cut to a plan and simply nailed together, whereas a barrel must have its parts each fitted to the other by hand. Boxes were not watertight, but steel drums came along and fulfilled this requirement, so the versatile old cask was replaced by two modern types of container. The woman on the right holds a basket; these were among the most widespread of all containers that people have ever used. Along with pottery, the woven basket turns up in graves and archaeological sites around the world. Every basket ever made by hand is different than every other; baskets are the ultimate example of a complex manmade object that has all its parts fitted to the unique particulars of its companions. This is the old way of making things, and it is under mortal attack today in the age of mechanized mass production.

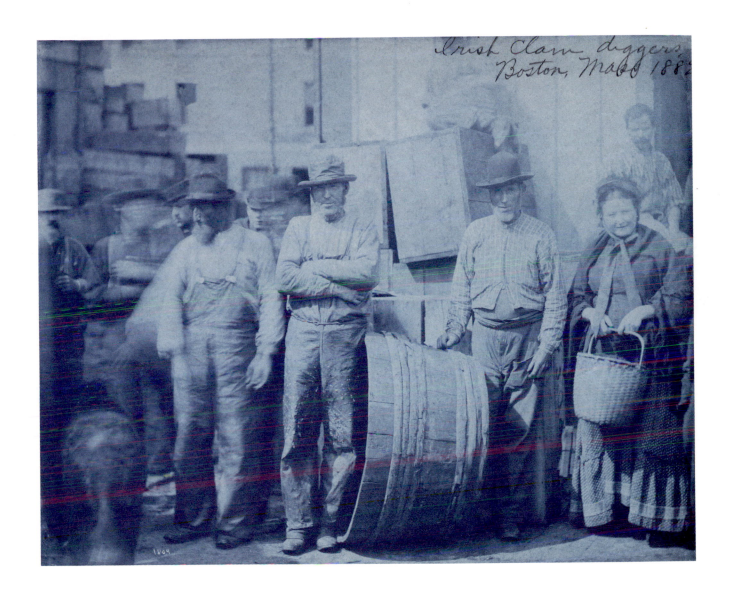

Irish Clam diggers Boston, Mass 1882

FISHING BOATS, BOSTON

J. JAY HIRZ active 1930s

This photograph dates from the 1930s and shows part of the fishing fleet in Boston Harbor. Little boats have traditionally been powered by wind or muscle, and even the advent of steam engines didn't change this much, as these new machines were expensive and complex to install and run. While the new power could be justified for a small vessel like the harbor tug, where the loads to be moved were so valuable, it was impractical for small fishing craft, which so often existed on the economic fringe of the marine world. Later, when the cheap and reliable internal combustion engine came along, a new class of fishing craft quickly grew up, often owned and run by a single person or family.

These boats fall into two categories; one uses nets, and the other hooks. Fish are almost always caught in one of these two ways, and both techniques were adapted for offshore use. The rigging needed for nets was complex, and the masts and lines they required are visible on about half the vessels in the picture. On most of these, the nets themselves are hung up to dry, and the small wheelhouses speak of long hours trawling in wet and cold weather. The other boats, which fished with lines, have none of this complexity, but instead each carries a dory on deck and has only a rudimentary house for protection from the elements. The dory could be launched far off shore, and the fisherman could work with a sunken line that carried multiple baited hooks that passively caught the fish. The life of the longliner was tough; tales abound of men who, separated from their boats, rowed back home from the Georges Bank with hands frozen to the oars after days of struggle. Their small dories, with a deep v cross section, are without exception the most seaworthy of boats. They have the remarkable characteristic of being open to the sea, yet so agile that they can survive any weather.

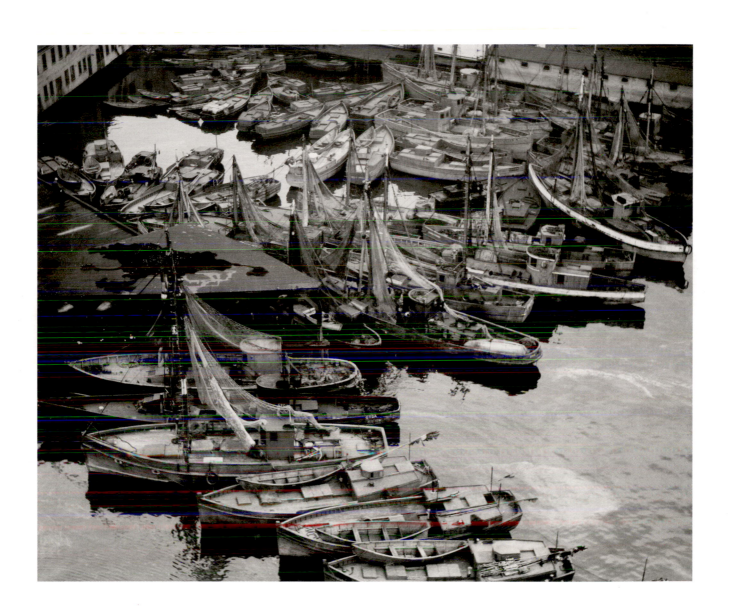

MAN HOLDING HALIBUT

EDWIN LEVICK AND SONS active 1909–1940

Off the New England coast lie some of the richest fishing grounds in the world; these run along the shore as well as farther out in the Georges Bank. Rumor has it that when the colonists first settled here the lobsters grew to three feet long and routinely lived to one hundred years. The lobsters could do this because the native population either disdained them as food or were too wise to fish them down to our modern levels. Whether this romantic notion is true or not, the wildlife of the sea today, near the crowded settlements of the Atlantic coast, is only a shadow of what it once was. The increase in human population has caused much of this depletion, and overfishing has occurred because the technology of the catch has far outpaced the relatively fixed ability of the fish to elude the fisher.

This fish is a halibut, the steroidal cousin to the flounder, and it is at least as long as the young man who proudly holds it up. Despite his grin, the man is dressed in the traditional black of the executioner, and we must recognize that this picture shows the extraordinary ability of mankind, with its clever mind and agile hands, to overcome all other life on the planet. Both creatures are far out of their element. The human being has gone to sea in a small fishing boat where the slightest mishap could spell doom. The fish has been pulled up out of the depths, the white belly no longer slithering along the sandy bottom but instead revealed to the air and light of the surface world like a forbidden sight that society has had the good sense to deny us.

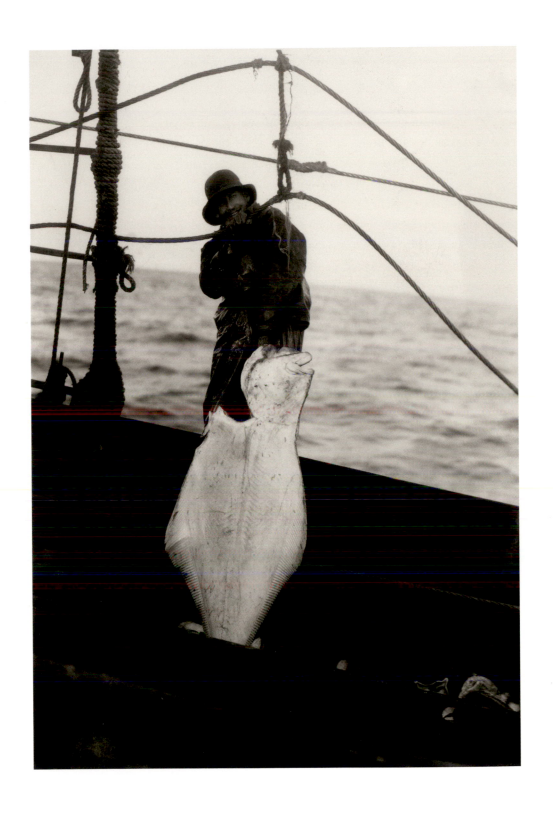

UNLOADING THE SEINE

EDWIN LEVICK British 1869–1929

———————————————

This photograph shows a large seiner taking in a catch somewhere off the Atlantic seaboard. In the Northeast, people always called these "pogie" boats, as this was the nickname for menhaden, their primary quarry. When fully loaded, the boats had the odd look of nearly sinking, since the huge hold between the two houses could take in enough fish to bring the gunwales right down to the water. The forward structure held the wheel and crew accommodations, and the rear one the engine and winch, which is being operated by a man visible through the open doorway. Out of sight, beyond the picture's righthand edge, would have been two davits capable of holding the double-ended net boats visible in the foreground. The system of netting being used here is the purse seine, one of the oldest and most efficient means of catching lots of fish.

The two small boats, almost canoelike in shape, carried the single net between them, half piled up in each open hull. Even when lifted on their davits astern, the net could still be loaded, part of it hanging from one hull to the other, and when a school of fish was found, the double-enders would be launched and run up on either side of the school. As the boats spread apart, the net ran out and hung down like a curtain suspended between floats at the top and weights at the bottom. The two boats would surround the fish and link the top ends of the net, so the curtain hung in a circle with the boats next to each other where the ends were connected. By pulling in a line that ran through a series of rings sewn into the bottom edge, the base of the net was drawn up like the neck of a string bag or leather purse. Once the net was tightened, becoming an enclosed container, the fish were caught.

The large pogie boat would run up to the smaller net boats and all three would form a triangle with the net hanging down between them. As the net was pulled up by hand, the ratio of fish to water steadily changed, until the space between the boats was solid fish, helpless and packed together, ready to be lifted up and loaded into the hold. This was accomplished with the small circular net hung from a crane that we see suspended in the air dripping fish in its swaying passage. Our next photograph, although probably made on a different day, and even on a different ship, shows a close-up view of this unloading operation.

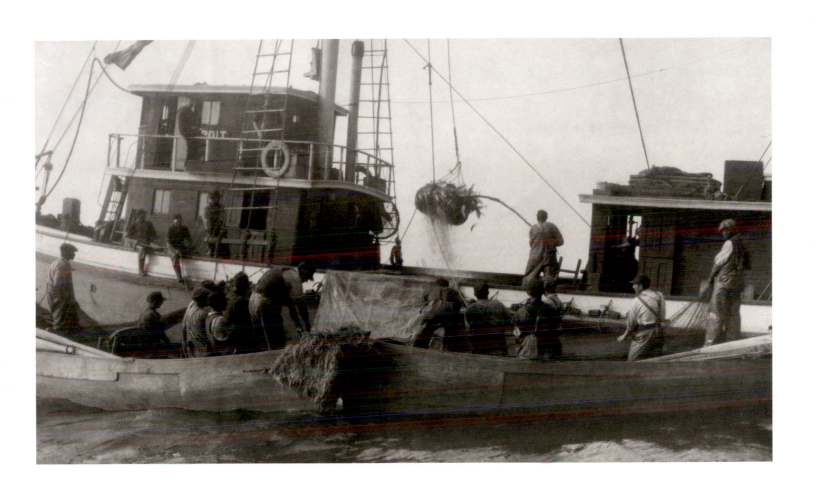

LIFTING POUND NET

EDWIN LEVICK British 1869–1929

The fish are a solid mass now, forced together by the steadily withdrawn net. Along the top of the photograph is one of the net boats, and along her side are the strong arms of the black crew, pulling up the net and packing the fish together. On the left side is the gunwale of the second small boat, and along the right edge is the pogie boat into which the fish will be moved by the small circular net that is dripping water and menhaden.

The small lifting net, with its circular iron hoop, is a miniature version of the purse; it is an open-bottomed net, made this way so it can be set down into the fish. Along its bottom edge is a set of rings traversed by a line, which we can see coming down from the upper right corner of the picture. When this line is pulled in tight, as it was when the picture was made, the bottom of the lifting net is cinched up and so can hold the fish in its grip when raised by the winched line. The heavy, curved pole coming out of the iron ring is probably made of flexible hickory wood; it is the net handle, which allows the hoop to be pushed down into the fish when being lowered for a fresh load. The taut horizontal rope, attached to the hoop by the old expedient of passing a line through an eye splice in its own end, is called a tag line. It is used to guide the loaded net over the desired part of the hold for unloading.

These paragraphs probably convey more than most people want to know about this complex operation, with lines, nets, and boats all forming a single efficient entity that catches fish. These men and their tools use this specialized system because the old way, catching enough for just ourselves, doesn't work anymore. We are looking at industry here, and the two dozen or so people who work these boats catch a product that serves hundreds of thousands of consumers. By doing this the rest of us receive the benefits of the fish, but don't have to go to sea ourselves. Instead each of us can have a specialized trade, yet reap the benefits of many others, because we each produce within our area of expertise for a larger group with whom we interact through commerce. In good years, the menhaden catch along the Atlantic and the Gulf of Mexico could total two billion pounds. The fish were boiled down, yielding the oil that was the basis of house paint that decorated many of the wooden houses in America — even along the streets of Midwestern towns, where the grains were grown that fed these same fishermen on their days ashore.

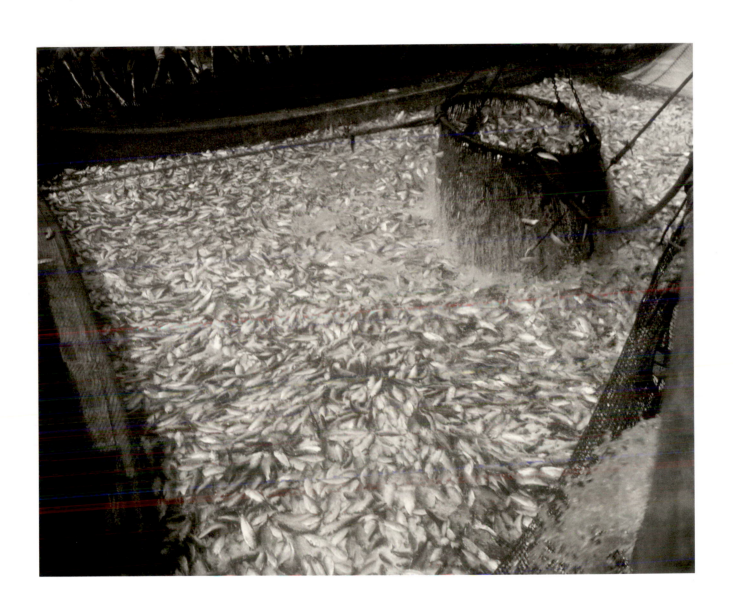

CLEANING FISH

A. AUBREY BODINE American 1906–1970

For diners along much of the Atlantic coast, few pleasures can match that of finding shad roe on the menu in a local restaurant. If dusted with flour and lightly pan-fried, this delicacy is supreme in the realm of seafood. The tiny eggs dissolve in one's mouth with a unique salty bite that is unlike any other taste.

The trouble is, it is hard to know if what we eat really is shad roe. For many years the processors of foods have understood that the consumer, at the end of the economic chain for their product, often can't tell just what is being purchased and eaten, and so the definitions have become blurred. In this photograph roe is being collected in pails, but the fish are alewives—not shad.

This goes a long way toward explaining the meaning of the word "scrod." If you ask any ten people in Boston, whether in the marine trades or not, you will get slightly different—but emphatic—definitions from each. When a large net dips into the sea many times in the course of a cruise, it brings up and dumps aboard different sorts of fish. When these come to market many are lumped together figuratively, as well as physically, often under the general heading of scrod. There is nothing wrong with this, except that a surprising number of people believe scrod is a particular creature, caught off the shores of Cape Cod, and sold exclusively in the New England markets.

It is an irony of our educated times that the name given to any product should be so deceptive. If we buy lumber for a home building project we most likely will find "hemfir" listed as a type of wood; this is simply the scrod of the building trades, and it too derives from the practical difficulties of keeping a harvest of multiple types (fir and hemlock trees) separate. The irony is that as we learn more and more, and live in a society increasingly dedicated to clarity and truth, the practical issues of commerce can lead to quite misleading information. Most likely this is done not to deceive, but instead simply to be efficient; if we don't fish or cut lumber ourselves, then we must have faith in those who do these tasks for us, and accept the quirks of mass marketing.

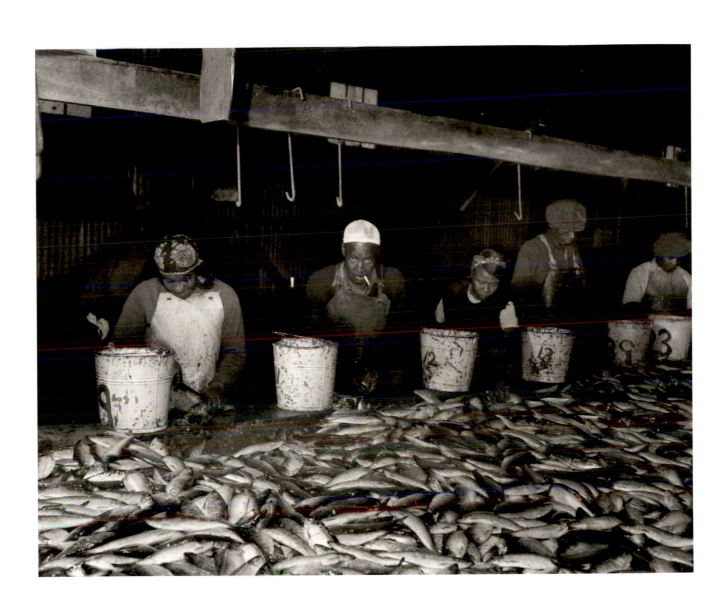

SOUTH MILLS, DISMAL SWAMP CANAL

H.C. MANN American 1866–1926

Sometimes we come across a photograph that presents a perfect world, and this is one. The sun shines on the intersection of road and canal, illuminating the small community that has grown up there. We see houses for living as well as working, and across the water from the photographer's perch is a long building with a two-storey porch that reeks of communal use, where people come together to share their social or working lives. The small house in the picture's lower right-hand corner houses the man who turns the bridge upon its pivot so canal boats can pass. This vital position in the community is probably held by an old and worn-out citizen whose wisdom remains available to the town through this carefully structured job. Except for the thin steel cables from which the span hangs, the entire scene is constructed of wood, and this comfortable and long familiar material gives a timelessness to this village, which has grown so perfectly out of the earth.

The extended view that technology gives us, of the world beyond our immediate lives, is distorted. Few of us go to Paris, climb the Himalayas, or sail before the mast, and yet we know of these things because the machinery of our time brings us pictures and verbal descriptions of them. What we learn from these messages is inaccurate because their makers usually record dramatic occasions rather than day-to-day events. Pictures of Paris, for example, portray lovers at the Eiffel Tower a thousand times more often than they do a residential street corner in the outlying districts, and photographs at sea virtually never show the rainy days that comprise about a third of any sailor's life. Maybe this distortion has given our culture the habit of striving for the best and biggest, as though extremity is a characteristic of quality. We cherish news of the most recent billionaire, and so forget that a dollar here and a dollar there make up most of our lives. We can forgive the makers of sensationalistic pictures and the authors of passionate travelogues because if they don't pursue drama then no one will be interested in what they produce. When a photograph such as this comes along, however, we can see that the clear description of a common bit of the world can hold lessons about how to live that no blaring headline on the evening news can ever match.

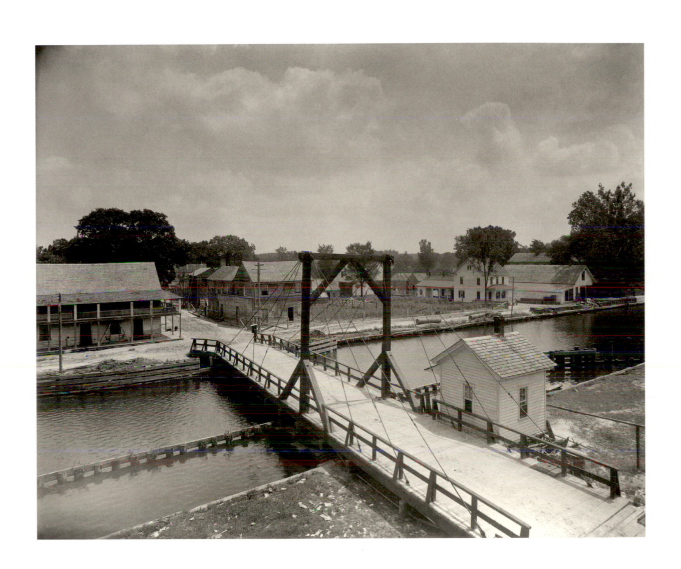

ENOLA, DISMAL SWAMP CANAL

H.C. MANN American 1866–1926

———————————

The United States is blessed with a series of bays and barrier islands that run down the eastern coast. Today these combine with manmade canals and passageways to form the Intracoastal Waterway, from New England down to Florida and then back up the Gulf Coast. Blocking passage below the Chesapeake, on the way south to Albemarle Sound, is the Dismal Swamp, and our picture shows boats locking up on their way through a canal cut there to allow unimpeded commerce.

The picture, thanks to the witnessing nature of photography, gives us a glimpse into its period; the canal holds at least five boats of different types, plying their trades in this earlier and quieter time. The *Enola*, in the right foreground, is a wide and shallow sloop, holding a few dozen watermelons and a crew of two, with an elegant narrow work skiff tethered at her stern. Next to her is a ketch carrying a full load of these melons, and there is a man on deck, partially obscured by the foremast boom, whose posture would be the envy of any artist's model. This boat is of a type that has completely disappeared, for she is a log boat, built of heavy lumber laid up in sequence, like early clay pots that were made of strips before pottery wheels became common. These boats did not use conventional ribs, but instead were structured by the thick boards of their hulls; their final shapes were cut by eye with an adze. Forward of the *Enola* is a much larger ship, a lumber carrier with a large deck load. Ahead of the log boat is a schooner, but she is conventionally built, which we can tell because of the high bulwarks supported by rib ends that are just visible between the heads of two men who tend her in the canal's crowded lock. Beyond all the boats is a three-master, larger than any of the others. She is too obscured to show her load or her details beyond the three masts that mark her as a large coaster, and the canvas awning spread as protection from the southern sun.

The canal lock was large, made to hold a huge ship if necessary, but it was most often packed with small craft, as in this picture. These boats are all loaded, and they seem to be in the process of being raised up, since the foamy water in which they sit is characteristic of a filling rather than a draining lock. The Dismal Swamp is eight feet higher than the bays it connects, and so the crews here are probably at the start of a quiet but bug-filled tow through the fifty-mile passage that saves them from the wild and unpredictable Atlantic rolling just a few miles away.

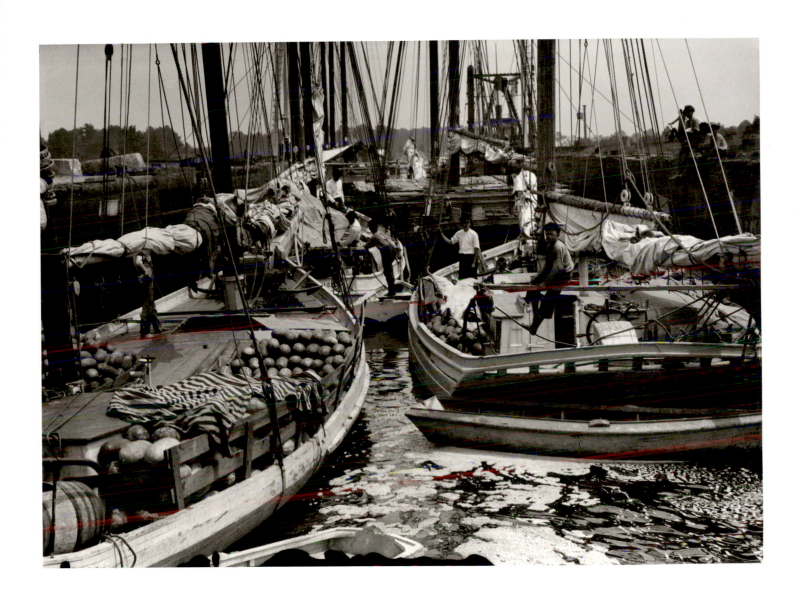

LOG RAFT

A. AUBREY BODINE American 1906–1970

These harvested logs are being moved down river by the labor of a small inboard engine, thumping away and handing its energy over to a propeller that turns in the quiet water. The taut rope that connects the boat to its load shows the pull that is being applied to the log raft; the slimness of the line reveals that a massive cargo such as this can respond to a very small force if it is steadily applied over time.

Going somewhere by sea is not the same as by land. When we travel ashore this activity is often sporadic, with stops and starts, and nerve-racking speed in between. At sea the rhythm is different. There, distances are covered by steady movement, through hour after hour, and the slow but dependable rate at which a boat moves can be multiplied by the hours spent traveling to anticipate a distant arrival. Weather can disrupt such plans on the high seas, but on a river such as this the turning engine acts much like a noisy but persistent clock that beats away the interlocked time and distance of a journey.

The log raft is moving down the river, because the forests that gave up their trees are found inland, not in the broad estuary to which the tow is heading. That the islands in the distance are at the river mouth is confirmed by recognizing that the boat and its load are fighting incoming water, which must be the result of tidal flow. The river is running down to the sea, and if its source is at our back yet the water is coming toward us, then this must be the tidewater — the place where fresh and saltwater mix in a daily cycle of changing flow. We know that the tide is running in, against the direction of the boat's movement, because there is no other reason for the pilot to have his large tow so close to the shore. When water flows smoothly in a channel, whether a river or a broad bay, the deep part reflects this flow more than the shallow, and so a boat traveling there hugs the shore if the water's movement is contrary, but goes out to mid-stream if its direction will help the passage. This might be the end of a long trip for the hauler, and after many hours of the river current giving its helping push he has a final battle against a foul tide before the cargo can reach its destination.

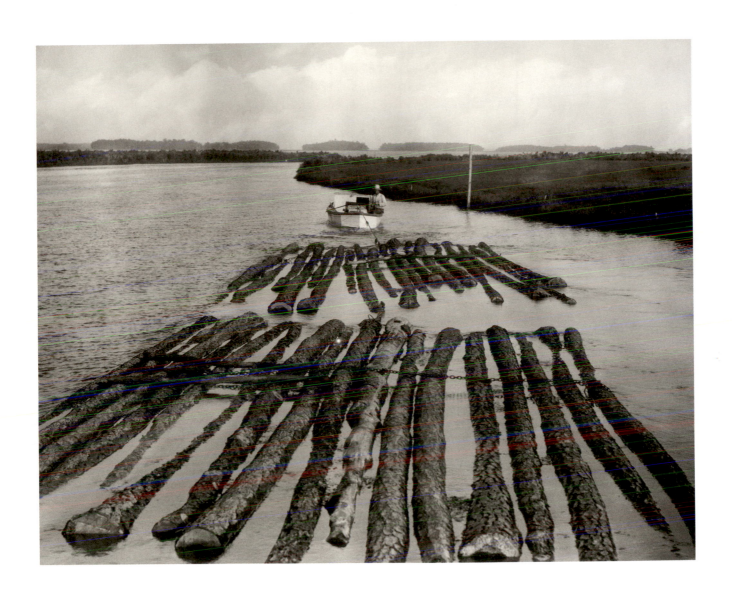

MANNING THE YARDS
PHOTOGRAPHER UNKNOWN

The sailors strung out along the yards have no business up there at all, unless laid out to impress a visitor, and we must assume that this is the case because the queen of the Sandwich Islands walks along the dock, ready to pass judgment on the polished troops in their white helmets and rigid ranks. The queen is a member of the royal family that ruled Hawaii in a transitional period just before it became a part of the United States. After Cook "discovered" the islands in 1787, they adopted a European sort of monarchy, and for most of the nineteenth century were ruled by the very capable Kamehameha dynasty, which seated kings I through V. After this orderly run of monarchs the islands experienced a tumultuous period; one of the rulers then was Kalakaua, whose wife we see here at the Brooklyn Navy Yard in 1887. The cruiser *Atlanta*, whose rigging supports this human display, has two large stacks hidden among her lines and poles, and these exhaust ports for her engines are telltale indicators of the politics that had brought the queen here. Hawaii sits smack in the middle of the Pacific Ocean, and these islands became U.S. protectorates at the century's end largely so they could be coaling stations for military vessels.

The transition of Hawaii from independence to union with the United States is similar to the upheaval experienced by the Navy as it switched from the age of sail to that of steam. The *Atlanta* spanned the two technologies, and did not perform particularly well with either. Her engines and boilers were horribly inefficient, and her design speed under steam was an embarrassing thirteen knots. She also had residual masts and sails, but it would have taken a tremendous wind to get these to drive her at even that speed. A clipper of ten years earlier could hit eighteen knots in a proper blow, when the tops of the waves turned foamy white and small craft hove to in terror. A steam cruiser of a mere five years later—like the *Olympia* in plate 44, which had no sails at all—was 2,000 tons heavier and sixty feet longer, and could run endlessly at twenty knots.

The end of the nineteenth century was a strange time, when the industrial revolution had begun to demonstrate its remarkable technologies and the old patterns of manufacture and transportation were being forced to disappear. By 1910, railroads covered the country, people were flying through the air, radio was erasing the temporal separation of the old and new worlds, and the Model T Ford was starting to turn up in the public's hands. Maybe the end of this century is the same, and the bits of the digital revolution we see filling our lives today are just the crude forerunners of wonders beyond imagination that are just around the millennial corner.

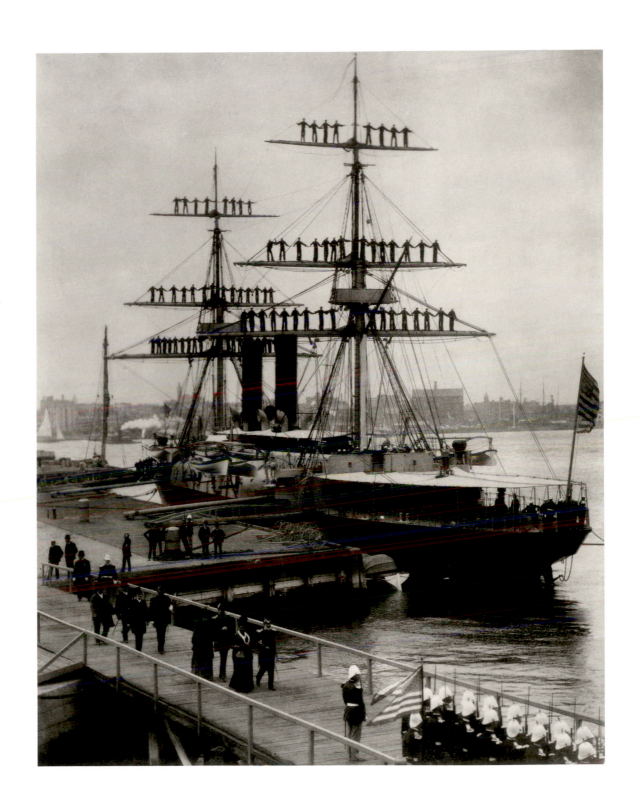

29

EARLY SCREW PROPELLERS

HANDY PHOTO

Photography's most basic reality is that it shows us the past. Whether we view a freshly made instant picture taken at a family picnic, or a very old one such as this of two propellers, they all inevitably look backward through time. One result of this photographic fact is that we can see a record of how things have changed, and so the picture takes on some of the role of the fossil in paleontology: it can provide evidence of intermediate forms that existed during an evolutionary process. Such is the case with this photograph.

The modern marine propeller, which today completely dominates the field of ship propulsion, was a tremendously hard thing to create. It had to be tough enough to hit debris without breaking, the thin blades had to sustain the full horsepower of the engine as it drove the ship, and it had to function efficiently as a converter of energy from rotation to linear movement. This pair of wheels did all three things poorly, because they suffer from the fundamental problem of being made of sheet instead of cast metal. The difficulty is that this blade should be a complex shape, one which cannot be made from a flat sheet without introducing compound curves and varying thickness. Casting lets the maker do this, as a cast form has no restraints put on its shape other than the easily solvable one of requiring a pattern that can draw cleanly from the casting sand. Cast materials also have great rigidity. They are brittle and inflexible, and so once a propeller is made to the correct shape it tends to hold this form until some catastrophic event destroys it. This characteristic of the casting lets a propeller hit an occasional log or even rock without becoming useless, whereas our sheet metal versions here would be distorted by even a slight impact.

21526

CREW OF THE *MONITOR*

JAMES F. GIBSON Scottish, b. 1828

The story of the *Monitor* and the *Virginia* is a part of our national myth, to rival Washington and the cherry tree, or Franklin flying his kite during a thunderstorm. It is strange to be confronted by a photograph, peering back through the years with such clarity, that has none of the story about it but instead only the harsh reality of the ship and her time. The word that comes to mind with this picture is "hot." The iron deck and turret baked in the sun, and even with the canvas shade the interior must have been like an oven. The cook has moved the pots and fire out on deck as a sort of marine summer kitchen, but even so the overpowering heat must have been at least as hard to deal with as any battle into which this ship would enter. The men stand, wearing tough leather shoes, and the one who sits on deck with his pipe has a good solid cushion under his behind as protection. Today in the South we treat ourselves carefully in the hot season, and the electric generators of the huge modern utilities reach their highest peaks on summer days when people take refuge from the temperature in artificially cooled interior spaces. None of that existed in the *Monitor's* day. She was a new invention, and creature comforts didn't come along until a few more generations of iron ships were built.

Few of us need to hear—yet again—the story of this ship and her famous Civil War battle. The picture, though, gives us a direct look at her, and makes the heat that the men lived with palpable. We have a new generation of photographs of this very ship, made far underwater by the magic of submersible cameras; they show her lying on the ocean floor, quiet in the green of the sea, with a mottled coating of marine growth. It is as though the heat and intensity of her short life have needed one hundred and thirty years of cooling off down below to atone for the cosmic scale of her suffering.

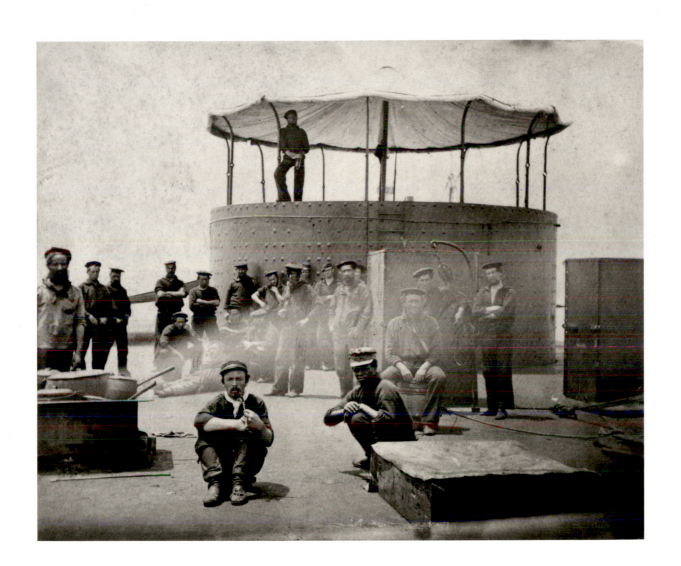

31

BOILER FOR THE *J. D. ROCKEFELLER*

PHOTOGRAPHER UNKNOWN

——————————

Back in the heyday of steam, boilers were everywhere. Factories had them, fancy houses were heated by low-pressure iron models in the basement, boats and ships used them, and even the corner laundry would depend on a little high-pressure unit to crease those starched white shirts that looked so good on the wide and shaded sidewalks of the nineteenth century. These heat machines fell into two broad classes: the fire-tube boiler, in which the gases flowed through narrow tubes that penetrated the water areas, and the water-tube boiler, in which water ran in small diameter piping through the spaces that contained the fire.

Our photograph shows a big Scotch marine boiler, and it is just about as large in diameter as a fire-tube boiler could be made. Invisible to us are the three main cylindrical flues that run through the machine, behind the fire doors low on the end facing the photographer. These were each about three feet in diameter, and the grates for coal and ash were inside them, so that the fires were entirely surrounded by water. At the far side of the boiler, an insulated chamber redirected the gases back through a great number of small tubes which fed the rectangular plenum at the boiler's top; this was connected to the ship's stack. Because of the back and forward flow, these boilers were known as horizontal return-tube boilers; the Scotch marine was the Cadillac of this type.

The steam engine is an external combustion engine, as opposed to the internal combustion engines common today. These new devices do their burning in the same cylinder that drives the engine, and so the boiler, where combustion used to take place, is eliminated. Many people tried to make steam cars, but the combination of fire, boiler, and engine was just too complex to work well on a small scale. In ships and factories, things are bigger. Intricate plumbing and the presence of an operating engineer were practical, allowing the age of steam to thrive there. Steam engines depended on coal being burned in boilers, but internal combustion uses petroleum ignited within a working cylinder; there is a nice irony in our picture, because this coal-fired boiler drove an oil tanker whose load fed the engines that finally put much of the steam era to rest. John D. Rockefeller must have been pleased.

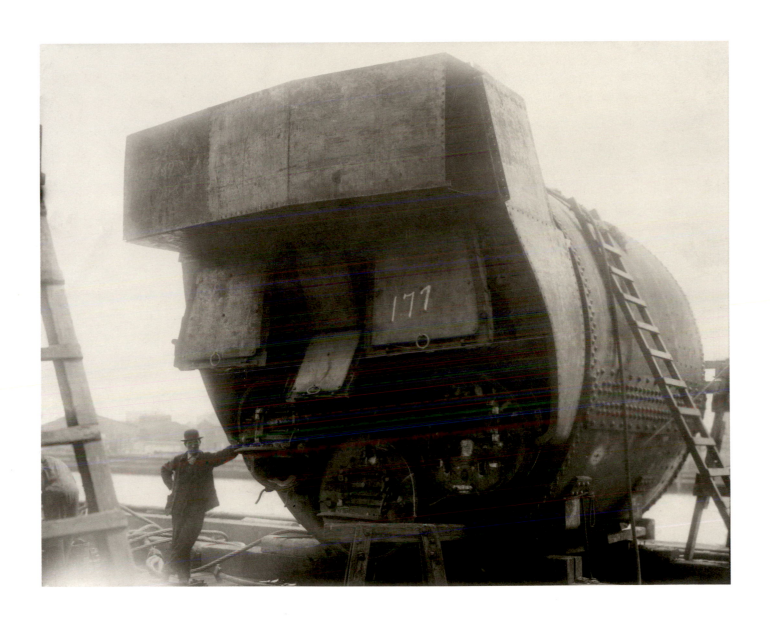

WRECKED BOILER FOR THE TUG *MORFORD*

PHOTOGRAPHER UNKNOWN

―――――――――――――――――

Boiler explosions take place when the outer shell of the boiler fails and can no longer contain the mass of heated water within. At atmospheric pressure water boils at 212 degrees Fahrenheit. If, however, the container is enclosed, then the pressure and temperature of the water and steam will rise above the normal boiling point. This is the mechanism by which steam holds such power; the confined water acts as a heat sink into which the energy of the fire can pass, and the boiler holds a large reservoir of this extremely hot water, with a space at the top which holds steam. The steam is the working medium of the system, and its temperature and pressure are manipulated in an engine to produce usable power.

Boilers blow up when the shell ruptures, and there is an instantaneous conversion of the water into steam, which creates an explosion of horrifying power. The boiler room is immediately blown apart, no matter how strongly it is constructed. The violently expanding ball of gas is at a lethal temperature, and in its travel out from the boiler's location carries with it bits of steel, masonry, and anyone who happened to be in the vicinity. A few tons of water, a common volume in a marine boiler, can destroy a ship in a fraction of a second. No one ever really witnesses these explosions because they happen without warning, take place in such short periods of time, and leave no survivors.

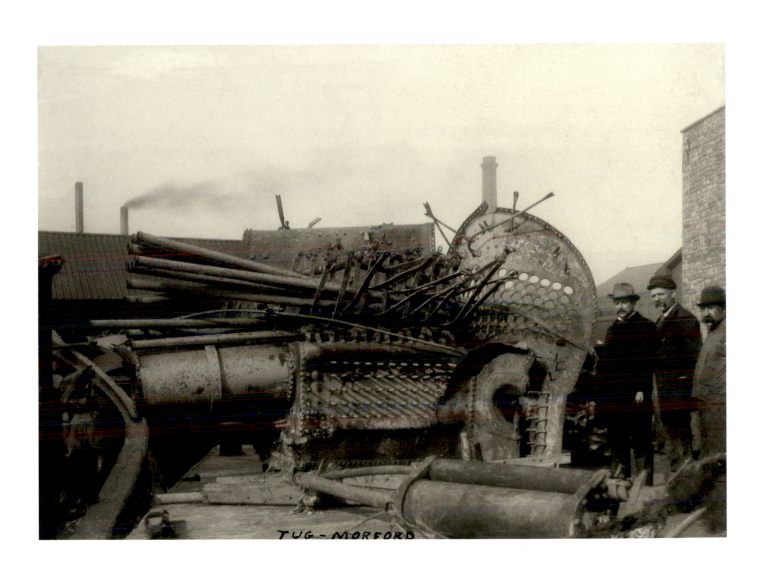

TUG - MORFORD

WHEEL FOR THE *TASHMOO*

PHOTOGRAPHER UNKNOWN

We are lucky to have the man in this photograph, as otherwise this mechanism could be misunderstood as some fine clock escapement rather than the frame of a massive ship's side wheel. If we assume that the photographer has been fair, and picked an average-sized man as his yardstick, then we know that this metal construction is at least twenty feet in diameter; the central shaft makes it clear that this large object spends its working life rotating. The constructions of the marine world are huge, and they also move.

The paddle wheel was an early form used to great effect before the screw propeller was fully developed. Some trials were made with steam-driven mechanisms that emulated the movement of manual paddles, but these quickly disappeared in the face of the practicality of a partially submerged wheel with flat paddles set around its perimeter. There was a problem to be solved, though, and this was that rigidly fixed paddles were very inefficient as they entered and left the water, driving well only during the part of their movement that was in line with that of the ship. The human paddler solves this problem by tilting the angle of the oar blade as it goes in or out of the water, and marine engineers adapted this idea of "feathering" to their rotative wheels. Blades mounted in this way changed their angle to the supporting spokes as the wheel turned, and maintained the most efficient angle to the water while carrying out their job. The pivots for these feathering paddles are clearly visible in the picture, one mounted on each spoke, and they make it clear that here we are seeing only the framework of a much more complex mechanism.

Paddle wheels were mounted either on a ship's stern or sides; river craft tended toward the former arrangement while coastal passenger ships used the latter. These two locations necessitated different engine forms; the stern wheel was turned by a pair of horizontal steam cylinders linked to either end of the wheel's shaft, while the side wheel was often driven by a walking-beam engine mounted amidships. This beam hung above the superstructure of the ship's cabins and became a symbol of the era, appearing in endless prints and photographs that set out the vision of life in the new age of steam-driven travel on the water. The beam itself connected a vertical cylinder with the paddle wheel crankshaft, and it tilted with an oscillating movement in time with the paddle wheel's steady rotation. Hanging above the passengers on deck, this giant, silent mechanism steadily moved through its arc as the ship traveled, demonstrating that the powerful machines created in the age of steam could live beside us as faithful and tireless helpers.

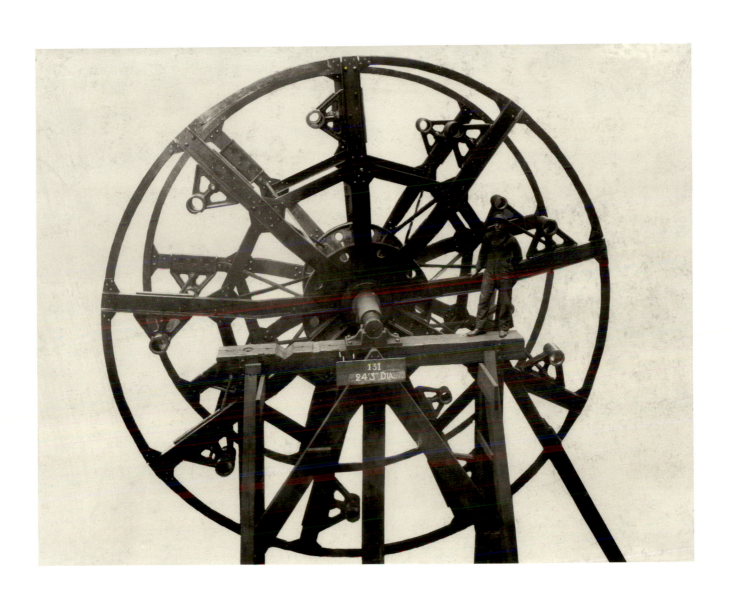

ENGINES FOR THE *JOSEPH HENRY*
PHOTOGRAPHER UNKNOWN

This young man had the thrill of growing up around the technological marvels of his time. We recognize how exciting it is for children today, being immersed in the world of the computer and microchip, and the only real difference here is that this young man has put up with tough physical labor in order to have the same sort of pleasure. While his overalls are dirty, his hair is neatly combed for the picture; posing for scale with a serious face, he is fully aware that both his hand and experience touch the very center of power in the industrial age.

When propellers began to be used to drive ships, it became clear that two were often better than one. A single screw had to be much bigger than a pair to produce comparable output, and this size led to problems with the bearings and sealed stuffing boxes that held the shaft. When two screws were used they could turn in opposite directions, and so eliminate the torquing motion that a single large propeller produced. Most important, twin screws could control the ship beautifully; by running one so it thrust forward while the other pushed back, a ship could be made to turn within its own length, freed from the need of forward motion to maneuver. These engines, like the wheels they will turn, are a pair, and this means that they are not just matched and equal in output, but counter-rotating as well. In order to do this, engines were made as mirror images, and we can see that each casting has been produced, or at least assembled, to create two machines that have the same relationship to each other that a right and left glove possess. The bright and finely finished control at the front of each engine is the Stephenson link; this mechanism shifted the steam valve to a different driving eccentric, and this reversed the direction in which the power plant rotated. Mounted on the end of the crankshaft, just behind the drilled coupling, is a large gear; this was engaged by the small worm gear to its side, which could be tilted to mesh with the large one, so the engine could be turned over manually when being serviced. The wrench used to do this lies on the floor in front of the right-hand engine, probably set down by the boy who had the tough job of cranking the machine over.

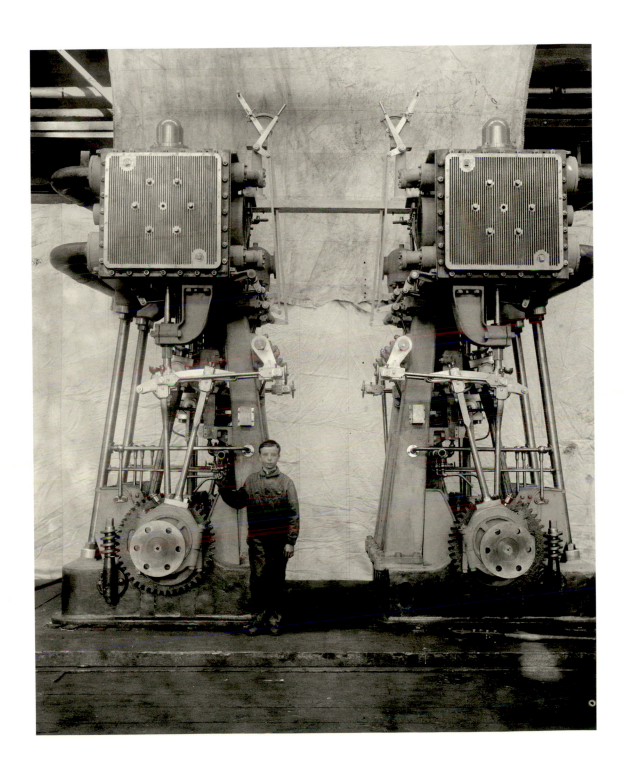

STEAM WINCH

PHOTOGRAPHER UNKNOWN

Ships are big and the forces used to move and run them are correspondingly large. When steam power became established, the principle of the old hand-driven capstan was adapted to this new prime mover, and the resultant steam winch became the most common and versatile of the marine pulling devices. The winch in this picture is a giant. It never went to sea, but instead was used to haul ships up on a marine railway. The drum to the right is for rope or cable, but to its left we can see part of an oddly shaped, recessed wheel that has been cast to fit individual links of chain; railways usually used chain for its immense strength and convenience of handling. The power from this engine is passed through a worm-and-spur gear, which reduces the rotational speed by about sixty times and vastly multiplies the effort applied to the winch head. Steam is fed to the two cylinders through a piston valve attached to the casting which joins them; this form of valve allowed the use of high pressures, often above 150 pounds per square inch. The engine probably produced a useful output of around fifty horsepower, and this means over 25,000 foot pounds of energy per second was applied to the slowly drawn cable or chain.

The entire winch is mounted on a large monolithic casting, and this supporting frame is securely bolted down to the platform from which it works. You cannot apply this massive power and pull up a ship without connecting the apparatus back to an anchor point, and the heavy framework of this machine carries that load. The small hand-wheel just to the right of center is a brake, tightening down the strap that runs around a large friction drum to the left of the winch head. We can see an elegant small linkage there, allowing the strap to be threaded through itself on its way to the circular handle. The notched wheel between the chain drum and spur gear is part of a ratchet that acts as a safety device; as the winch slowly turns and the hundreds of tons of ship are pulled out of the water, a clicking pawl bounces from notch to notch ready to lock the wheel, and hold the load, if there is a mechanical failure in the drive train.

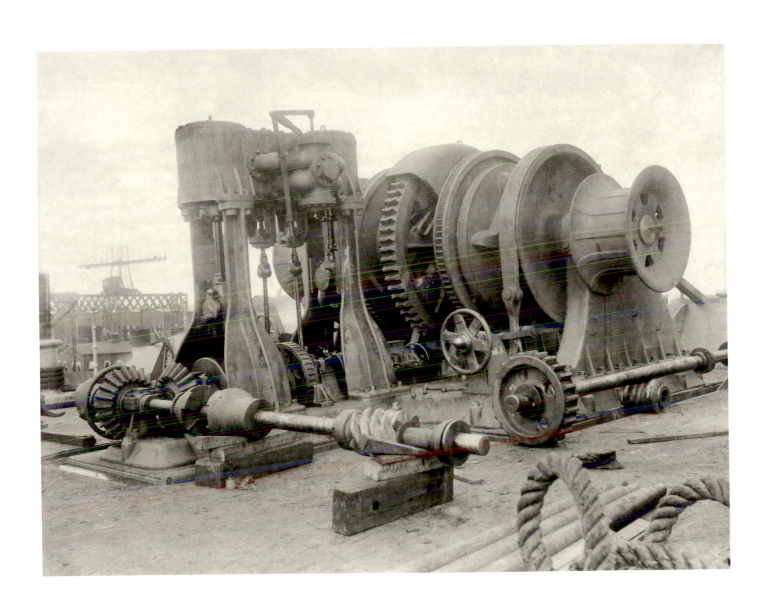

MODEL-BUILDING SHOP

PHOTOGRAPHER UNKNOWN

This is a machine used to make models of ship hulls to be tested in the controlled environment of a towing tank. Models have a long history in boat construction, as a small carved and smoothly finished wooden replica could show a designer the ship's form in an immediate and direct way. Boats are not created according to some magical formula that dictates shape, but instead are the product of complex calculations and hunches on the designer's part. The model has helped the synthesis of thought that the astonishing human computer carries out to predict efficient hull forms. Up until the beginning of the twentieth century, these models were visible in every marine architect's office, hanging on the wall or lying on a drafting table, and they are one of the beautiful relics that remain from the early days of industrial design. Most were "half models"; ships are symmetrical about their centerline, so only one half of the ship needed to be made in miniature. Usually these wooden forms were so accurate that they could be measured to create the final lines for the full-sized construction.

When formal science began to play a part in marine design, a new sort of model was needed, and this is what our photographed machine makes. A small version of a ship can be built, ballasted in proportion to the final design, and then tested in a tank by being towed at fixed speeds under variable conditions. As it must float, this model can no longer be only half of the hull. It also tends to be larger than the old designer's helper because the way in which water reacts to a boat is a function of scale as well as form and speed. Models to be tested often had to be compared to each other, so it was necessary to make identical versions of one hull shape—a task for which this machine is specifically designed.

The device is a pantograph—an old gadget invented years before in a much simpler form to make duplicate copies of writing through a system of levers. In our picture, we can see two wooden hulls; the lower one, built up with thin bent strips of wood, is the pattern, and the upper one, made out of glued planks, is the model being sawn out to match the pattern's shape.

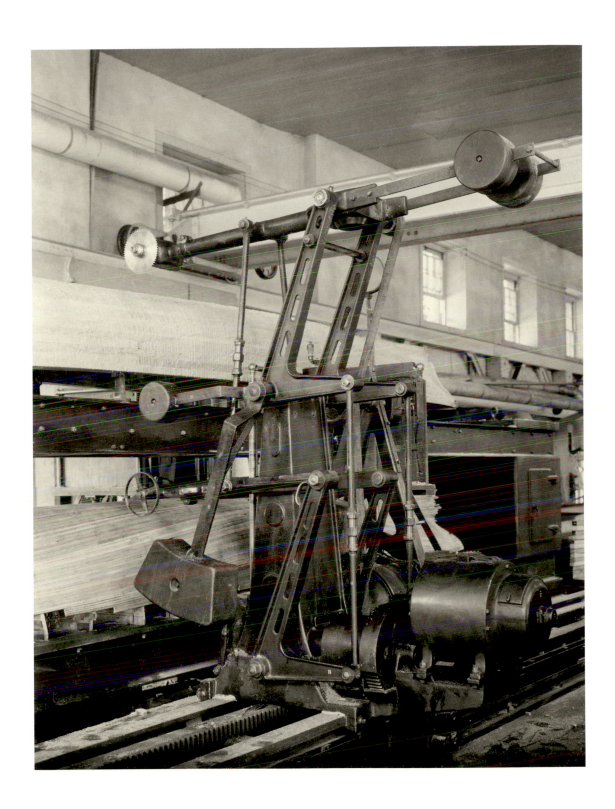

ARGONAUT

PHOTOGRAPHER UNKNOWN

At first glance, this submarine seems right out of the Keystone Cops. The comic portholes on the bow and the unlikely wheel can only be there to accommodate some manic underwater plot through which the Cops will be rushing on the silent screen. A closer look reveals that this is a real ship, and she shows the problems confronted by engineers when they are called upon to break new ground. Usually invention comes in small steps, but occasionally there is a drastic move, such as going underwater in a powered craft, and the only way to tackle it is with a radically new machine. The first aircraft faced a similar difficulty, where any attempt that was unsuccessful was bound to be a dramatic disaster.

The hull actually has an excellent shape, mimicking that of a cigar, though only in the next century did naval architects understand that this form would allow a submarine to achieve speeds that could surpass most conventional ships. The presence of the portholes tells us that this is an early submarine, because sight was eventually given up while traveling underwater. Modern submerged ships are piloted with precise instrumentation for distance, direction, depth, and speed, as well as with sonar, which uses sound waves to navigate in the manner of dolphins and whales. The real problem with this ship, however, is her wheels, only one of which is visible.

Perhaps there were one or two other trials that put wheels on a submarine, but it was an idea that simply did not work. The wheel has a rough enough time on dry land, where roads can be beaten out of the wild country and where repairs to axles and bearings can be carried out when needed; it has no place under water. On land a wheel can do two jobs—that of carrying a load, and that of applying the torque needed to move the load—but only through extensive engineering of both machine and landscape can this be carried out successfully. Our primitive submarine doesn't have a chance with its wheels, and it was only made this way because its builders did not yet realize that the functional realm of the submarine was to be found when its buoyancy matched that of the water, so it could hang and maneuver like an enormous fish in the dense fluid of the sea.

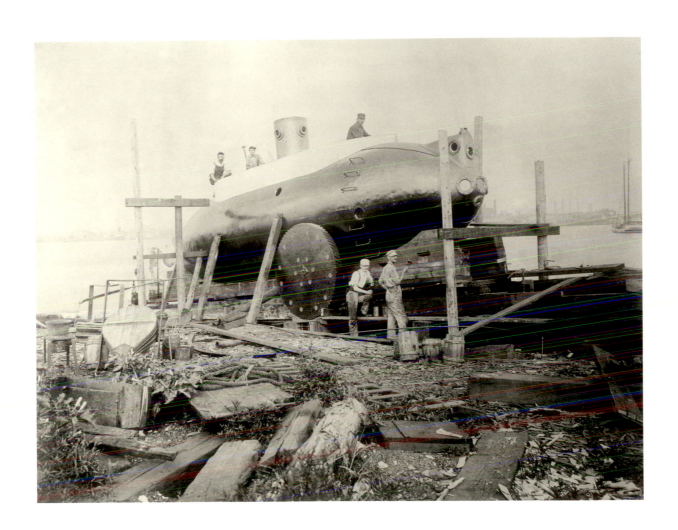

REMOVING ICE FROM THE ST. MARY'S LOCK

PHOTOGRAPHER UNKNOWN

Photographers are always trying to make pictures of people at work, but they seldom turn out well. This one is pretty good, because the figures have become locked in an appealing pattern that fills the frame against the intricate backdrop of finished stone and riveted plates. Work is active, and movement is fundamentally incompatible with the still photograph, despite all the blurred pictures we see in magazines and books. These arrested laborers move us because they are frozen in their tableau like the lock gate and block walls caught in the grip of solid winter ice.

Canal locks are filled and emptied throughout their cycle of work, and when winter has set in, ice can create problems. We may think of water as being the enemy in the cold months, if we live and work around it, but the tendency of water to hold its temperature means that it is usually warmer than the surrounding air. In a canal, the water moves slowly but has enough depth so that freezing solid never occurs; in a canal lock, however, the water is regularly removed, and then the mechanism of the gate is subject to freezing. This lock has been drained, for some reason unknown to us, and the gate and floor have frozen up completely. The picture was made on a mid-April day, with a warming sun above, and the lock might just be getting its spring cleaning after being allowed to freeze up for the winter. While the men down on the ice are obviously hacking away at it, there seems to be some painting going on as well, and the picture smacks of routine maintenance rather than an emergency struggle.

Early canal locks were made of stone and wood, but this one is late, using an iron gate. The stone walls have remained the same, since they did the job better than any new material, and this picture shows the beautiful way in which the ancient material of stone has continued to be used in the context of modern, technologically complex construction. The Brooklyn Bridge, spanning the East River in New York, is one of the best examples of this hybrid construction, where iron and steel are hung from stacks of granite blocks which form the towers. Modern skyscrapers use stone as well, but there the system is reversed, with the old material used as a decorative sheathing hung on a steel framework. Some things last and others go. The pick and shovel remain a part of our lives today, and window washers on flashy city buildings use hanging seats and scaffolding like the painters here. The heavy rivet, forming its almost calligraphic pattern across the surface of the gate, has just about disappeared, as well as objects made of sheet iron. These have both left the lexicon of industrial construction because steel and the welded joint have proven superior.

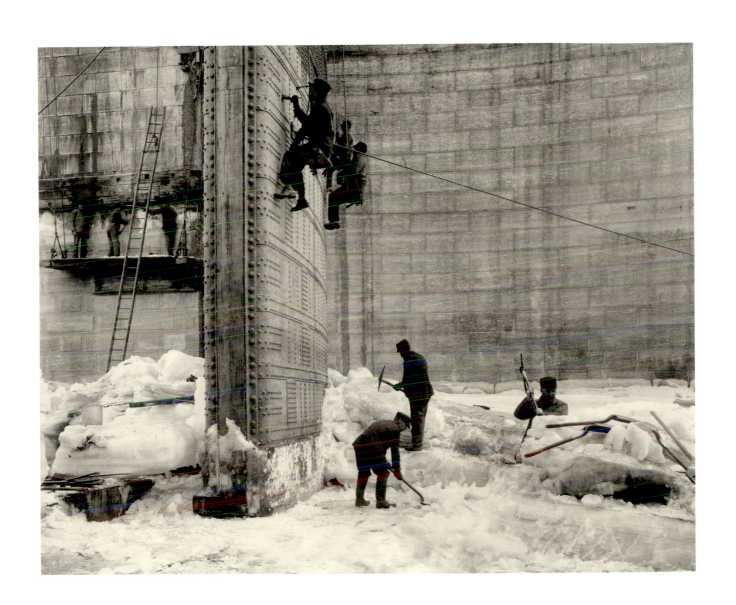

ROOSEVELT IN A PANAMA STEAM SHOVEL

UNDERWOOD & UNDERWOOD

The machine is a crane, and it sits on steel rails laid down in the jungle of Panama for the construction of the canal that would connect the Atlantic and Pacific oceans. The crane could be a steam shovel (they really were run on steam back then), an earth-moving dragline, or just a heavy-duty hoist, there to lift the machinery used in this immense construction project. Whichever it is, the device is pre-hydraulic, and so chain and cable, running off winch heads, turn and lift as needed. Today the same things are accomplished by sleek hydraulic excavators that move the earth with steel and fluid muscles on large construction projects.

The character in the immaculate white suit is Teddy Roosevelt, who has come to Panama to encourage the workers in their almost impossible job of creating the canal. Before this trip, no American president had left the country while in office. Roosevelt was an irascible and strong-minded individual, but he understood that the isolated and self-centered pattern of U.S. history wouldn't do in the new century that had just been ushered in. The canal, like his trip down there, stemmed from an awareness that the many bits of civilization scattered across the globe were being drawn into a single organization by the power of technology. Whether radio waves and wires carry information, or planes, cars, and ships move people and goods, the web of modern invention turns the diverse tribes of our planet into one family. Theodore Roosevelt, swinging his misunderstood big stick of national pride and strength, was the architect of this new time. He forced the canal to be built, after fifty years of failure. He intervened boldly in foreign affairs, and he beat up the giant trusts of industry so that truly big business could grow, be healthy, and yet behave responsibly toward the consumer upon whom it depended. The canal, thousands of miles from America's shores, pulled our two coasts together and opened up the Pacific to western nations by eliminating about 5,000 miles of travel from the average trip between the oceans.

During and after his tenure in office, Roosevelt worked tirelessly to strengthen the national park system, as though he knew that all the unleashed power of modern times would wreck the pristine planet. Those pieces we have managed to save exist as they do because this great instigator of change saw the down side of rampant progress, and tried to do the best he could in the face of the destruction he believed was necessary in pursuit of our destiny. This is why we have the old bird looking down upon us from Mt. Rushmore, in the company of three other men whose greatness is so much more easily understood and accepted.

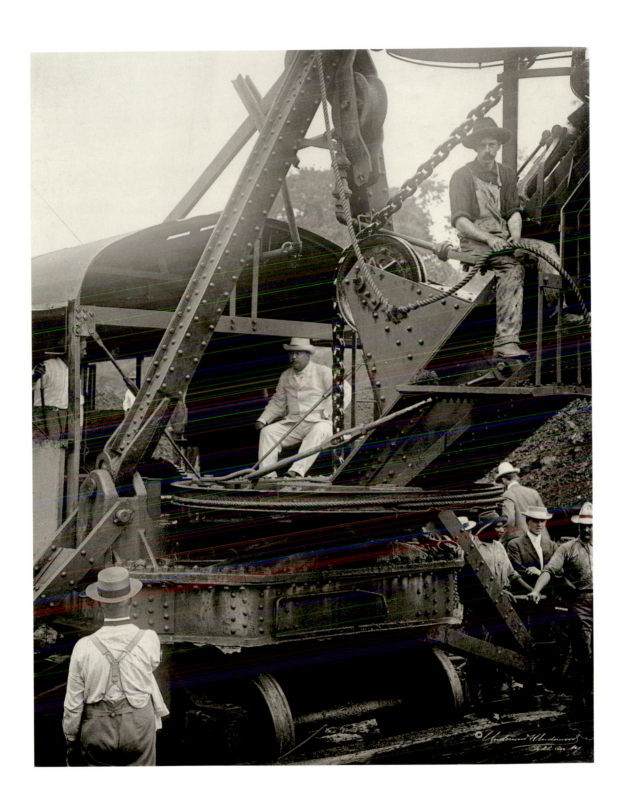

THE PANAMA CANAL
PHOTOGRAPHER UNKNOWN

If we find one of those plastic globes that show the topography of our planet as well as its seas and continental masses, then we can see that North and South America share a common backbone. This ridge of mountains starts way up in the lumpy confusion of Alaska, becoming the Rocky Mountains as it travels south, where it is also called the Continental Divide. The idea of the divide is that there is a fine line running all the way along this ridge, marking the point where falling rain will run to either the Atlantic or the Pacific shore. The mountains split and wander a bit through Mexico, but then reform and run cleanly through the remainder of Central America before becoming the continent-long Andes range in South America. At their southernmost extreme, these mountains dip into the ocean at Cape Horn, site of some of the worst weather in the world.

This 12,000-mile range is a barrier between the Atlantic and the Pacific oceans. It cuts the United States in two, stopped Columbus in his quest for the Orient, and has forced shipping to go the other way around the world for much of its history. Along its run the Continental Divide rises and dips; its lowest point is in Panama, where the width of the land barrier between the seas is also at its narrowest. As soon as accurate maps of this part of the world were available, the coherency of the globe as a whole was understood and people started planning to cut a canal through this neck of land in the tropics. Our picture shows a scene at the end of the long construction job that finally pulled off this feat.

The canal project got its first real boost from the California gold rush in 1848, when the trip across the Rockies made the dream of new-found wealth so hard to realize. After many false starts, the U.S. government-built canal opened in 1914. The two oceans the "big ditch" connects are at nearly the same elevation, differing mainly from tidal variation, but in the center of the isthmus of Panama, Gatun Lake reposes eighty-five feet higher. The canal, as finally built, has locks on either side of the lake to raise and then lower shipping, so the lake itself can span more than half of the total distance a vessel must travel across the isthmus. This photograph shows two mudslides in the Galliard cut, the largest slice made, which connects the lake with the Pacific side. These slides delayed the opening of the canal for nearly a year, and a substantial portion of the quarter billion cubic yards of earth moved in the project was due to them. This panoramic photograph, which distorts the canal shape to make it appear curved, shows a pair of dredges that will slowly pump the offending mud back up onto the sides of the cut where the engineers wanted it to remain in the first place.

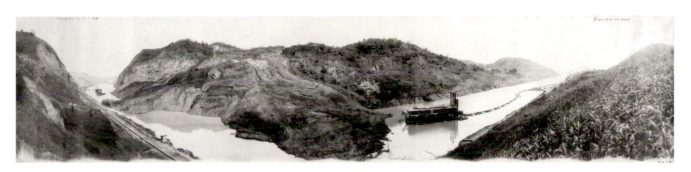

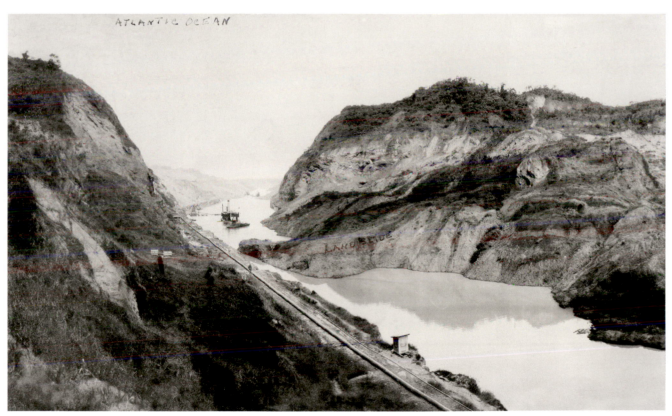

RUDDER OF THE USS *TRENTON*

PHOTOGRAPHER UNKNOWN

The USS *Trenton* is pulled up on the ways following the great hurricane of March 1889 in Samoa; we have seen another view of this storm's work in plate 12, showing HMS *Adler* on her side on a coral shore. The *Trenton* is a wooden ship, and her meticulous copper sheathing is plainly visible, tacked securely onto every wooden surface below the waterline to discourage the tornedo, a wood-loving tropical worm that could bring a ship of the line to ruin in just a season or two. While the storm's damage might not be too clear, the construction of the stern works of a ship of this period is plainly revealed in the picture. The rudder and propeller have always been trouble spots in ship design; they are vulnerable to damage, hard to fix, yet vital since movement and control are both implemented from these relatively delicate structures.

The rudder hangs down from its shaft. It is made thin and tough so it will disturb the flow of water as little as possible except when turned at an angle, to create thrust against its forward-facing side that pushes the stern to steer the boat. The rudder's foot and leading edge have been set in bearings connected to a flat metal extension of the keel, and without this support the force of moving water would immediately bend the thin rudder shaft. The propeller cannot have an outboard bearing, since any obstruction there would impede the flow of water from the rotating blades. Because of this lack of support, and to accommodate the full power of the engines, the propeller shaft is massive, and held in a large watertight bearing hidden beneath the oval plate visible to the right of the bronze wheel. All of this works well until the inevitable moment when the ship scrapes across a rock; then the inertia of a few hundred tons moving ahead is brought to bear on the delicate members we see here, and something bends or breaks. Often the damage can be fixed, but at sea it is difficult, since only divers with their puny strength can go down to work below the stern, and then the tremendous scale of blades and fittings becomes an almost impossible obstacle to repair. In the days of fighting sail, the rudder post was often exposed at the stern of a ship, and a well-placed shot there could be crippling. Many a battle was fought between two damaged ships steering by sail alone while frantic efforts were under way to fix an inoperative rudder.

The frightful storm must be a few days in the past, because an orderly harbor life goes on in the background of our photograph. The beautiful local sloop sits in front of a docked square rigger; a small harbor crane pokes its frame up between rudder and propeller, and a launch with white-clad seamen sits perfectly in the lower left corner of the picture's frame, making the *Trenton*'s gear appear larger than it really is.

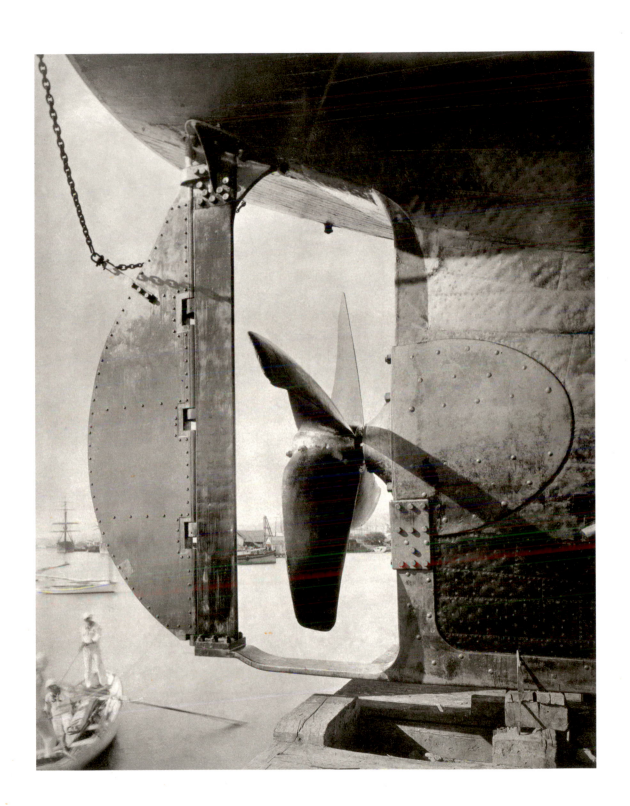

LAUNCH OF THE USS *ILLINOIS*

GEORGE PRINCE

The hard shadows on the ground show that the umbrellas are held as protection from the sun rather than the rain. If we saw a scene such as this today the parasols would be white, built of some mildew-resisting synthetic that could reflect the solar onslaught with more efficiency than the dark and pungent oiled cotton that covers most of those in the picture. The town's people have gathered, in their finery, to see the launching; this is clearly a festive occasion that crowns the huge civic achievement of the construction of the battleship.

The launch is a time of celebration, but it creates high tension in those responsible for getting this ship into the water at the right time. The *Illinois* will end up displacing over 11,000 tons, and she is at least two-thirds of that weight now, sitting up on the blocks of the marine railway. The launchers face the challenge of keeping her there, immobile, until the moment at which a symbolic bottle of wine breaks upon her bow; then, with no perceptible hesitation, the battleship must slide smoothly into the water. This is a daunting task. The traditional way to manage it is to have the ship poised on greased ways, set at an incline to the water. The tremendous tonnage is kept from slipping down by a bar of steel that acts as a line connecting the ship's undercarriage to a fixed point on the railway. This connector is partially cut through with a torch just before the christening. As the cut is completed the bottle is broken, and the ship slides as she is supposed to.

The most famous launch that didn't work was that of the 690-foot *Great Eastern,* built in England during the 1850s. She took four years to make and another two years to launch. Constructed on the muddy banks of the Thames River, this monster simply refused to move when launching day arrived, and she was stuck there for many months, resisting the push of the biggest hydraulic rams in the world and the tug of the largest chains. After a succession of failed attempts, the giant ship finally moved into the water and began her career of bankrupting successive companies that tried to manage this leviathan, built so hugely out of scale to the technology of her time. For many decades thereafter the lessons of the *Great Eastern*'s launching hung in the mind of every shipyard foreman who had to oversee this sort of public event.

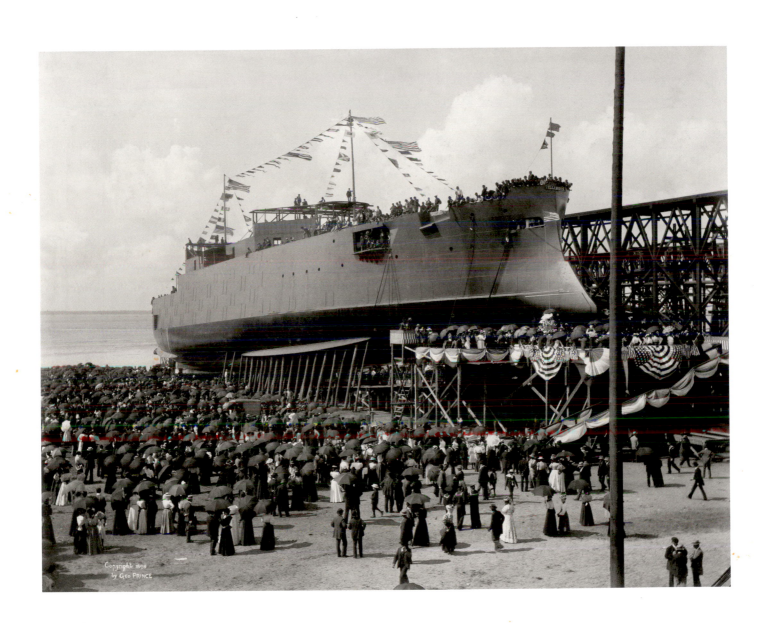

CHRISTENING OF THE USS *ARKANSAS*

PRINCE FOTO

The *Arkansas* was a monitor, a direct descendant of the eponymous *Monitor* of Civil War fame pictured in plate 30. These early ironclad ships were an attempt to find how iron, armament, and the sea could go together in warfare. This particular ship was one of the last monitors to be built, and she only served the United States Navy for ten years before being mustered out in favor of the destroyers and battleships so familiar to us today. We can tell from the photograph that the ship is fairly small, as her impractical ram bow relates easily to the scale of the people in the picture; also, the white numbers running up the hull show draft in feet, so at most the ship might only need nine or ten feet of water in which to float. The photograph shows the christening ceremony, in which a young lady breaks a bottle of champagne across the new vessel's bow to send her sliding down the ways into a life on the water.

The ship is a "she," and so is her sponsor, the bottle breaker, whose name is Miss Bobbie Newton Jones, daughter of the then Governor of Arkansas. It is impossible to tell which of the women on the platform is Miss Jones, and the photograph has been made at the very moment of christening, when the wire wrapped bottle, swung upon its rope, is breaking on the hull. Each participant in the ceremony is frozen in time, transfixed by the noisy climax of this odd ritual. The ship's bow has a distinctive shape, as does the woman in white, and perhaps both these subjects of the picture are feminine in our culture because of some shared attribute that has always made people see ships in the female gender. It is difficult to raise a subject like this today, because we live in a time when distinctions between male and female commingle with contemporary ideas that blur the differences between the sexes. Even so, the fact that ships have a female sponsor is an old tradition stemming from a belief that a woman should instill the spark of life into a fighting ship. This concept is a holdover from a time when differences between the sexes were accepted without the slightest doubt about their primacy in human affairs.

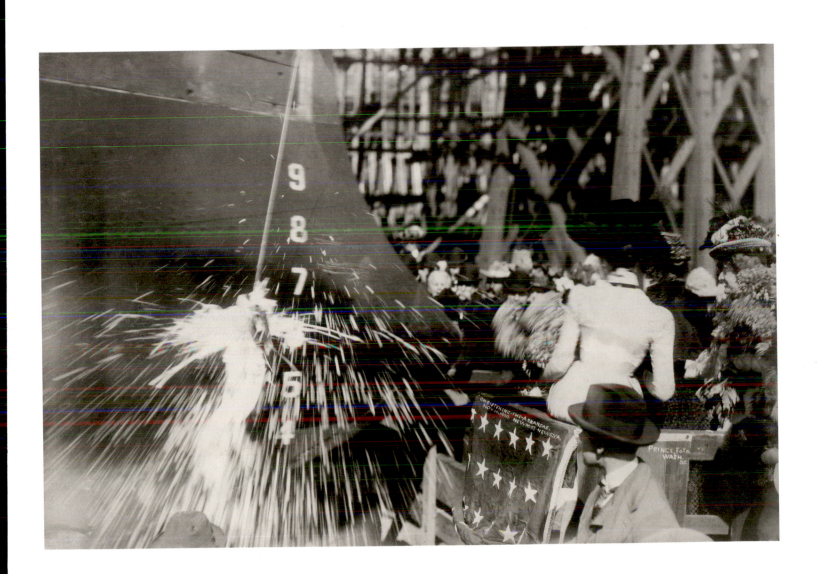

THE USS *OLYMPIA* AT MANILA HARBOR

PHOTOGRAPHER UNKNOWN

This photograph is probably bogus. It purports to show the USS *Olympia*, an iron cruiser of the 1890s, in the heat of battle at Manila Bay, during the Spanish-American War. The *Olympia*, Admiral Dewey's flagship, was certainly there. Records show that she joined in the fray and even fired on the enemy, which many naval ships never get a chance to do. The picture, though, is quite a different matter; it reeks of heavy retouching, but it is part of this book because the falsehood is interesting and the picture is good.

Whoever messed with the photograph of the *Olympia* did so before the age of the computer, and they had a tough time doing it in a convincing way. First, the ship hangs in an impossible relationship to the surface of the water. We can see this in the lower left corner, where a bit of the sea is too clear and too obviously unrelated to the hull it should be supporting. Second, the ship appears to be firing simultaneous broadsides from both port and starboard side, and this is a particularly rare and unlikely event, once carried out by Lord Nelson, turning and running the line at Trafalgar, damaging ships on either side of him in an audacious dash back through the enemy's ranks. Third, the smoke, from both guns and boilers, just looks too much like a hand-made addition. The wiggling clouds and curling black roils of ash cannot possibly have looked that way anywhere except in the mind of a painter. Fourth, and finally, the crew has all the characteristics of well-dressed men at sea for a weekend cruise; there is not a helmet in sight, and none of the confusion of battle is apparent in the photograph. The evidence of the picture is obscure, in part because it has been copied at least twice. We can see indications of this in the angular cut across the picture's top, and in the black triangle at the bottom left, which show that the copy camera was tilted for one of these reproductions.

The picture is good because it stops us dead in our tracks. The ship, for whatever reason, comes at us out of the picture plane with an immediacy that is shocking. The coat of arms bearing the stars and stripes is bent across the stem, and brings home the fact of our history of war at sea. We cannot help but believe that the photographer is about to be rammed by the huge mass of the ship, barreling along with guns blazing in a rare view of battle as it actually took place, nearly one hundred years ago.

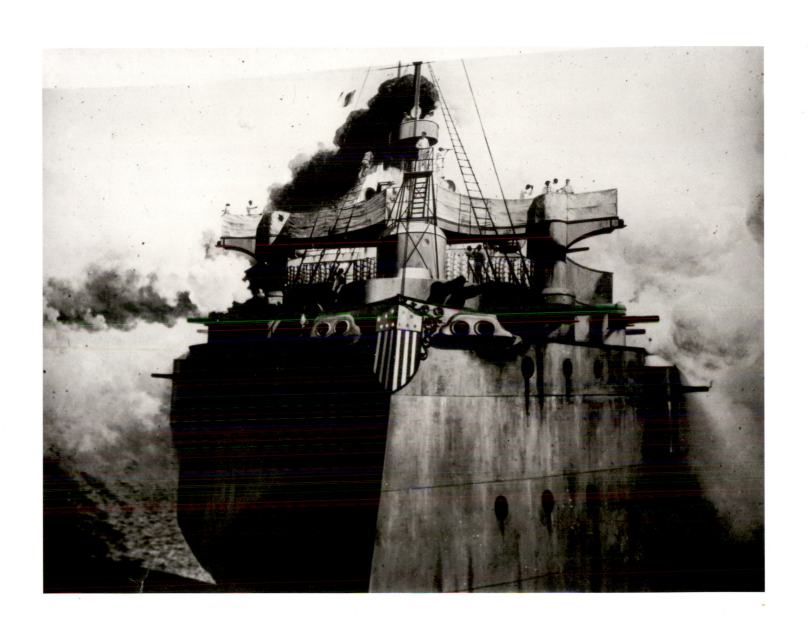

THE GREAT WHITE FLEET

O.W. WATERMAN

This picture was made off Hampton Roads, Virginia, on February 20, 1909, the final day of a world-circling cruise by America's battleship fleet. President Theodore Roosevelt had ordered the trip fourteen months earlier, as a means of asserting his country's military strength at sea. Sixteen battleships and three auxiliary vessels had traveled westward around the globe to wave the "big stick" at all the squabbling countries along the way. This armada was called the Great White Fleet because the ships were painted white between the waterline and the deck, but shortly after the cruise all United States Navy vessels were covered in gray, a less conspicuous color at sea.

The White Fleet made American power visible and frightening, and Roosevelt created the cruise because he felt war was soon to break out. It was as though a malignant force was in the air, and he hoped the strong display of the fleet would prevent an outbreak of hostilities. Of particular concern was Japan, and one of the successes of the trip was that thousands of sailors came ashore there and were welcomed by the government and populace with much ceremony. When World War I finally did begin some years later, it originated in Europe, instead of in the Pacific theatre.

Even if the White Fleet seems almost childish in its display and strutting showiness, it did the job. Every nation that saw this line of ordered ships with their gleaming guns knew that the United States should always be kept as friend instead of foe. Forty years later the Soviet Union and the United States entered into the Cold War, both countries devoting huge portions of their economies to the creation of suicidal military strength. Many people were appalled at the potential of these insane weapons, but, like the White Fleet, they probably kept war from happening.

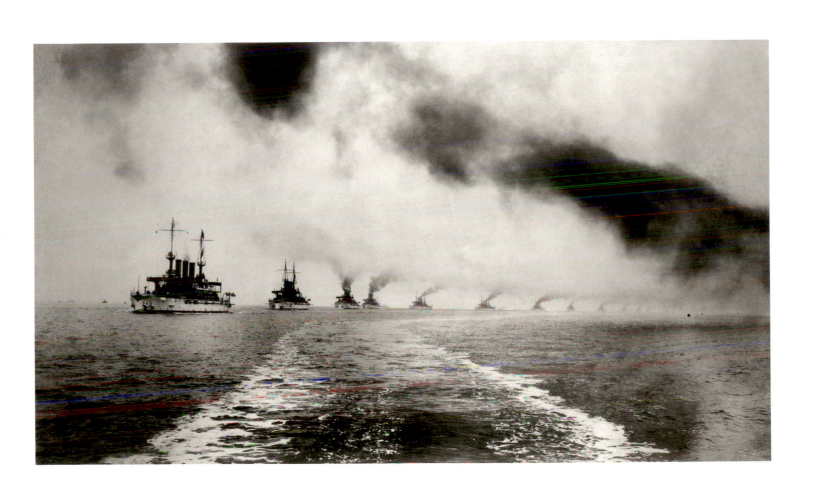

GROUNDED SCHOONER *BESSIE A. WHITE*

EDWIN LEVICK British 1869–1929

The *Bessie White* ran aground some time before this photograph was taken and we know this because she has that tilted aspect that only a falling tide can impart to a ship that sits on the bottom. The sails have all been furled, or stowed below, and the neat four-master seems merely to be waiting out the calm weather before putting to sea again.

The cargo listed for the *Bessie White* was 900 tons of coal. The caption on the picture's back says she was abandoned here, on the beach at Fire Island, in 1919. A fine sailing ship such as this would only be discarded if she broke her back in the accident, and with such a massive load that could easily occur. She was probably deep laden, and the tide has fallen enough to strain the wooden structure of her hull beyond repair as she settled onto the uneven beach. Wooden ships in her size range, nearly 150 feet long, depended on the even lift of the water to preserve their shape, and when loaded they could break themselves fatally with their own weight if caught on a rock or hard sand bar.

The dory on the beach, which could be a rescue boat or simply one of the schooner's small craft, is being used to unload the ship, not of her cargo but rather of the crew's personal belongings. Tucked in the bow is a Windsor chair, the most unlikely thing imaginable to find here, and it may well have been on board because the captain had his wife living there with him. This was often the case in the coasting trade, and even a small family could live easily in the cabin available to the master of a large ship like this one. Many early photographs show a proper chair on the afterdeck, accompanied by a parasol, with the lady of the ship sitting outside on a fine day to watch the approach of land or the unloading of cargo that were part of a coaster schooner's normal routine.

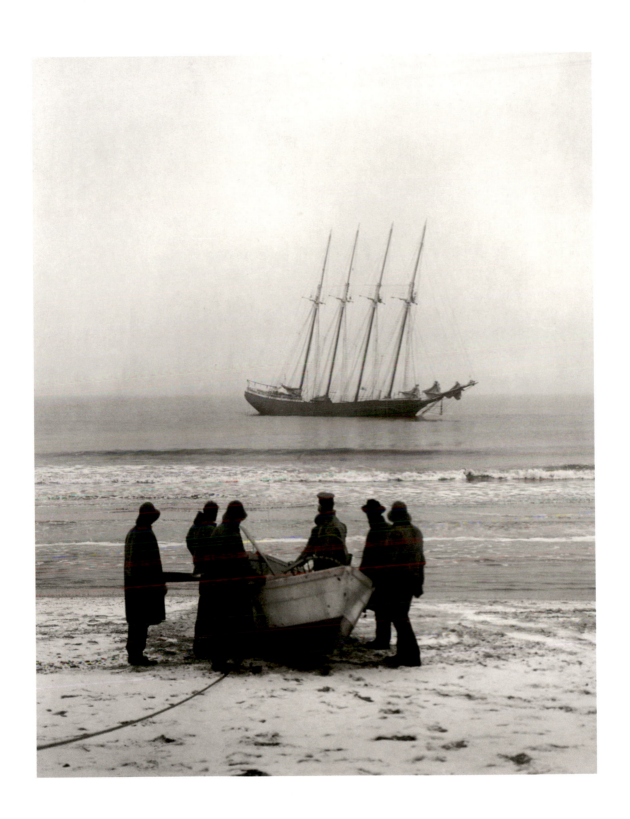

47

CAPTAIN ORVIS MURRAY GRAY AND HIS SON

PHOTOGRAPHER UNKNOWN

The little boy might live on the boat with both his parents, or this might be a rare visit to a father who is seldom seen. Whichever the case this well put together youngster, probably raised so far by his mother, sits here at the brink of his conversion into the father.

Girls have been raised by women and then turn into women, and boys have been raised by women and then turn into men. This cultural pattern is an odd reflection of the Y and X chromosomes, which determine sexuality by giving two X's to create a woman, and a Y and an X to engender a man. In our culture the man has usually been created by a split system that started him out in the female world, where he was fed and nurtured in a way that men seemed incapable of, before shifting over to the male world, where he turned into the strange and pre-occupied sort of creature that we see here so tentatively holding his son. The father is probably only 25 years older than the child, but his world is one of ships, the sea, paint and rigging, and the little boy now must make the transition over into this male life of gear and commerce, that men have always found so engaging and enjoyable.

It is probably a good thing that we are overturning this pattern, and that we state firmly in our own time that men and women can both nurture the young, and likewise both can command the seats of power, such as this ship. In our picture, however, the little boy has been created by a mother's loving care; he poses with firm set mouth on his father's lap, doing his best to lean away from the strange man into whom he will gradually turn.

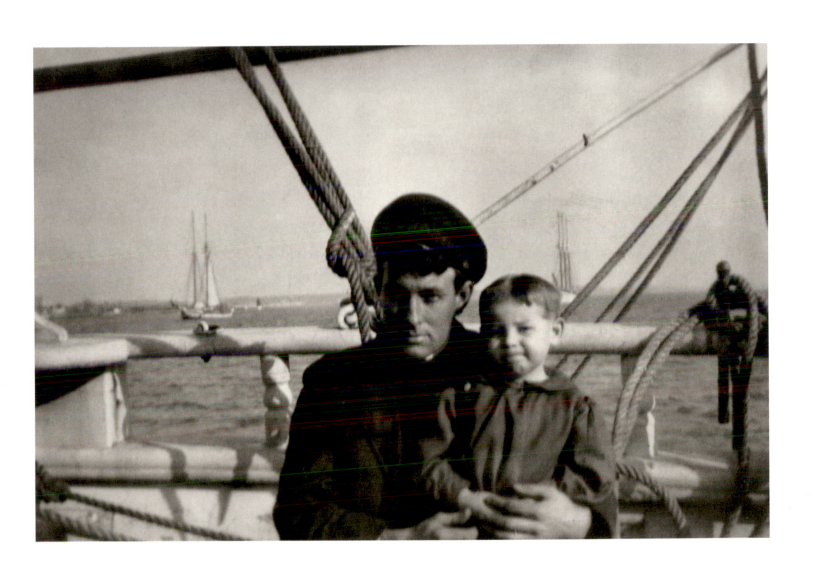

HORSE-DRAWN LIFEBOAT

PHOTOGRAPHER UNKNOWN

The caption for this photograph is obviously incorrect, but we have retained it because the error teaches a lesson about truth in photography. Years ago, someone looked at a dark print of the picture and decided that the only reasonable explanation for a boat, horse, and men on the beach must be that they represented a specialized sort of rescue craft and its equine launching team. When the negative was located in the Mariners' Museum archive and a clear print made, the scene resolved itself into a boat, horse-drawn wagon, and group of men on the beach unloading a good day's catch of fish. Photographs make no effort to create sense out of a scene, as painting traditionally did, but only lay out the jumble of facts. Occasionally a viewer comes along who cannot tolerate this indefiniteness and so declares the subject with some notation or enlightening caption. Often this description bears little relation to the scene that generated the picture, but a written declaration convinces us with an authority based on centuries of literacy in our society.

The boat is a beautiful, general purpose, lapstraked rowboat, and she is out of her element here, sitting on the sand. The edges of her white painted planks are scratched and beaten up from being used to net fish; yet she is not a neglected boat that sits in the water all the time, because there is no grass on her clean bottom. Whether she was originally intended to be on deck, like the almost identical lifeboat shown in the next plate, or to be a harbor craft, is impossible to tell from the picture, but her fine lines and small upturned stern mean she would move gracefully in any reasonable sea. The wagon is nowhere near as good. Its bed is simple and shaped like a shallow box, and if we saw a long-range, overland freight wagon sitting next to the boat, we would be struck by the similarity of their shapes. In our picture the vehicles for land and sea have completely different forms.

The wagon, like the boat, is out of its element, and the most striking thing about the picture is how clearly it declares the character of this no-man's-land of the shore. There are no vehicles made just for this place, where land and sea meet, and as the waves and beach grind against each other, the men struggle to function there with tools that really belong somewhere else. The boat suffers from being run up on the sand, and the wagon can easily sink into the beach if it runs over a soft spot hiding some buried kelp. There is no pier for the landing, because the shifting sand won't hold one long enough to justify building it, but the surf is down and the catch was good, so a quick unloading is in order. The large gentleman standing in the boat, the only one not physically working, barks out orders so this questionable activity can be finished as rapidly as possible before land or sea swallow up one of the hard-working vehicles that have come together at the water's edge.

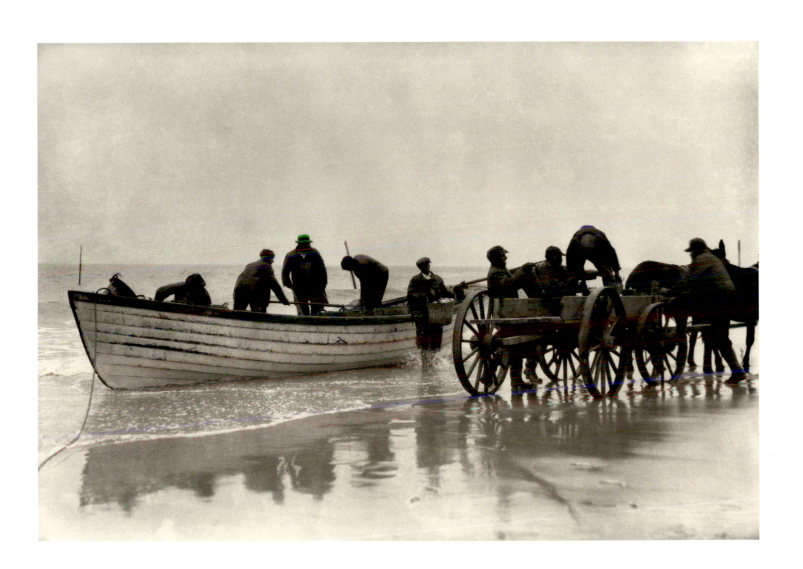

BARK GARTHSNAID

PHOTOGRAPHER UNKNOWN

This ship is certainly earning her keep. We are probably looking forward, and the white foam comes from her bow plunging down into a sea; the entire lower right half of the picture shows a solid wall of green water coming over her lee rail. The photographer, who obviously has nerves of steel, is hung in the slack rigging of the mainmast, relatively dry and well-positioned for his camera to grab this spectacular view. The ship leans down from the pressure of the wind, and her heel is even more than we see in the picture because the horizon is slanted as well, through an unconscious tendency on the photographer's part to try to straighten things out. The bark is probably boring along at twelve knots or so, and she is making a fine passage, low down in the water from her holds full of cargo.

We only see square-rigged sailing ships at dockside today, and so are unaware that a scene such as this shows the normal life of these old vessels on the high seas. This is the sort of weather and sailing that the owner, skipper, and crew all longed for, which could make a brisk passage, earn everyone a profit, and keep the ship economically healthy while she did her job. As we try to preserve things from the past with museums and displays, it is easy to forget that all we usually keep intact is the rigid and non-functioning frame of an old organism. Ships such as this were built for the stresses and risks of life far out on the ocean, under a howling wind, where every line and spar was strained near to the breaking point during the normal course of a journey. The three lines running out of the picture at the upper right corner lead to the main yard, and we can be sure that this pole, hanging from the mast up in the full flow of the wind, is bent near to breaking as it supports a reefed sail that itself is close to shredding from the forces that drive the ship.

A sailing ship at pierside, adorned with colorful visitors who walk the decks, is little different from the carefully reconstructed skeleton of a dinosaur. Like huge old steam engines in exhibition halls, these remnants from the past are mute and harmless. Yet, if we could stand next to any one of them when they were alive, we would be shocked by the vigor and reckless intensity with which they moved through their working lives.

LETTERS SALVAGED FROM THE *EMPRESS OF IRELAND*
PHOTOGRAPHER UNKNOWN

The *Empress of Ireland* sank in the St. Lawrence River one month before the assassination of Archduke Ferdinand of Austria, an event which touched off World War I. The ship carried people, goods, and the modern cargo of information in the primitive but efficient form of paper letters. These survivors have been somewhat battered from the tragedy, but have been laid out to dry and be photographed. They will soon be repacked in new mail bags, to go on to another ship so that they will finally reach their individual destinations.

The addresses are all in Europe and the cancellations from Canada, and each envelope has a precise date and a stamp showing that the transportation of each letter has been properly paid for. In many cases the address is written with a flourish of individual penmanship that speaks of the writer's nature, but one-third of the letters are machine addressed, and this new look shows just how deeply the mechanized wheels of commerce are intruding on the old age of personal discourse. Bank statements that hold the key to the economic health of companies and families are mixed with notes and even a postcard. All the pieces of mail are sacred, because our society has long since understood that without dependable and clear communication a rich and stable worldwide culture cannot flourish.

The two continents connected by this mail each hold millions of people, and the brief addresses are a miracle of efficiency. With just a few lines they can single out a lone recipient from a packed nation of people. The lines are in descending order of specificity, starting with the individual's name, then house, then town and finally country, so the postman must read the information from the bottom up. First the letter goes to England, with its twenty million souls, then to the city of Northampton, which only holds some thousands out of that population, then to 77 Derby Road, where Mr. Gibbs probably lives with a few other people, and then to the man himself, the only male member of the household with a first name starting with the letter C. The power of this type of address, successively cutting down the huge numbers of modern times to smaller increments, so the individual can remain functional in immense populations, is such a fundamental and powerful tool that it has reappeared virtually unchanged in the age of the computer. Whether we search files on the desktop, or fly through the ethereal skeins of the Internet from our living rooms, all communication today is based on this progressively selective sort of address that was developed in a time when pen and paper were new and empowering inventions.

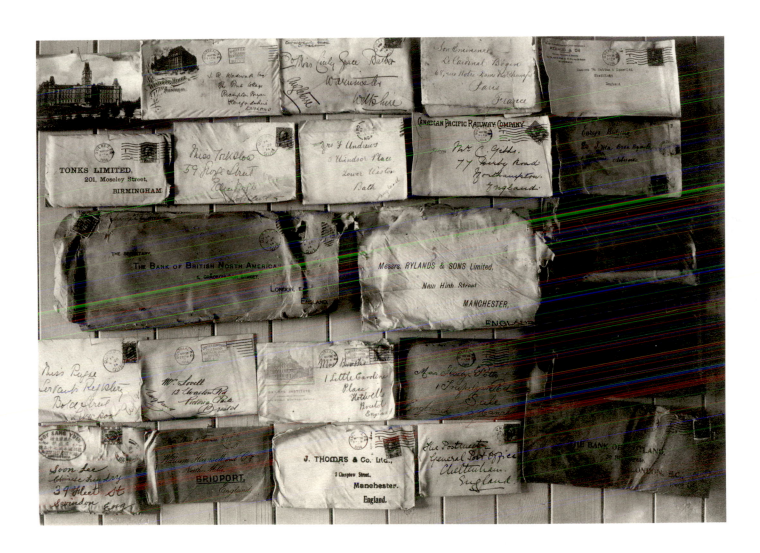

GREAT LAKES FREIGHTER

PHOTOGRAPHER UNKNOWN

Ice has always been a problem for those who must work on the water during winter. The sea, or the lake in the case of this picture, acts as a great heat sink, losing heat slowly as winter progresses. As long as the surface remains free of ice, shipping can continue, but any spray coming on board is likely to freeze immediately onto the superstructure of the ship. This happens because in winter the lake water is near the temperature at which its physical state can change to ice, and the air and hull of the ship are well below this freezing point; the finely divided spray quickly gives up the stored heat that has allowed it to remain liquid.

Ice thus formed coats the ship in a design similar to that of hair growing on a mammal's skin, and the linear patterns show at a glance what has occurred on these surfaces. Airplanes and modern cars are designed in wind tunnels with bits of string attached so comparable lines of flow become visible to engineers, who can spot turbulent areas in their creations that must move smoothly through air. The ice shown in this picture is a record of how the ship, wind, and water interacted during a stormy winter passage.

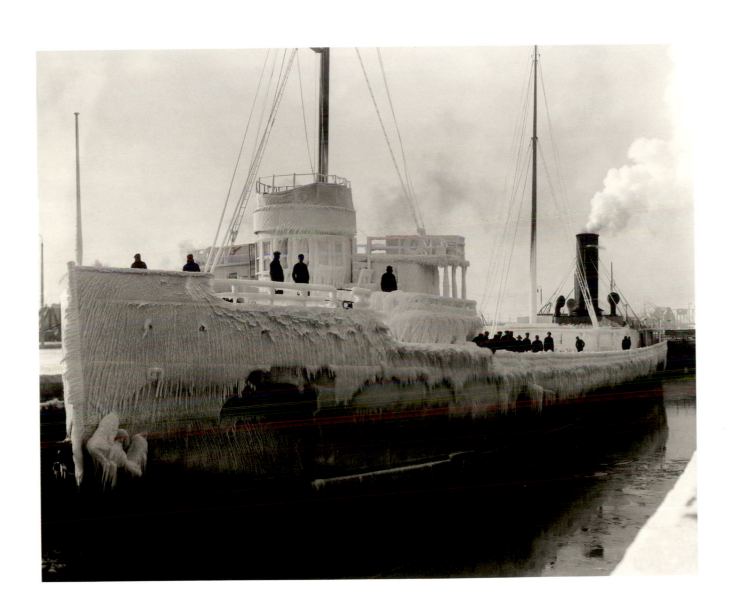

THE COLLIER *NEPTUNE*
PHOTOGRAPHER UNKNOWN

Sailing ships were fueled by the wind and by the muscles of the sailors who manned them. Because the muscles in turn needed to be fueled by food and drink, the square-rigged ships with large crews had to carry many tons of food and water in their travels. With the advent of steam, crew sizes declined, and so did the weight of food on board. Instead, however, a new and bulky fuel — coal — had to be transported. Practical steamship operations required coal in massive quantities.

Coal is difficult to handle. The ship in this picture is a "collier" — the traditional term for a coal miner — and she was built to carry coal and load it onto naval ships located anywhere in the world. The tremendously complex rig, of which we see only a part in the photograph, could pull the coal up out of holds in the collier and then shift the load out over the water to be lowered into an adjacent ship that needed refueling. We can tell at a glance that this machine is simply too complex to be tolerated for long, and in truth the inconvenience of coal contributed to the adoption of petroleum as the seagoing fuel of choice for large ships.

Coal is used as it comes out of the ground, needing only to be broken down into a size suitable for any given furnace. Petroleum, on the other hand, can be refined to make different sorts of fuels, some for use in cars that burn gasoline, some for diesel engines or household furnaces, and others, thick and near to the original stuff from the oil well, to be used in large boilers. As ships shifted to petroleum, the collier disappeared and was replaced by the tanker, a part of all naval fleets today. Oil can be transferred relatively easily between a moving tanker and the ship it supplies, through large flexible piping that hangs from one hull to the other as the ships steam parallel courses at the same speed. This trick from the sea was even adapted to aircraft; fuel used in long-range bombers can be pumped from a tanker plane as both craft travel at hundreds of miles an hour far up in the thin atmosphere.

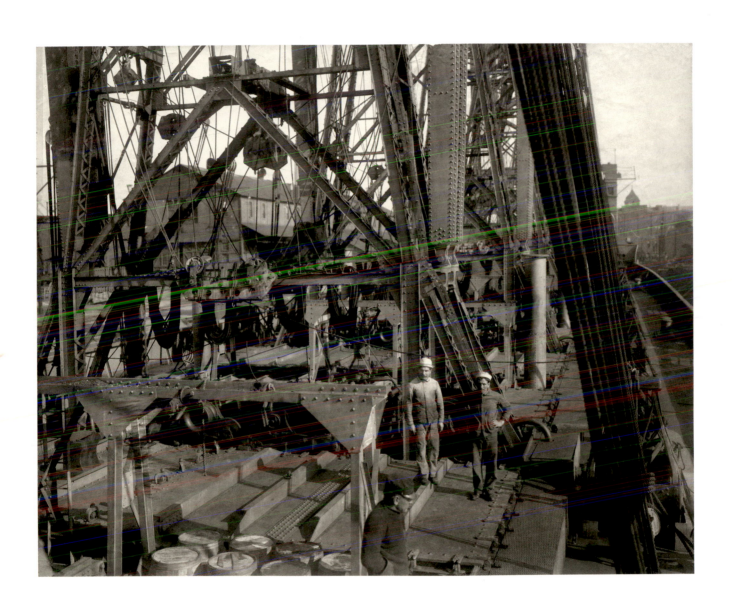

ELY'S FIRST FLIGHT

KEVILLE GLENNAN

This is a photograph of the first flight ever made by an airplane from the deck of a ship. On November 14, 1910, Eugene Ely made a short run down the raised wooden structure we see built on the deck of the USS *Birmingham* and took off successfully. In January of the following year he completed a landing at sea, and these interdependent events marked the start of the age of marine aviation. The *Birmingham* was a heavy cruiser that went on to fight in World War I; the aircraft was a Curtiss biplane.

Wilbur and Orville Wright flew first at Kitty Hawk in 1903, capping an era of American and European experimentation in gliders and primitive powered craft, and so only seven years were required to make the airplane versatile and dependable enough for the risky procedure we see here. Within thirty years of Ely's flight, the nature of war had been completely changed and the ancient idea of hurling a projectile with a gun was being supplanted by the novel one of dropping explosives from a high and inaccessible aircraft. If we look at the toy-like struts and unprotected man so cleanly described in the photograph, and then jump ahead to imagine the *Enola Gay* over Hiroshima a mere thirty-five years later, we are astonished by the rapid and uncontrolled progress these two scenes demonstrate.

The photograph is remarkable for what it brings together. The wood of the launching ramp is to be phased out of warfare, replaced with tough steel and aluminum. The cruiser that supported the test will disappear, because the deadly efficiency of airborne war will determine that only one more generation of huge gun-bearing vessels is to be built. The photograph reports the event, and battlefields of the future will be recorded with this sort of frozen clarity. As these images return to the public eye, war will finally be seen by all for the horror that it truly is.

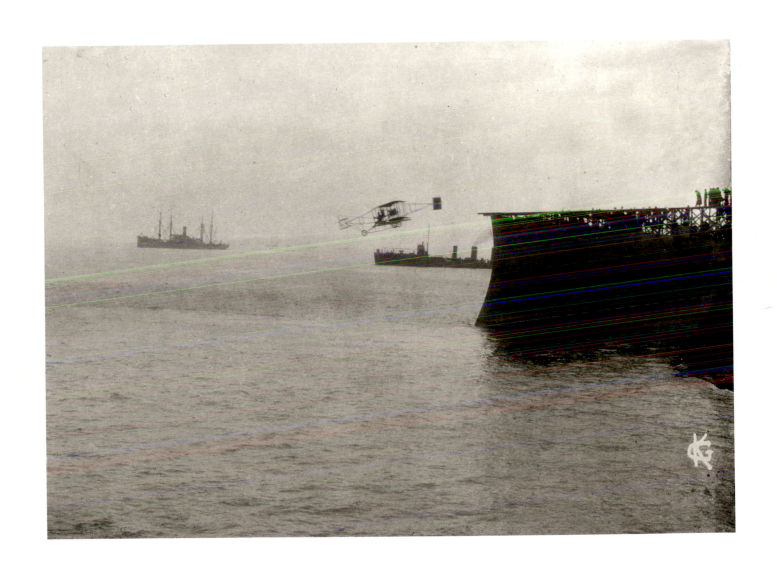

CANADIAN LOCK ACCIDENT

YOUNG, LORD & RHOADES

Lake Superior, the largest of the Great Lakes, is forty feet higher in mean elevation than adjacent Lake Huron into which it flows. This photograph shows a connecting lock on the St. Mary's River after a gate failure which allowed the water to rush unimpeded between these two huge inland seas. The first thing that springs to mind is the comic question of how quickly Superior will drain itself through this breech, but we need not worry; the surface of the lake, and its surrounding catch basin, take in an average of 72,000 cubic feet of water per second, and this volume flows out of the lake into Huron whether we put puny lock gates there or not. The accident simply reveals this natural flow taking place in a dramatic, single event.

The water loses its normal horizontal surface as it enters the lock, and tilts down in a smooth incline until it reaches the recesses in the lock wall that once held the open gates. There a large standing wave forms, and on the side of its crest facing us the glassy surface begins to run white and disrupted before falling into the violent turmoil that fills the rest of the chamber. The large wave will remain in the same location as long as the water runs because it is a reflection of the shape of the waterway's channel; this lump of rushing water is the same one that a rafter finds, on a smaller scale, when shooting rocky rapids. To a sailor this rapidly moving water in a wave that stands still goes against the natural order of things, because at sea the waves move but the water does not. When we go to an ocean beach and walk out past the breaking surf to swim, it immediately becomes clear that the waves lift us and roll by, while the water in which we swim obligingly stays in the same place. Water has this astonishing versatility, that it can express two completely different versions of the wave form. The first is a shape that it assumes while in rapid motion to pass obstructions in an efficient laminar flow, and the second is in an identical shape that expresses a harmonic up-and-down movement of water that remains relatively stationary while the form of the wave travels horizontally.

The job of shutting down the lock after this accident was a tough but manageable one because the wall of water could be arrested bit by bit instead of all at once. Workers were able to build a new temporary wall across the lock, moving in from the sides, adding to it gradually in small increments. This is understandable if we realize that using our hands alone we could hold a stick into the rushing water and resist its movement because the stick would only be stopping a tiny fraction of the leak; the rest of the water would not take offense at this small obstruction and push harder as a result. Once the gap was closed, a new gate could be built below the temporary blocking wall.

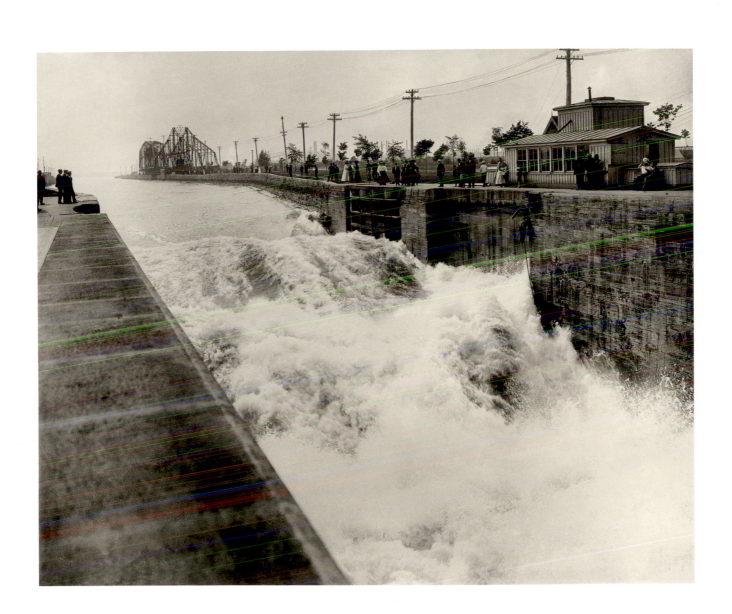

NORDENFELT II, TURKISH SUBMARINE

PHOTOGRAPHER UNKNOWN

Many new objects and ideas were spawned by the Industrial Revolution, and we see some of them in this picture. The steam engine packed into this early submarine's half-built tube was the central creation of the new age, and by supplanting living tissue as humanity's prime mover it set the stage for the great constructions and frenetic activity of the last 150 years. Not as glamorous but hugely important was the invention of the standardized rivet, which held so much of the mechanized world together until welding reached its current level of refinement. The rivet holes running around the edge of the iron tube were punched to a set size, with confidence that the rivets produced in some far-removed manufacturing plant would fit the holes properly without any hand adjustment. Not so quickly visible in the picture, but every bit as much in evidence, is the new presence of the desk-bound engineer, that person who managed to design this unlikely ship with its watertight shell, engine, boiler, fuel and crew all carefully assigned to their respective spaces in the hull.

The engineer is really a kind of designer — but one who pays attention to the functionality of things as well as their appearance. This new position was needed when technology became too complex, and jobs too large, for the traditional builder. One unfortunate result was that members of this new breed of designer often didn't experience their own creations.

Life aboard this submarine must have been absolute hell. No one who had ever run a reciprocating steam engine would imagine putting such a large one in such a tight space and then asking a human being to control it. These machines are benign and comforting when running in a proper engine room, but up close and confined they are awful. The metal is hot and vibrating and the high pressure line burns skin at the slightest touch. The crankcase is not covered, as in modern engines, but instead is open. Lubricating oil must be continually applied to the bearings and also can coat a bystander. Steam joints and valves should not leak, but eventually they all find a way to do so. The lovely smell of steam and oil that holds such nostalgic force for engine buffs can become a choking vapor. It may be absurd to think we can travel beneath the sea, but in the early years of the submarine, war and human suffering made it possible.

BIG TIMBER

PHOTOGRAPHER UNKNOWN

This piece of lumber, cut from a single tree, is so large that even this dramatic photograph cannot do it justice. It contains 518,880 cubic inches of wood, and if we decided to cut this giant down into the ubiquitous 2x4, which has become the primary structural element of most wooden houses today, then it could supply the framing for the walls, floors, and roof of a substantial two-storey building.

The grain in the center of the beam shows that this was the tree's middle as well. Faintly visible on the side nearest to the viewer, running vertically, are the parallel marks which show that the cutting was done with a bandsaw. Running along the top, halfway down, is a slight irregularity caused by the straight cut running out of the log for a bit, revealing the tree's original bark-covered surface. Back in the sawmill where this monster was cut, the sawyer made a nearly perfect judgment about how the log should be oriented and where the cuts should be made to allow the largest possible timber to be extracted from the tree. A number of smaller but still massive beams came from the sides, so the yield was much greater than this single chunk would imply.

People differ and so do nations, through no preordained plan of logic or fairness. In the United States it is all too easy to forget that our country fed on an incredible gift of natural resources. In Europe nearly all of the trees had been cut when the sawblades of the nineteenth century started to log the climax growth of the United States. From coast to coast the ranges held wood, minerals, fertile soil, and abundant water, each in a profusion unmatched elsewhere, and we tend not to admit that this wealth always stood behind America's achievements.

IMPROVING ST.MARYS RIVER, MICHIGAN
NEW LOCK AND CANAL. 3 RD LOCK GATES
20 INCH BY 46 INCH BY 47 FOOT TIMBER
FOR UPPER GUARD GATES
JANUARY 6, 1914

PROPELLER ADVERTISEMENT

PHOTOGRAPHER UNKNOWN

Advertisements are of two types: one informs potential buyers where to purchase a needed item, while the other makes the reader imagine a need for something—followed by a desire to buy it. One way to tell the difference between these two types of ad is to study how each type presents the item in question. In the first group, to which this bulletin belongs, objects depicted tend to look realistic. Only in an advertisement such as this could so accurate and down-to-earth a man appear. He has a comic moustache and a bit of a pot belly, with its balancing posture, and presents irrefutable proof that people gradually come to look like the things they make. Compare him to the population of a modern fashion magazine, the bastion of the second type of ad, where we see creatures so far removed from the ordinary world that only by extending our imagination can we accept that they are people at all.

The picture shows wooden casting patterns, rather than actual propellers, although a small four-bladed bronze wheel has sneaked into the picture in the front, slightly to the right of center. Because the multiple blades of any propeller must be identical to each other, a single pattern can be used to make the impressions in the casting sand into which the molten metal will flow. We can also see patterns for the hubs where the blades will be joined together and into which the precise shaft hole will be machined. Propellers can have blades that are rigidly fixed onto the hub, or they can feather, so that a propeller can actually shift the direction in which it pushes by altering the angle of the blades while continuing to turn the same way.

In the age of steam, an engine could be stopped or started at will; to reverse a ship's direction, the powerplant was stopped and then started up again turning the other way. The internal combustion engine, which replaced steam in small boats, likes to turn all the time whether carrying a load or merely idling; the clutch and the feathering propeller both were used to accommodate this new requirement. Some early slow-turning diesels were made to reverse direction like the steam engines they replaced. To stop a forward-moving ship powered with such a machine, the engine room crew was called upon to shut the diesel down, shift its camshaft to the reverse position, and then start the engine back up again. It could be quite colorful if some quirk prevented the vital restart; the rope fender that we see being made in plate 77 really came in handy when that happened.

BRONZE or CAST IRON
PROPELLER-WHEELS
SOLID or SECTIONAL

The illustration below shows a few of the Propeller Patterns which we have in stock and on which we can give quick delivery in either bronze or cast iron

ANY SIZE OR TYPE BUILT TO ORDER

A few of our Stock Propeller Patterns

AMONG THE STEAMERS EQUIPPED WITH OUR PROPELLERS ARE

Revenue Cutter Woodbury	Schoodic	Katahdin	Portsmouth
U. S. Suction Dredge, Key West	Monhegan	Merryconeag	Francis C. Hersey
St. Croix	Henry F. Eaton	Lubec, and many others	Charles Mann
City of Stamford	Eastport	Towboats: Pejepscot	Portland
Arctic Steamer, Roosevelt	Mineola	Orion	Cohannet
J. L. Lawrence	Aucocisco	Miles Standish	Eleanor L. Wright
Maquoit	Sebascodegan	Charles T. Gallagher	Marguerite, and others

 Manufactured by
THE PORTLAND COMPANY
MARINE ENGINEERS
PORTLAND, MAINE

DIVER WITH DIVING SUIT

PHOTOGRAPHER UNKNOWN

It is clear that we are not suited to living underwater, and this picture demonstrates our unwillingness to accept this fact. The depths present us with problems, which this unlikely creation tackles: by giving the diver a tough exterior shell, survival, and even movement, can go on under the deep sea. All indications are that this thing worked and it was even possible to move around in it as long as the user was built like the substantial man in the photograph, and as long as the surface-borne supporting hook continued to hold the lumbering construction upright.

The two biggest problems we encounter underwater are the impossibility of breathing and the fact of increased pressure below the surface. These issues are closely related because our largest internal air spaces occur in the lungs, and these relatively empty chambers will shrink if subjected to unusual external pressure. Three possible solutions to surviving underwater deal effectively with the issues of breathing and pressure.

First, we can simply hold our breath, and dive for as long as the body will stand it. In early days, professional divers would hold a weight such as a rock or cannonball and so descend quickly to the desired depth. This worked well as long as the diver did not go so deep that the steadily increasing pressure could crush the rib cage.

Second, we can make a container such as the one shown here. The aim of this mechanical shell is to bring conditions on land down under the sea. Such "one atmosphere" suits work on the same principle as a submarine, allowing the user to breathe normally with pumped air under surface pressure conditions. The chief difficulties with this solution are that the shell must be extremely tough and rigid to withstand the compression that occurs at even modest depth, and the apparatus must be watertight.

A third alternative is to make a machine that will deliver air to the diver so breathing can be continuous, yet adjust the pressure of this air to match that of the water. This is the solution so elegantly worked out by "hard hat" divers, who have labored underwater for years in salvage operations, and by Jacques Cousteau, creator of the now-familiar S.C.U.B.A. apparatus. By breathing at a pressure identical to that of the surrounding water, physical stresses in the chest are eliminated. However, a new difficulty can arise: the lungs now transfer dissolved gases into the bloodstream, where they remain invisibly in solution like the carbon dioxide within a bottle of soda. Ascending to the surface too quickly is the same as popping open the bottlecap, allowing bubbles to form in the bloodstream with tragic consequences.

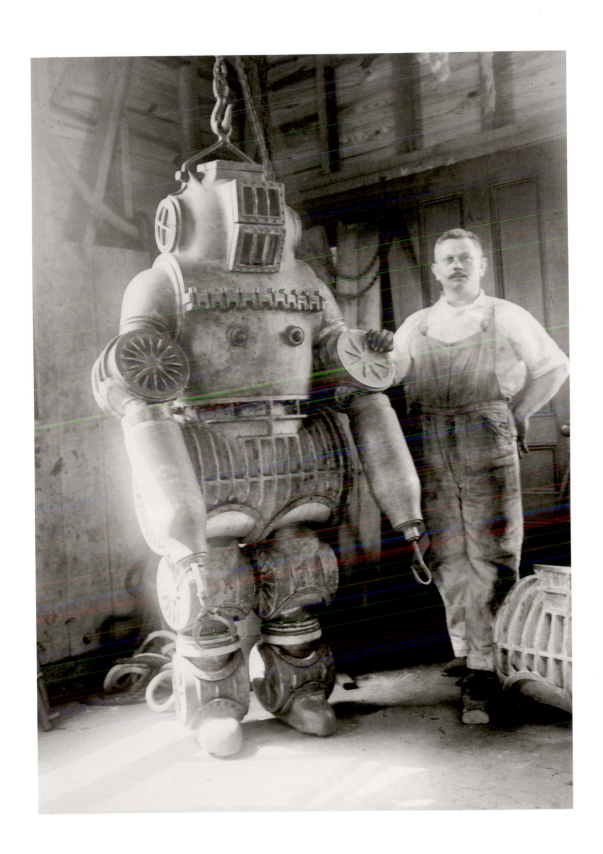

RAISING OF *LORD DUFFERIN*

PHOTOGRAPHER UNKNOWN

The *Lord Dufferin* was rammed and sunk in New York Harbor, and this picture shows part of her that was pulled out of the water by a pair of large steam cranes. A sunken ship immediately becomes an unmarked reef, and when it lies in shallow navigable waters it must be removed. A piece of the hull is hanging here. The salvage operation that freed it from the ship was one of the first to use underwater cutting torches, which enabled the sunken freighter to be removed bit by bit. The flame of a metal cutting torch is so intense that the oxygen in the atmosphere is inadequate to feed it; because this ingredient must be supplied from a tank, the process can take place underwater, where we do not think of fire being possible. The two cranes are old and new: the one on the left is built of wood, with a round, banded leg visible on the left side of the picture; and the one on the right uses a stronger girder, made of riveted iron in a square cross section. The barge hulls on which the cranes sit are both tipped in toward their load, an orientation revealed by the tilt of the boiler house and stacks on the older crane.

Sometimes we have to surrender our analytical eye and enjoy a photograph for what it is. This is such a picture. The tough plating hangs like folds of skin, with rows of blank rivet holes drawing a ritualistic tattoo of industry across its surface. Woven by the tangle of wire rope and sticks, the entire scene can be read as a miniature until we see the tiny human forms on deck who direct this large operation. The mountain of wreckage, suspended within a triangle of cable in the picture's center, cuts the sky in two, and the clear areas thus formed prepare the eye for the confusion of the cranes along the picture's edges as they tip in toward their massive load. The flag, probably the ensign of the salvage company, lends a note of ceremony to this resurrection and makes the viewer calm and sensitive to the death of this ship and perhaps the sailors who ran her.

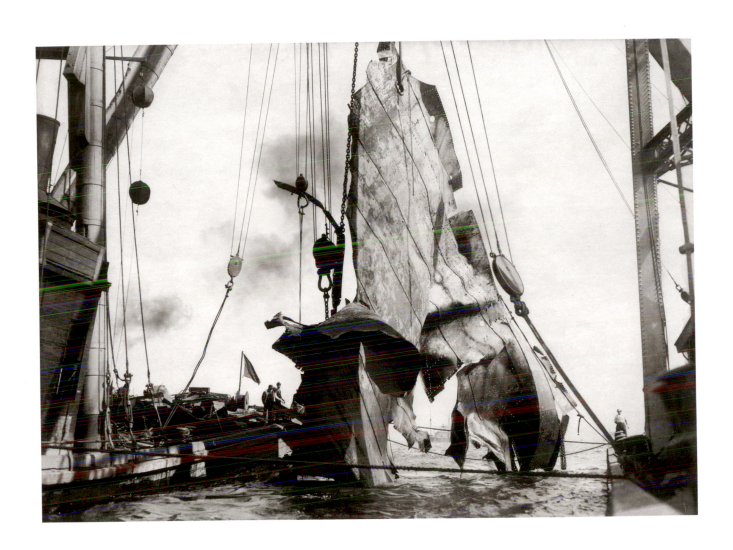

THE STERN OF THE USS *ARIZONA*

PHOTOGRAPHER UNKNOWN

There is so much to see in this picture that it is hard to know where to begin. How often do we get a glimpse of the undersides of a massive battleship? The sheer scale of this iron monster is unnerving, and the notion that she will soon be slid into the water is hard to accept. It turns out that June 19, 1915, the date painted onto the negative from which this picture was printed, is the actual launching date of the USS *Arizona* (BB-39), the third United States Navy vessel to bear the name. On the wooden platform underneath her stern we can see a couple of fancy folks, decked out in Panama hats and starched shirts, and their presence is consistent with a christening ceremony. If this is the case, then where are the propellers? The *Arizona* needs four of them, each probably a full fifteen feet in diameter, and the tapered shaft ends are mysteriously empty, wrapped in cloth and tape to seal them from the water. One suspects a bureaucratic bungle here, or problems in the foundry, or maybe just an urgent demand for the launching site, to shortly ease another ship into the water. We can be sure that the battlewagon will be launched and then, at some later date, taken out again for the installation of these vital parts.

The ship is held together with rivets. These versatile fasteners were everywhere in the marine world from about 1850 until World War II. The *Arizona* is plated with sheets of iron that butt together, rather than overlap, as do those of the freighter in plate 78. The seams are covered by a strip that is riveted on top of the joint. The rivets are not the run-of-the-mill sort that appear elsewhere in this book, but instead are countersunk, so their heads are flush with the surface, producing a smooth hull. Only in the most luxurious ships do we find such a refinement, and only with the backing of taxpayer dollars could a 600-foot-long weapon be made with such unnecessary lavishness.

There is a marvelous casualness throughout this photograph, a mood missing in shipyards today because advanced technology and a litigious society have made large-scale construction much more complex and controlled. The *Arizona* was built with a good dose of common sense filling in the blanks of the blueprints, and if a visitor on launching day slipped and fell while walking across the narrow plank bridge then everyone would understand that this accident was that own person's problem and not one that could be blamed on someone else.

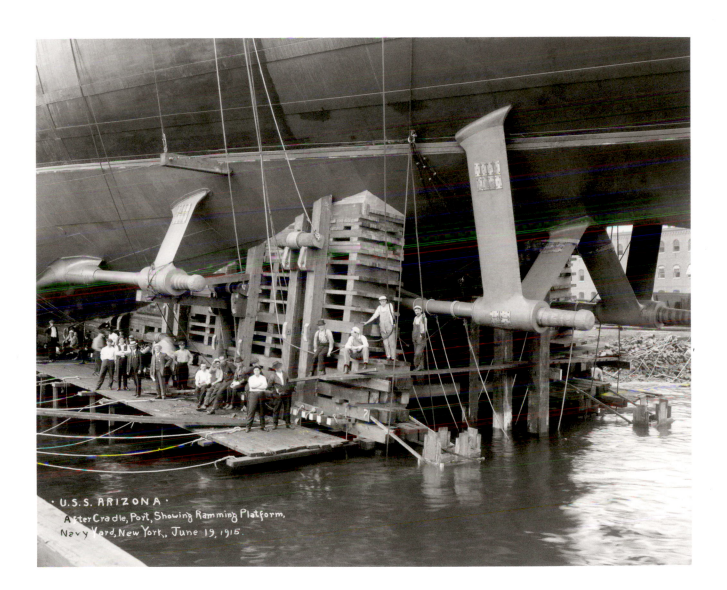

· U.S.S. ARIZONA ·
After Cradle, Port, Showing Ramming Platform,
Navy Yard, New York,, June 19, 1915.

LAUNCH OF THE USS *MISSISSIPPI*

PHOTOGRAPHER UNKNOWN

This photograph shows the USS *Mississippi* (BB-41) just after she slid into the water in 1917. All around her float the blocks and rigging that supported the hull while up on the ways. Once the unfinished battleship is taken by the tugs to her pier, there will be a flurry of activity while these bits are collected for use in the next launching. The ship floats high out of the water, as shown by her elevated waterline. We forget that iron ships, even though built out of a material denser than water, float like eggshells until loaded down. Buoyancy comes from the volume of water displaced: the thin but tough iron plates can make a hole in the water that holds even the largest ships high up in the air.

The *Mississippi* was launched unfinished because she needed to make way for the next vessel to be built. She was also lighter and easier to move then, and her completion could be done at dockside. Much of the superstructure has yet to be added, none of her armament is present, and even her ballast is not aboard. Probably this last item will be in the form of concrete, poured to fill spaces down in the bilges. This heavy load will settle the ship low in the water and provide her with a righting moment, so the large seas she will confront in mid-ocean can only roll her temporarily out of plumb while she travels on her mission.

In the foreground, looking almost sinister with their silhouetted shapes, we see members of the press, there to record the public event that was the culmination of so much work and money. Movie cameras had just recently been invented, and their ability to show movement was perfectly suited to the slow and massive slide down into the water that the 600-foot hull had just completed.

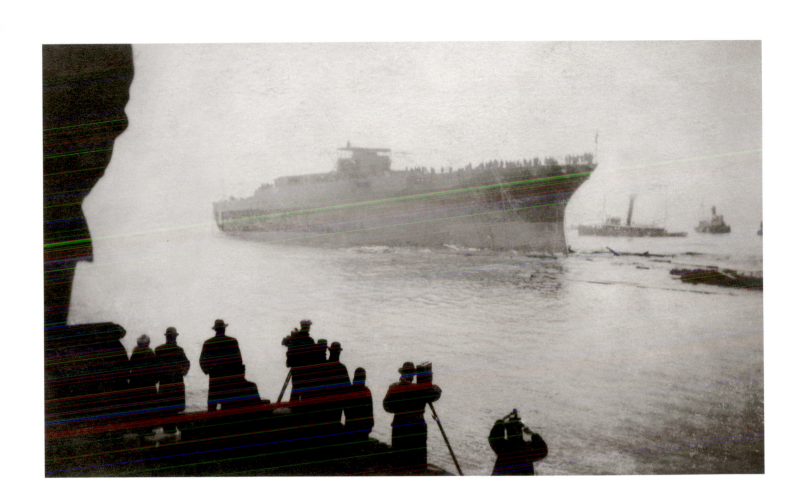

CREW OF THE USS *TEXAS*

PHOTOGRAPHER UNKNOWN

There are exactly 629 men visible in this photograph of the crew of the USS *Texas* (BB-35). The ship's total crew complement was 1,052. This means that even for so carefully planned an event as this picture, a full one-third of the men were missing, either at their watch stations or enjoying time ashore during the relaxed days in port. The perfectly consistent dress and the ordered ranks, even while sitting on a fourteen-inch gun, contrast marvelously with the appearance of the shipyard crew in plate 68. Those civilian workers approach their group picture with the varied poses and expressions that the military grinds out of its members early on in their careers.

Commissioned in 1914 as part of a new fleet built to deal with the turmoil of the twentieth century, the *Texas* still survives, as a state memorial floating at San Jacinto. Five hundred seventy-three feet long, the ship could move her 27,000 tons at twenty-one knots, driven by a pair of 14,000-horsepower triple-expansion steam engines. The *Texas* was a new sort of battleship for her time, throwing off the archaic look of the Great White Fleet. She could lob her massive shells for miles to soften up an enemy shore in preparation for an invasion. She was modernized for the Second World War and pummeled the coast of France in 1944, when it was under German occupation. The *Texas* is about as big and heavy a ship as could be run with the reciprocating engines developed in the nineteenth century; the steam turbine had to be perfected before battleships could grow another step in size. The giants built for World War II were fully 300 feet longer than the *Texas,* and their turbines produced 212,000 shaft horsepower. The USS *Missouri,* upon whose deck the Japanese surrender was signed, displaced 45,000 tons, and could steam at thirty-three knots.

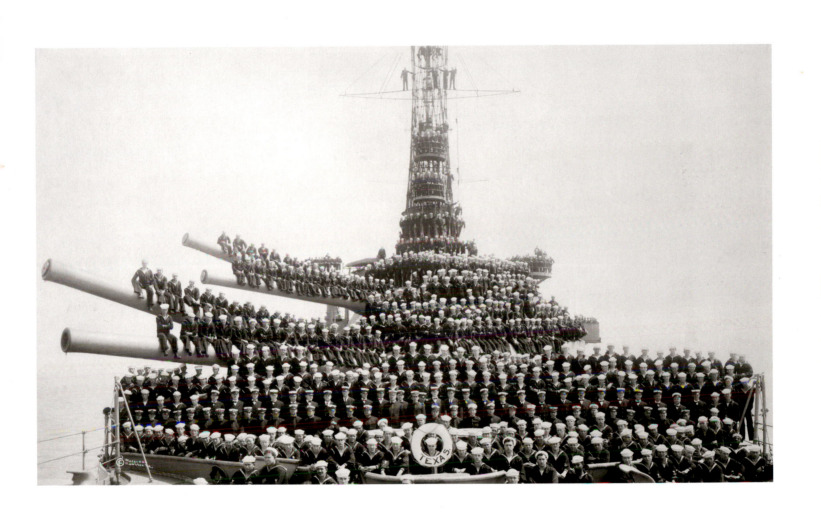

63

SOUND MUFFLING TRUNK

PHOTOGRAPHER UNKNOWN

This photograph is mysterious. Why would someone be blowing a bugle down a wooden box into the barrel of a twelve inch gun, and all this taking place on a naval ship, where public displays of humor were virtually unknown?

Maybe there is just an incredibly deep sleeper hiding away in the turret to avoid the morning muster, and this is his official wake-up call.

VIEW OF SOUND MUFFLING TRUNK AT MOUTH OF LEFT 12" GUN, FORWARD TURRET ON THE U.S.S. CONNECTICUT. DEC 21, 1916.

FIRST WING PANEL MADE BY GIRLS
PHOTOGRAPHER UNKNOWN

The title of this photograph is very carefully typed on the back of the original print in the Museum's collection. It could easily have been changed to the more appropriate "women," but this would alter the significance of the picture, which presages such sweeping change in our society. "Girls" was a common word in 1918, a holdover from earlier times when men ruled by muscle power and women kept to the home and hearth, doing the real work. The twentieth century has finally started to alter this state of affairs, and here we can see a beginning of the change in a wartime Philadelphia factory. The wing panel is a beautifully made thing, with metal struts, tensioned cable diagonals, and smooth wooden outer surfaces. It has been carefully engineered, and perhaps there was some idea that women could produce such a delicate and precise object better than men. Whether they ended up in industry because of a notion like this, or simply due to a lack of male labor, women began to find openings in American factories around this time, and much of our country has been constructed by them ever since.

The rectangular bricks of the wall and the similarly shaped lights of the factory's glass windows are reminders of how much the right angle has served us in manufacturing. It is as though the ruler and drawing board tended to design only geometric forms. One striking aspect of this picture is how differently the human beings are shaped than the things that surround them. The photograph is almost a perfect gridwork of lines, and the living creatures that have created this Euclidean world stand out as oddly shaped, non-idealized strangers. The wing panel is really quite primitive, because in plan view it too would be completely rectilinear. Within ten years engineers would understand that successful flying machinery needed less of the right angle and more of the sort of complex curved forms that characterize the organic world. The photograph foreshadows this watershed as well: industry was coming to realize that the form of its creations could no longer be determined by the nature of convenient materials at hand, nor hide within old and comfortable patterns of design.

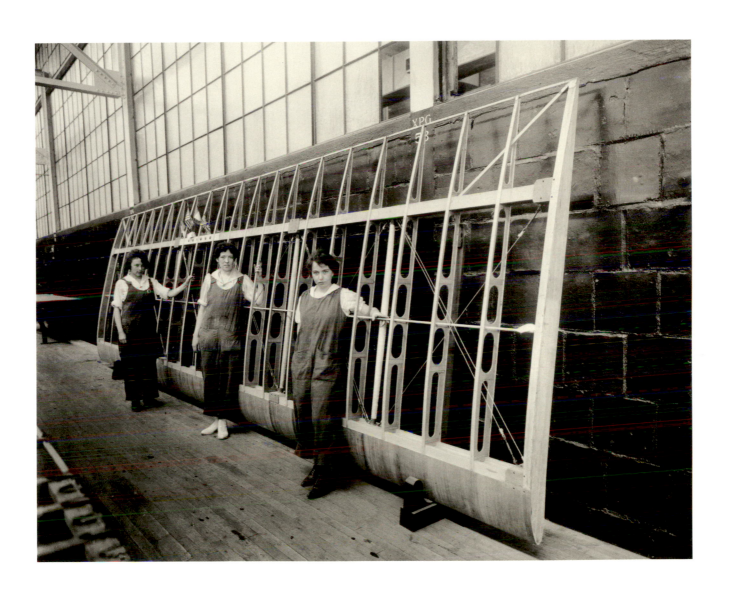

CHANGING PILOT OF OBSERVATION BALLOON
PHOTOGRAPHER UNKNOWN

This photograph is unclear and beaten up—qualities which speak of advanced age in pictures as well as people. The stuff in the photograph is also old; we are witnessing the transfer of personnel from a ship to a towed observation balloon, and these large but unpowered gas bags haven't been used much since the Battle of Britain. We also know this photograph is old because this sort of blatantly dangerous activity isn't allowed anymore. The man being swung out over the sea, hanging there from the thin cable and looking as though his life depends on an extraordinary feat of strength, is obviously in great danger. He is actually nestled in a canvas sling, what sailors call a bosun's chair, but the coincidental position of his arms makes it appear that he has no support other than his grip.

Sailors in Mother America's Navy simply don't do this anymore. Over the years there have been too many letters from irate legislators, instigated by bereaved constituents, complaining about the death and destruction that the old military life handed out. It is as though the mentality that believes that the worker need not be consumed by his or her job has infiltrated the military world and tried to set up controls to keep the common soldier safe. This works a bit during peacetime, but falls apart completely during war. Then risk and destruction are the daily lot, and lives are lost with shocking frequency. In the case we see here, the balloon holds observers who protect the ship and her fleet through their high and all-seeing station. If a huge risk was undertaken in this enterprise, then the risk—to one or two individuals—was minor compared to the dangers that could be avoided through the power of their observations. A simple formula, balancing a couple of lives on one side to a much larger group on the other, dictated that these men hang out over the water, from the swinging lines and slings, risking their lives daily so their comrades at arms could be better protected. This sort of coldhearted but clear and accurate weighing of human life appalls us today, when we have adopted the historically untenable notion that the individual life might be worth preserving at any cost to the greater social body.

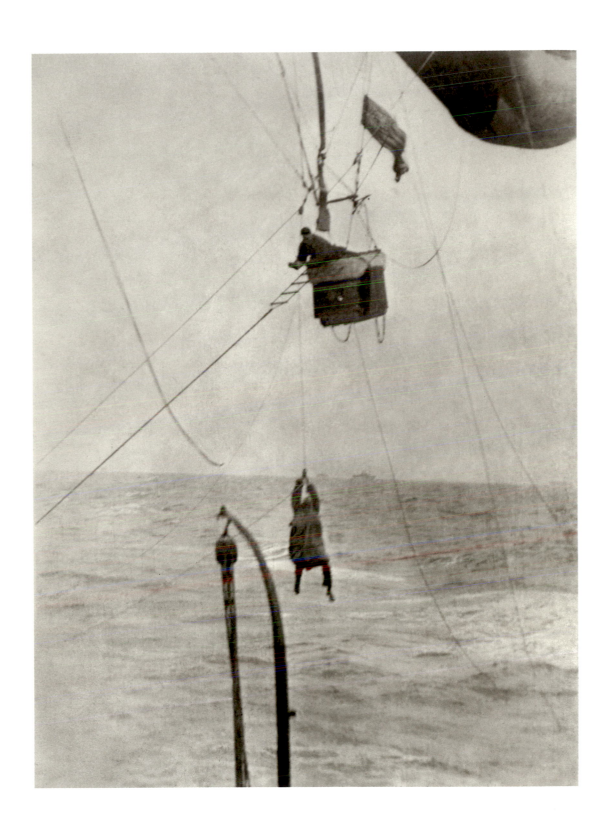

FIRE ROOM CREW, USS *NORTH DAKOTA*

H.C. MANN American 1866–1926

The engine room crew of a naval ship was called the "black gang," and we can see why in this picture. The coal that fed the boilers spread its blackness everywhere, coating clothes and skin alike. The dust gathered around a person's nose and mouth as air moved there, and the amount we see on the skin of these men is an indication of the extraordinary ability of the human body to handle such pollution and still survive. Much of the dust inhaled through the nose ends up caught there, to be blown out later in the day onto a handkerchief that becomes as black as the coal itself. If breathed in through the mouth, the choking dust heads for the lungs, and the remarkable cleaning apparatus of the body does its best to eliminate it.

A respiring human breathes to get oxygen and eats to obtain solid fuel, and the boiler is fed as well, taking in coal and air for combustion and water for steam. There is a cleaning problem in the boiler also, as burned coal produces ash which must be removed from the fire grates, and boiled water leaves behind a tough sediment of dissolved chemicals that gradually choke the water-holding spaces. In the boiler's lifetime a vast amount of liquid water is pumped in but it leaves as pure steam; contamination in the entering water does not boil away, and so remains behind. This steadily accumulating scale has caused continual trouble in the steam world, since it occurs in hard-to-get-at places inside the boiler and interferes with the necessary transmission of heat through the steel walls separating fire from water.

The black gang is under the direction of the suspiciously clean young officer standing second from the left in this group portrait. He is one of nine people in this photograph, and this ratio approximates the relative numbers of officers and men on a ship such as this. The ruling officer class, each member of which operated under commission from the President, had at least as tough a job as the enlisted men. We can be sure that a bit earlier the young ensign would have looked as exhausted as the men who surround him, but for purposes of the photograph he had to clean up and put on a fitting appearance to represent his service and station in society.

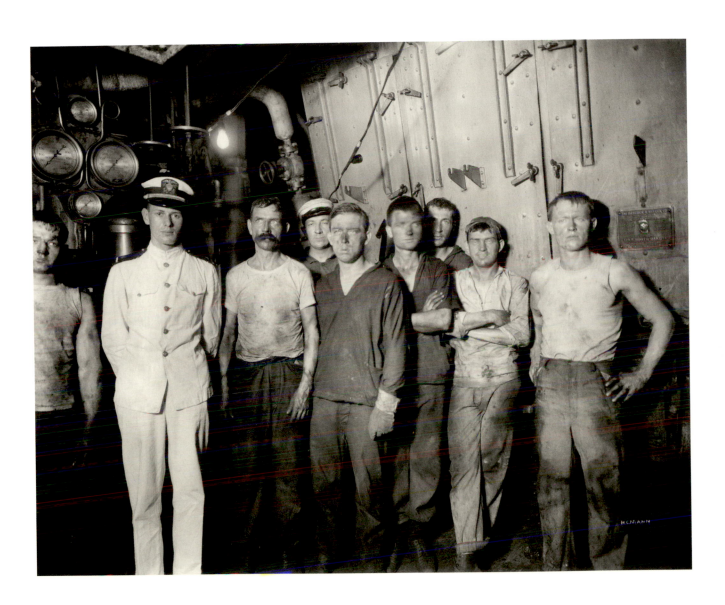

67

THE USS *SHAW* AFTER COLLISION

PHOTOGRAPHER UNKNOWN

When a ship of a few hundred tons is underway, its inertia, or tendency to keep moving, is huge. If a collision happens at sea, and one or both of the vessels are moving at a good clip, then the damage can be horrifying. This destroyer, the USS *Shaw*, displaced 1,100 tons and had a design speed of 29.5 knots. She was one of the famous four-stack destroyers, a type that worked in both world wars. She probably wasn't traveling at full speed when the collision occurred, but must have been going along fairly fast. When the tip of the bow touched the HMS *Acquitania*, a British passenger liner, the massive *Shaw* was unaware of the contact, and simply continued to move forward. Gradually the inertia of the entire destroyer was absorbed by the structure of both boats; we have no view of the liner afterwards, but it is clear that the *Shaw* shortened herself by at least 80 of her 315 feet.

The USS *Shaw* didn't sink because she was divided into a number of interior compartments separated by watertight doors. These passages are open in times of safety and closed when a ship is in the presence of danger, such as anticipating battle or moving through a foggy sea. If the hull is breached and water pours in, the ship is kept afloat by the compartments that remain watertight, as long as they possess enough buoyancy to support the entire ship. One flaw in the tragic *Titanic* was that the bulkheads which divided her into compartments did not reach all the way to her upper decks, and as the ship settled into the Atlantic the icy water in the damaged compartments simply poured over the bulkhead tops and filled the next space, and then the next, until she sank.

When ships were made of wood they had a more casual relationship to the water than modern steel boats; the watertight bulkhead was developed for iron and steel ships. A wooden boat can be breached in an accident and water can pour in, but she is, after all, made of wood. Although the total weight of most wooden ships will cause them to sink when filled with water, they have the nice habit of sinking less rapidly as they settle because the natural buoyancy of their material becomes a factor in their flotation. In the days of sail many a lumber carrier ran into trouble and limped home floating on her load. Those carrying sand or paving blocks went down like the proverbial stone.

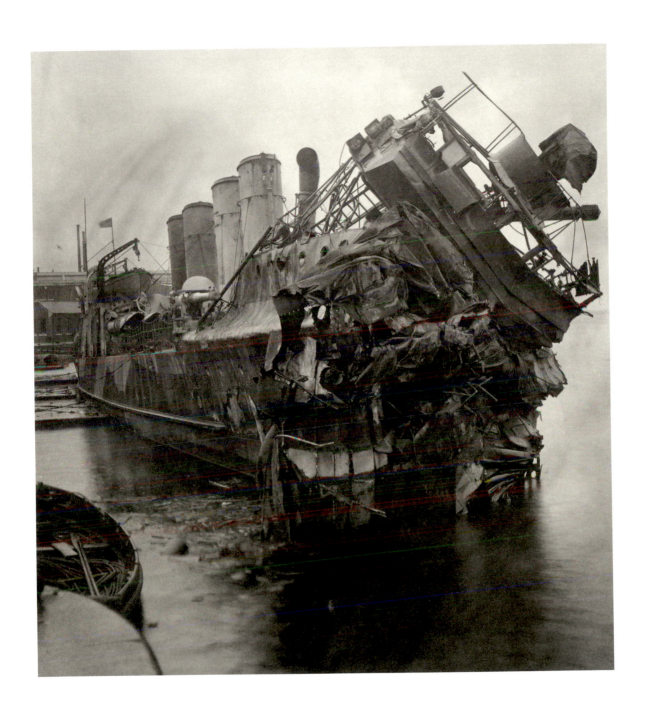

68

SHIPYARD WORKERS, SUPERIOR, WISCONSIN

DAVID BARRY American 1854–1934

———————————

The ship the men have built is large and orderly as she sits behind them for this group portrait. Her smooth plates and painted surfaces have come out of mines and foundries, and she has been assembled and beaten into shape according to plans made in lighted lofts by banks of draftsmen, working each on a piece to design this complex marine craft. The men we see, who built her, have spent their lives together working at this shipyard, knowing each other well, seeing each individual in the context of their own shared history, and accepting each other's faults and strengths so their cooperative life can be healthy, long, and rewarding.

Men have always found projects to do as a group. These have been activities like war, hunting, exploring, or building. The male half of humanity loves its own company, and has always formed a tight club from which women often have been excluded. These men probably came to the shipyard in the morning, around 7:00 A.M., and worked until at least 6:00 P.M. This went on for six days a week, with only Sundays left for rest and family duties. At night the men would be exhausted (or at least pretend to be) and fall into bed after the shortest possible time spent with their families. If we add up the hours spent at work, asleep, and with wives and children, we can see that time at the shipyard formed the largest portion of their lives.

The men come in all types: short and tall, young and old, tough and meek. At the shipyard they have learned to be universal mechanics who can work at many jobs and operate under varying conditions, according to the different ships being made or the immediate task to be done. Craftsmen of this sort, with their general knowledge and capacity to tackle varying problems, were the norm in America when the assembly line started to appear in the giant automobile factories of Detroit. There, the demands on the worker were different; the tasks became repetitive as each person was limited to a small part of the overall job that had to be done exactly the same way time after time in a numbing pattern driven by the fixed pace of the moving line. The children of our workers in this picture, pursuing a similar life to that of their fathers, often ended up in these new, impersonal factories, where the pay was good but the rich shared life we see here was absent. The well-rounded workmen, bred by generations of complex achievement, were like the old and irreplaceable growth of trees that covered America when Europeans came: once cut down, whether by the saws of the Industrial Revolution or the deadening life of mass production in a factory, these great national assets were gone forever.

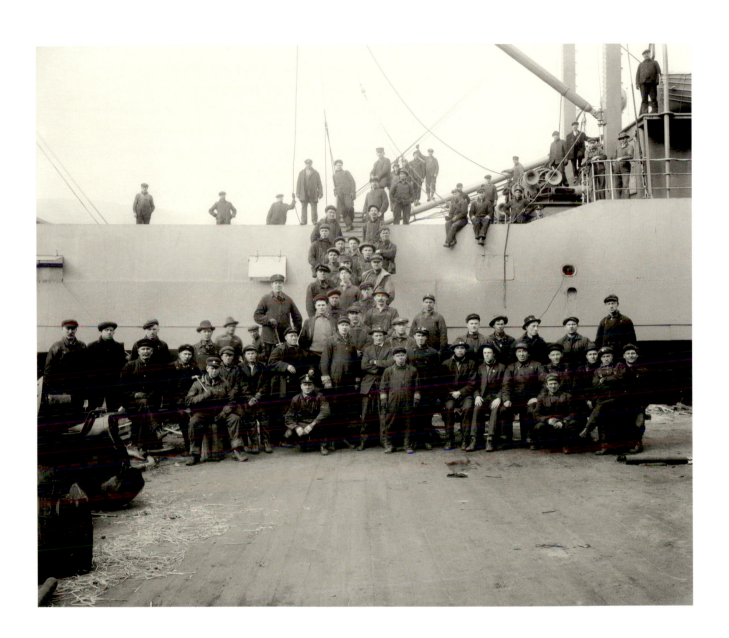

THE USS *GEORGE WASHINGTON*

EDWIN LEVICK British 1869–1929

The copper lady stands in the background facing out to sea, and the fruits of her liberty scurry about on the harbor surface, running every which way on their varied tasks. The freedom that she represents is all tied up in notions of equality, and when we are enthusiastic about America we must be careful not to jumble these two great principles together. We are not all created equal, and the national principle Americans cherish is really one of equal opportunity. It is likewise true that we only have limited freedoms, carefully worked out to ensure that we can all live together with relative degrees of contentment. Equality and freedom are rights given under law, and what they do is allow any activity, and even any ideas, to exist as long as this system of laws is followed. The American Constitution is very precise on this point, and one of the revelations of reading it is that so much is left out—which is the only way to be truly open-minded. The founders understood that the more they dictated, the less freedom and equality would thrive.

The most vital outgrowth of the principles of our country has been capitalism. It shows up nowhere in the Constitution, because the ideas of labor, commerce, and profit do not encroach on fundamental liberty. Each tug, barge, and ship in this picture is a capitalistic structure, created and made alive by the basic notion of money being exchanged for work and goods, and wealth being allowed to accumulate in the hands of those who cleverly utilize the system of laws by which we have agreed to live. Capitalism rewards excellence on the part of those who embrace it, but it gets a bad rap because it is genuinely heartless in its connection to the law.

Each boat in the picture is a concentration of financial power. Substantial investments were made, at great risk, to build every one, and the crews and land-based workers who run them each extract a living from this carefully ordered structure we see in New York Harbor. The large ship carries President Wilson, returning in triumph from his time at the Paris Peace Conference. She was originally a German luxury liner taking refuge in New York when World War I broke out. Seized by government decree, she was painted gray and used as a troop ship through the war, continuing in this new role until the end of the Second World War when she burned and was finally scrapped. A ship such as this can have a life as brief as that of the *Titanic*, sunk on her maiden voyage, or a long and useful one like the *George Washington*, if she can successfully negotiate the perils of life at sea. Little is predictable when we leave solid ground.

THE LAST FAREWELL

W. R. BOMBERGER

The odd-looking ship receiving the wave is the *Nautilus,* skippered by the explorer Sir Hubert Wilkins. This submarine started out as *O12,* a United States Navy torpedo ship built in 1916 by the same Simon Lake who had earlier created the wheeled monster of plate 37. When the London Naval Treaty was signed in 1930, armament had to be cut severely. The U.S. government mustered out the *O12* as surplus, and sold her to Wilkins for one dollar. He took the old boat to Lake's shipyard in Bridgeport, Connecticut, and had her modified for exploration under the Arctic ice cap. The strange profile *Nautilus* presents is due to a reverse sheer built onto her deck that Wilkins thought would allow the submarine to work under the ice with no danger of getting caught in the rough underside of the floating pack.

The entire expedition was troubled; it was a near miracle that the ship made it across the Atlantic. She had to be extensively repaired in Europe before heading to Norway (and more repairs), and thence on up to the edge of the polar ice. Once there, the submarine refused to dive properly and was only able to submerge by using a frightfully dangerous running start that allowed her to get below the surface.

Before the expedition, scholars generally believed that the mass of ice at the pole was deep, reaching down into the sea in the same way that a northern iceberg does. However, Wilkins theorized that the continually changing ice of the Arctic Ocean never got much thicker than fifteen feet. In its few brief dives, *Nautilus* explored the green gleaming undersea, confirming Wilkin's theory of a shallow floating polar cap. The ship then headed south, barely managing to bring her crew back alive. Once they were safe she was scuttled in a Norwegian fiord, having been deemed not even worth taking back to the States.

This *Nautilus* was named after the one imagined by Jules Verne. A later *Nautilus,* famed as the Navy's first atomic-powered ship, emulated both Captain Nemo's magically powered submarine and Wilkins' vessel of exploration. Freed from the need for air to run internal combustion engines, the atomic *Nautilus* went under the ice as well, and even reached the Pole itself, surfacing through the thin icepack to enable its crew to plant a flag in the spinning no man's land of the North.

"The Last Farewell"

PORT OF NEW YORK

MAJOR KEITH HAMILTON MAXWELL

This is a view of the southern tip of Manhattan Island, made far up in the air on a calm, smog-free day. If we look into the left background there is a large ocean liner just visible, tied to the west-side piers that were the landing point for passenger ships from around the world. In the lower foreground are the ferry terminals that even today handle thousands of daily commuters, allowing them the brief respite of a boat trip each morning on the way to work. When this photograph was made, New York was the greatest shipping port in the world, but the warehouses and piers had long since moved over to the Brooklyn and Jersey shores. What we see in the picture's center is the financial district, from which the city ran much of the world's commerce during the first part of the twentieth century.

The occasional wisps of steam coming from the tops of some buildings indicate that the United States still had not built the monolithic electrical system that unifies the country today. While these buildings were all steam heated by coal-fired boilers, many also had their own generating plants to supply electricity for elevators, lights, and ventilation. Smoke from a coal fire is black but steam shows up pure white; both the little tug in the lower right corner and the buildings in the center betray their boilers with the pale plumes of this versatile nineteenth century gas.

A great building boom in the 1930s culminated in the Empire State Building, erected on the corner of 34th Street and Fifth Avenue. This structure would just be visible on the right if our picture had been made a few years later. There was another real estate expansion in the late 1970s and 1980s, when the World Trade Center was built; these huge buildings would shoot up in the middle background and go straight to the top of the picture's frame if our photograph had been made after that time. Instead, what we see here is the first great barna-clelike growth of the original financial district, home to Wall Street and the New York Stock Exchange, and corporate headquarters like the Woolworth Building, standing taller than anything else in the picture.

Most buildings, and even entire cities, sit on the Earth in the same way lichen covers a rock; they don't stand up very high, but instead rest on the surface with hardly more effect than a discoloration. Manhattan is a monolithic hunk of rock, and so the builders there, swept up in the grandeur of their powerful city, could go upward and safely make this intricate masonry outburst. The rock of the island could be depended upon not to move, and also the level of the sea was stable enough that low-lying parks, with concrete walks and shade trees, could be built just a few feet above the water's surface. Despite the occasional hurricane or blizzard, the planet is quite calm and stable in our human time frame, and it lets us build a complex but delicate city such as this right on the brink of the sea that gives it life.

RUNABOUT *RASCAL*

EDWIN LEVICK British 1869–1929

This speeding runabout of the 1920's has the knifelike sharpness that characterized these refined and specialized pleasure boats. The *Rascal* was built to contend in the Gold Cup, a prestigious race that is the Kentucky Derby of the speedboat world. The idea that a boat can move through the water with ease if it is long and narrow is accurate, but the reasons that boats move well at certain speeds is no simple matter of slicing the waves apart with a cutting stem. Traditional boats sit down in the water to a degree that reflects their displacement and hull shape; in order to move, they must in turn move the water that supports them.

From the start of boatbuilding it became apparent that longer boats could move faster than shorter ones, and gradually the concept of hull speed came about. There is a formula that roughly equates length with speed, because a boat makes its own wave out of the water it moves, and the length of this wave, crest to crest, is a direct function of the length of the hull that produces it. The laws of fluid motion dictate that a wave moves faster as its length increases, and so a large ship, with its correspondingly longer wave, can move through the water more quickly than a short boat and its slower accompanying sea. Hull speed assumes that a boat is driven by normal means and that it remains imbedded in the water at its normal displacement. While the formula dictates that a thirty-foot craft might have a hull speed of about eight knots, it admits that a boat could be driven at faster speeds, but only with large excesses of power and turbulent disruption of the water through which the boat moves.

Our runabout is clearly exceeding the hull speed assigned to a vessel of this length, and this is because the boat is no longer operating as a displacement hull. Instead it is flying across the water's surface in the same way that a skipped stone can glide from crest to crest across small waves lining the shore. As soon as we push the boat hard enough, and have a hull that can rise up and "plane" across the surface, we can break through the restrictions of hull speed and all limits are off in the pursuit of exhilarating travel. The *Rascal* looks like a normal displacement boat, but a kick from her powerful gas engines could lift her above the water and she would then reveal herself as the refined racing machine that she really was.

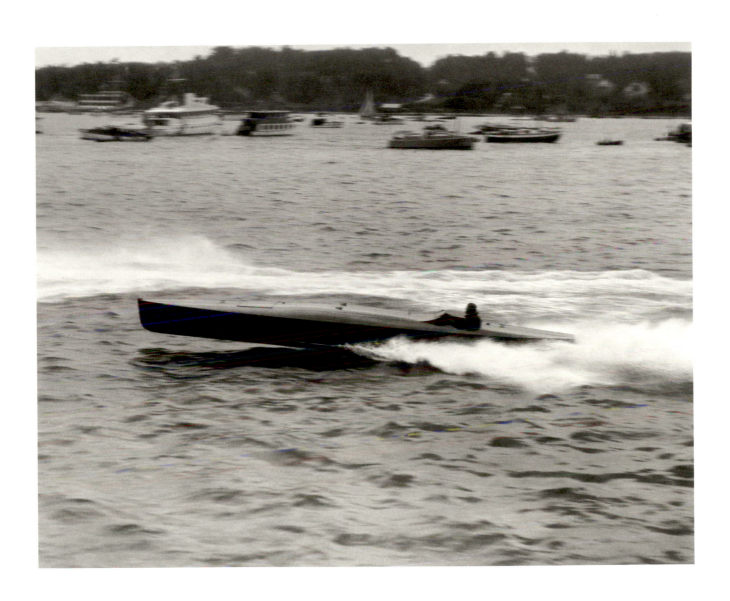

BOMBING OF THE USS *ALABAMA*

PHOTOGRAPHER UNKNOWN

The *Alabama* served her nation well even though she never actually went to war. The vast military machines try to keep themselves busy in peacetime, and much exercising and threatening go on when no one is fighting; this ship spent her whole life thus employed. The *Alabama* lived through World War I, sailing in the Atlantic fleet as a flagship and trainer. It seems that she never fired a shot in anger through her thirty-six year life span. In 1921 she was pressed into service as a practice bomb target, and this perfect picture shows the downward flash of an explosion, enhanced by phosphorus for visibility, shrouding the massive battleship while the fragile yet all-powerful aircraft that has just dropped the bomb flies away with impunity.

It took the military some time to accept that the airborne bomb would be effective in battle. Guns traditionally hurled shells, and for some time these missiles had been made explosive, so they weren't just a refinement of a thrown rock, but carried real destructive power. The bomb, however, was a new thing, because it could be massive and made of pure explosive. The aircraft, cheap and expendable, could take huge risks to drop its deadly load, because many, many planes could be built and operated for the same cost as a single large ship. Lots of smart people pushed the intransigent military minds to accept this, and the political maneuvering that preceded this test must have been as dense as any that takes place in the Pentagon today.

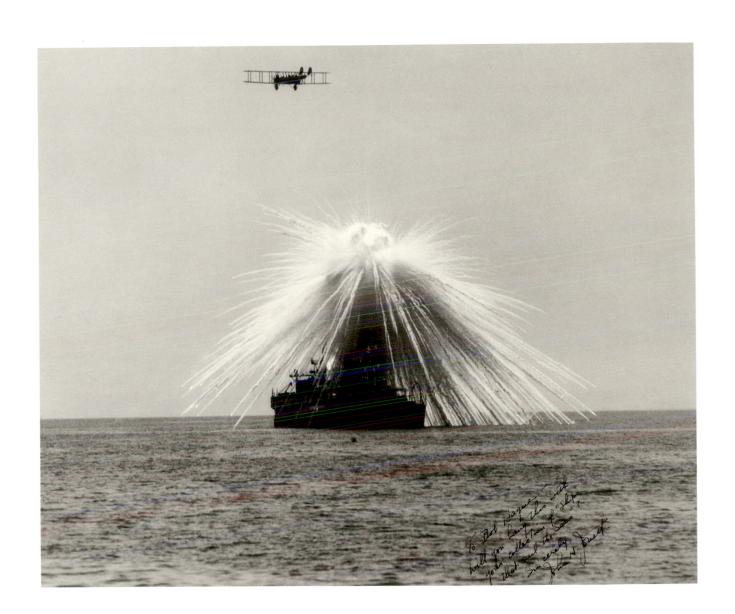

To Bob Hogue

will you have this with
your collection of "ships
that seed the sea"?
Sincerely Frank ___ Brett

SHAMROCK AND RESOLUTE

EDWIN LEVICK British 1869–1929

The America's Cup is the supreme event in the yachting world. It began in 1851 when the United States yacht *America* sailed across the Atlantic to participate in a prestigious race around the Isle of Wight. She won the contest handily and began an escalating competition that brought out the best and most expensive string of sailing yachts ever made. All through the balance of the nineteenth century and up to 1986 this set of match races, run at irregular intervals, was dominated by the United States defending the Cup on its home shores. Britain never won the ugly mug back. When the United States finally lost, it was to Australia, a relatively young and vibrant country, which snookered the staid Americans by building a better boat and sailing her to perfection off Newport, Rhode Island. The brash Australians took the Cup in just the same way the upstart Americans had first gotten it from tired old England more than one hundred years earlier.

One of the grandest competitors for the Cup was Sir Thomas Lipton of tea fame, who mounted five successive challenges, each one based on a new and more refined sailing yacht. The Americans insisted that the challenger sail across the Atlantic, as the *America* had done, and so these huge impractical yachts put on a shortened rig and came over here on their own bottoms, to be refitted with racing spars and sails. *Shamrock IV,* which we see here racing against the American *Resolute,* sailed over in 1914, but was laid up on a cradle through World War I; the races were not held until 1920. During her years on the beach this elegant sloop became hogged, sagging at her bow and stern, and in the photograph we can see some of this droop when we compare the lines of her dark hull to those of the American entry.

Hundreds of thousands of photographs exist from this golden age of yachting, yet few show such a streak of magical light as this one, taken during a race for the Cup off the shores of New York. The boats sit like flawless models on an ideal sea, with light sliding across the taut cloth triangles. The heat of passionate sportsmen and the power of immense piles of money are invisible here, as photography once more rolls out its own seductive version of the truth.

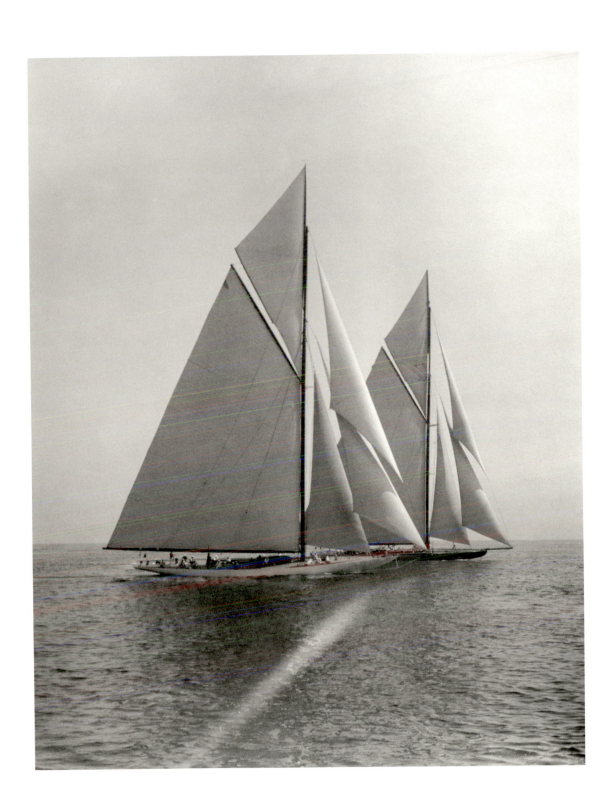

VADIM MAKAROFF AT THE WHEEL OF *VAMARIE*

EDWIN LEVICK AND SONS active 1909–1940

This certainly appears to be a happy man, sailing his yacht on a sunny afternoon. We have to be careful, though, since photography can, and often does, deceive us when we least expect it. The smile could have been put on just for the picture, worn by Vadim so a memory of him as a content man would remain long after his more complex reality had passed on.

Marine society had long possessed a working class made up of the multifaceted crews, and a ruling class made up of the officers who directed them. These two interdependent groups remained separate, but they lived and worked on the ships together; if disaster happened, death by drowning came to both. The yacht changed all this. Wealth, and a love of the sea unhampered by the grim realities of a working life there, led to elegant boats built with great care and beauty. We see all the evidence of this in our photograph: the polished brass binnacle with its immaculate glass panels, the fresh varnish that reflects the helmsman's face, and even the marvelous linen coat he wears, pressed to white perfection. Vadim was the son of a famous nineteenth-century Russian admiral, and somehow his family managed to smuggle their financial heritage out of collapsing Czarist Russia so this child of the upper class could live a fitting life in the young haven of the United States.

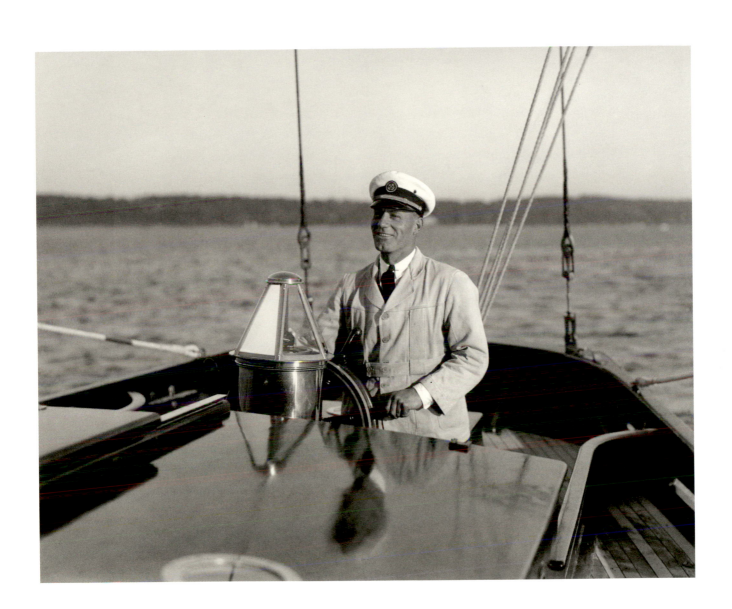

NINETEEN-FOOT CHRIS-CRAFT RACER

PHOTOGRAPHER UNKNOWN

Muscled young men and fashionably made-up women have been the stock in trade of advertising pictures for as long as such photographs have been made. This picture was taken for selling speedboats, but the thirties were a new time; instead of the woman being a passive figure in the ad, just leaning back in the seat, she could now be given the wheel and not look out of place driving the boat. The wheel could just as well be on an automobile, and the Chris-Craft Company probably designed it to look like that from some fancy car. The boat is clearly screaming along, humming from the smoothly balanced gasoline engine that spins the perfectly tuned propeller, and she skims over the enclosed inlet whose barrier island we see in the background. The boat takes the new pleasure of the speeding automobile and transfers it to the leisure realm of the seaside. As women drove more and more of the cars, it finally dawned on men that they might just be capable of driving and enjoying a fancy runabout.

Even today ads show a depressingly large number of inactive women, and precious few like this person who wheels the Chris-Craft around the bay. This is true of male models as well, who tend to be unshaven, with slightly too much clenched jaw, standing around trying to look intelligent, athletic, and sexy all at the same time. Still, the models are posed this way, and statistics indicate that many products are sold when promoted in such manner. We probably shouldn't draw any conclusions based on anything that comes from the world of advertising, but the presence of a speeding female driver in this picture is most likely an indication that ancient sex roles were starting to break down in those turbulent times when the picture was made.

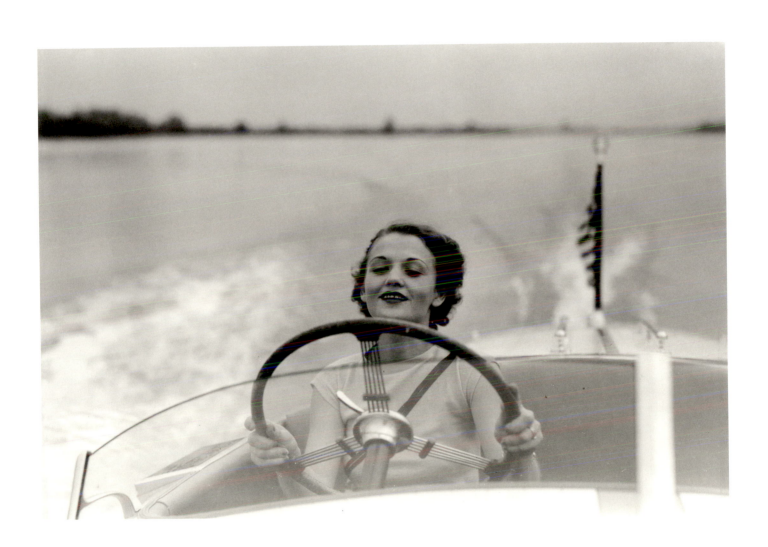

BOSUN EARL WARREN MAKING A FENDER

WILLIAM T. RADCLIFFE American 1913–1997

Like a mad sausage maker, Bosun Warren pauses to survey his newest creation. Of course it isn't sausage but rope, and it's not some giant pudding but instead a bow fender for a harbor tug, maybe even one destined to nudge the great liners of the 1930s into the piers on New York's Hudson River. Tugboats had sharp steel noses, and from their invention at the start of the steam era they needed cushioning so this prow could ease up to a massive hull and then apply tremendous pressure to direct the seagoing ships to their docks in crowded harbors.

The line looks like sausage because the bosun has had to unravel it to make his fender. Rope consists of many fine strands, which gain strength and become workable only when they are tightly bound together. In some lines the individual strands are actually wrapped into a larger entity; the most familiar of these are the giant cables that span suspension bridges. Most line, however, is made by twisting a bundle of fibers and locking the threads together by the force of this rotation. This twisting ensures that there is much friction between the sides of the fibers as they press against each other, and this contact is what really makes up the accumulated strength of the line itself. The intimate connection thus produced also allows the tiny fibers to be short, and in a random fashion the short pieces are able to sustain their share of the overall load through contact with adjacent bits of yarn. Common rope has three such bundles, and it is finished with a second twisting that creates the spiral form we associate with ordinary line.

Today these fenders are still made in shipyards and in the slack hours on the broad and sunny afterdecks of tugs. But while the one pictured here has a chain and rope core, modern ones can have the tough cushioning of rubber hidden in their center. This particular example is quite special, though, because the beard of a tugboat is traditionally made out of junk line, short bits that are no longer useful as hawser; here, however, we see brand new line being sacrificed to the fender. Some of this line has been unraveled, as the rippling strands hanging down the center show, but much of it is in the form of fresh bundles of strands that have never before been twisted into finished line. These hang limp and straight, whether from the sides of the fender or the bosun's able hands. This must be a very special construction, to be made of such expensive stuff, probably destined for a new and splendid tug that must make her owners proud as she slips down the ways to a hard working life.

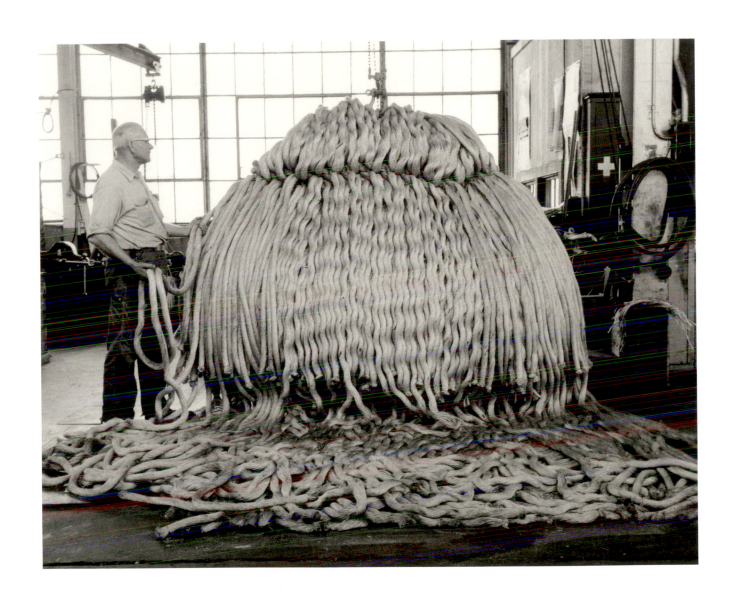

UNLOADING SULFUR

EDWIN LEVICK British 1869–1929

The material being unloaded is sulfur, and if this photograph were in color then there would be a brilliant yellow streak running through the picture's center. A haze of this color would also hang in a cloud around the unloading cargo, and patches would be visible on the shoulders of the man operating the conveyor that brings the powder up from the freighter's hold. Nowadays such casualness around a chemical load would never be permitted, and everyone in the picture would be wearing respirators, but this photograph was made during the 1930s, when the destructiveness of concentrated chemicals was not recognized. If the men who breathe the sulfur will suffer from its effects, they are not alone, because the man walking in the foreground, slightly bent and showing gnarled hands, has the unmistakable look of someone beaten up by his job as well. He probably shifts the piled hatch covers upon which the foreman, decked out in hat and tie, stands.

This picture shows a dirty and difficult job being done on a fine sunny day in the harbor, far from the sea that dictates the high sides of the cargo ship, or from the rainy days to come that are anticipated by the water gutters that fit between the loose hatch covers on the lighter receiving its load. The labor is done by men, and the men are changed and affected deeply by the work they do. All of us work in one way or another, and a central fact of the human being is that any work changes the creature. Sometimes we call this change education, at other times experience; whatever we name it, the passage we make through any action leaves its mark upon us, and that modification prepares us for the same activity in the future. If our endeavors are chiefly intellectual, then the reshaping happens to our minds, but if our labor is physical, then our bodies accommodate to the change. We speak of old people being worn out by strenuous lives, and this can be true; everyone grows old, and a life of ease produces a different person at the end than does one of stress and strain.

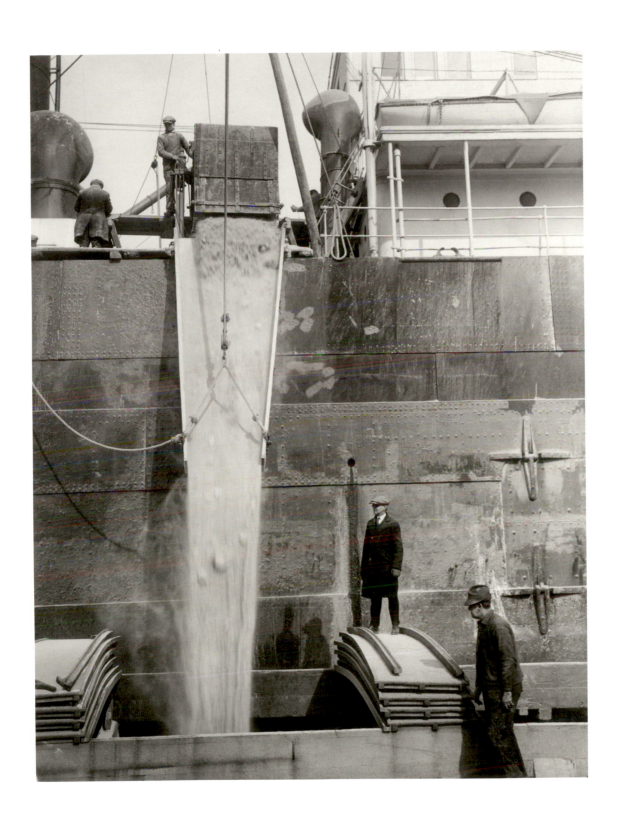

BARGE IN HIGH WIND

EDWIN LEVICK AND SONS active 1909–1940

The backdrop for this picture is a windy harbor where the stiff breeze kicks up a short chop and forces the vessels against the lee shore of their dock. The three-masted coaster is a beauty, and her sheer line curving smoothly from stern to stem is as perfectly formed as on the day of her launching. Even though she is in great shape, sitting high up out of the water with her rig intact and properly furled for the blow, this schooner is old and starting to outlive her era. The half-swamped barge, with its mysterious load stacked up on deck, is from the new age, when powered harbor tugs were available to push or pull cargo from one spot to another. The barge is having a rough go of it, and she must already be floating on her buoyant load, even as it starts to dissolve despite the ministrations of the man working on the slippery surface.

Before the steam years, nearly all boats had to carry their own source of power. Once we had engines that could defy wind and tide, the barge developed. These workboats needed to float, have the maximum volume possible (no pointed ends here), be built strongly enough to hold a load, and be capable of withstanding the stress of being slowly pushed around. Many of them had a small house astern, as in this example, with a tin chimney serving an iron stove that kept the crew comfortable during cold weather.

Barges carried huge volumes of cargo, and even today, where the water highways are long and broad, they are the most efficient means of moving bulk material. Around harbors the barge population is usually old, and today barges occupy the same position in time that the coaster does in this picture. Roads appeared with advancing technology, and before too long the brief age of the harbor barge was fading. Large freighters and tankers, like the coal-carrying railroads, still serve us for the long hauls, but the efficient truck handles virtually all short-distance movement of goods today.

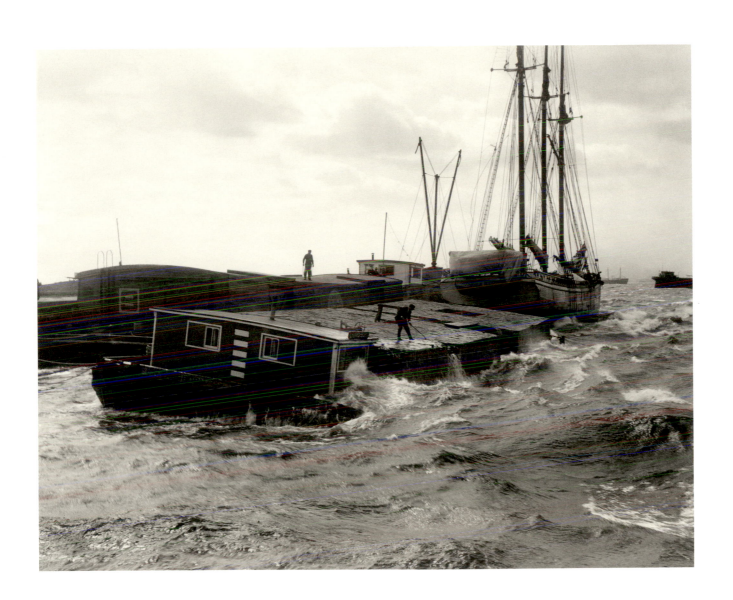

ROMA DISASTER
PHOTOGRAPHER UNKNOWN

These burned and twisted girders are the remains of the semi-rigid airship *Roma,* which struck high tension wires in Virginia in 1922 and crashed with the loss of thirty-four people. Today our experience with lighter-than-air craft is confined to televised sports events, where a blimp has materialized carrying a camera far overhead, or to hot air balloons silently lifting up on perfect calm mornings to drift across the landscape. The huge gas-filled vessels of an earlier time were actually the first powered ships of the sky, and many years before heavier-than-air flight was possible, the dirigible was taking off and landing at will.

The relationship of an airship to the atmosphere is similar to that of the fish to the sea. We call them "ships" out of a recognition that they float, but they behave more like submarines than surface vessels. Some early types even controlled their altitude in the fluid air by the use of a gas bag that could change volume. This is similar to the mechanism in fish having an internal swim bladder, which allows the animal to remain buoyant in the water through which it swims. The airship could be rigid, with an immense but lightweight frame that held individual gas cells, or non-rigid, which is the class of our modern little balloon-like blimps. The *Roma,* an in-between type, had a keel and frame but kept some of the flexibility of the pressure-formed blimp. Because they were huge and relatively slow, these giant craft were imbedded in the air in which they floated, and the roughly fifty years of their era were marked by a string of crashes resulting from loss of control over the lumbering creatures. The most dramatic of these impacts with the ground was probably that of the *Italia.* Returning from the North Pole in 1928, the *Italia* fell onto the ice, broke up, and then lifted off again to carry some of her men to their death many miles from the site where the captain, a few crew members, and the ship's dog were initially dumped out.

Airships of the pre-World War II era suffered from the additional problem of being filled with hydrogen. Modern blimps, filled with inert helium gas, can fly through lightning and electrical disturbances with impunity, but hydrogen is always ready to explode when around oxygen, and the slightest spark could start this runaway reaction. In 1937 the giant *Hindenberg,* 800 feet long and containing over seven million cubic feet of gas, blew up at Lakehurst, New Jersey—a tragedy that marked the practical end of these ocean liners of the sky.

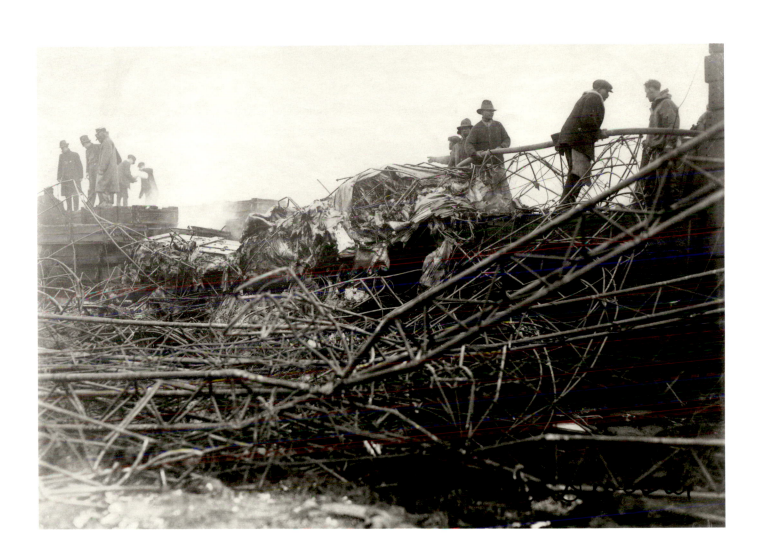

COLEMAN'S TATTOO PARLOR

WILLIAM T. RADCLIFFE American 1913–1997

Thirty thousand years ago there were no people in North or South America, but by 5000 B.C. both continents were home to well-established cultures. These people appear to have come to the Americas over a land bridge that connected Asia and Alaska during the last Ice Age, when sea levels were lower. After this migration no one else ever came to the Western Hemisphere by land; instead, all the newcomers arrived by water, bringing with them complex interwoven threads of behavior and experience. Sea travel led to a rapid intermixing of human populations, and the variations of appearance and culture that had grown up between diverse groups, through hundreds of thousands of years of isolation, began to be eliminated. Today we live in the midst of this homogenization, when old ideas of difference and superiority break down in the face of human genetic solidarity.

The gentleman in the photograph is clearly of European descent, but the patterns on his skin derive from islands in the Pacific. Coleman's Palace, where he is a customer (or perhaps even the proprietor), is located in Norfolk, Virginia, oceans away from both these places. Sailors went to exotic lands, and they brought back opened eyes and ink-stained hides, and the ancient practice of tattooing became inseparable from the culture of the sea. Prominently displayed in the window is a design for a full-rigged ship which could be permanently installed on the skin, along with dragons, the names of loved ones, pin-up girls, and wing-spread eagles, to proclaim our national predatory pride. Getting one of these pictures drawn was painful, but strong drink was a vital part of the sailor's life as well, and the two complemented each other perfectly. The tattoo held appeal because of the commitment implied by the permanence of the act; once the needle made its design, the marks were there forever. This sort of finality was consistent with life before the mast, where one slip in the rigging could have irreversible results as well.

There is a charming irony in this picture because the shop next to Coleman's is a rubber stamp business. Here are two different ways of making a design, both using ink, and both dependent upon soft and flexible materials: skin and rubber. At first glance, we think of the rubber stamp as one of the most transitory of forms and the tattoo as one of the most permanent. Yet the soft stamp of the human hand has created some of our oldest images, in carbon black on the walls of European caves, and what type of picture is more surely bound to a brief life than the tattoo in living flesh?

TUGS WORKING IN ICE

EDWIN LEVICK British 1869–1929

It is hard to resist the pair of carved eagles on the wheelhouses, or the spectacle of such a large ship being moved sideways through the water, but these are not the central subjects of this picture. Here, for the first time in our book, we can clearly see water in its three states of ice, liquid, and vapor.

Water is the thermal flywheel of our planet. Through seasonal cycles it takes up and releases vast quantities of heat, thereby giving stability to Earth's climate. If this common but remarkable material becomes too cold or too hot, it undergoes a physical change of state and becomes ice or steam accordingly. While liquid, water absorbs or releases heat in a smooth progression, and changes its temperature gradually; the unit of heat used to measure this is the British Thermal Unit, or BTU, and if we add or remove one BTU from a pound of water then it will rise or fall in temperature one degree Fahrenheit. If the changing temperature of the water reaches the point of freezing or boiling, however, then this relationship between heat and temperature is disrupted. The upcoming change of state can only happen if additional amounts of heat are brought into play.

As the temperature of water falls the water becomes denser, so that if a large mass is cooled it sinks, gradually forcing warm water up. This means no ice can form until all the water has reached the point of maximum density, which occurs at about 39 degrees F. Once this has happened, during the early months of winter, the surface water can resume its cooling, going down to 32 degrees F, which is the normal freezing point at sea level for fresh water. Once at 32 degrees, however, the water temperature stops falling even while the water continues to give up heat, and 143 BTUs must be released before a pound can become ice. Once ice forms, still at 32 degrees F, the thermal decline can continue.

This odd fact, of heat moving while temperature remains the same, happens during boiling as well, but for that change of state a full 970 BTUs must be added to convert a pound of water, at 212 degrees F, into a pound of steam. The steam carries energy in the form of the latent heat that has created it; this heat is what powers a steam engine. The conversion from liquid to gas in a ship's boiler puts the energy of the fire into this usable concentrated form, and the task of a successful engine is to remove this heat as work while keeping the steam in a gaseous state within the working cylinder of the powerplant.

Nature plays this game of changing state, with frozen polar caps and boiling geysers, but only since the Industrial Revolution have people done this as well. Refrigerators and spinning engines are our tiny playgrounds in the thermal game, and here in New York Harbor we see the waterborne boats, sustained by steam, overcoming the tough coating of ice produced by nature.

CLEANING THE *MAJESTIC*

EDWIN LEVICK British 1869–1929

The *Majestic* is getting cleaned up before a fresh paint job. She is moored in a Boston dry dock, confined to a narrow space where waves can't form and the painters can work in peace to clean and then re-blacken the hull so the white of her top will gleam in contrast as she is viewed by the public during harbor appearances. These ships were so huge — this one was the largest ship in the world for a while — that once launched, they were nearly impossible to pull back up out of the water. There had to be a way to get the beasts out of the water for maintenance, a purpose for which the graving dock was invented. These deep and thousand-foot-long hollows could be filled with water so a ship could be pulled into one; then a gate was floated across the open end to seal it off. The water could then be pumped out to allow the ship to settle down on carefully placed blocks laid out on the floor of the dock. The blocking had to be in exactly the right places, because the weight of the ship could only be supported by frames within the hull; if not properly positioned, the wooden supports would punch right through the ship's thin plating. All large vessels carry a blueprint of their blocking plan, so an emergency repair can be done anywhere in the world.

It could be that we are seeing a busy shipyard at work, and the cleaners and painters have already started their jobs while the ship slowly moves down during the five or six hour process of completely draining the compartment. There is an old joke about two people leaning on the rail of a liner at mid-ocean. One says "Just look at all that water," and the other replies "Yes, and to think that it's only the top." This is a constant truth about the sea and its ships. We really do only see the skin of the water, and forget that its unimaginable volume goes down to the sea floor. The *Majestic* stands in our picture sustained by an invisible mass of ship equal to what we see, which lies hidden from view below the surface. Once the dry dock is emptied, by huge pumps handling this immense volume of water, we would be able to see the whole ship out of her element, perched like a teetering sculpture on the tiny wooden blocks set beneath her rounded bottom.

This picture is especially enjoyable because we usually see photographs made on the decks of passenger ships, where finely clad officers and wealthy travelers pose, or pictures, like the next one, which show the whole moving vessel from a distant vantage point. Seldom is a part of the giant shown, close up, with people nearby for scale, so we understand just how immense these things were, and just how small their builders were by comparison.

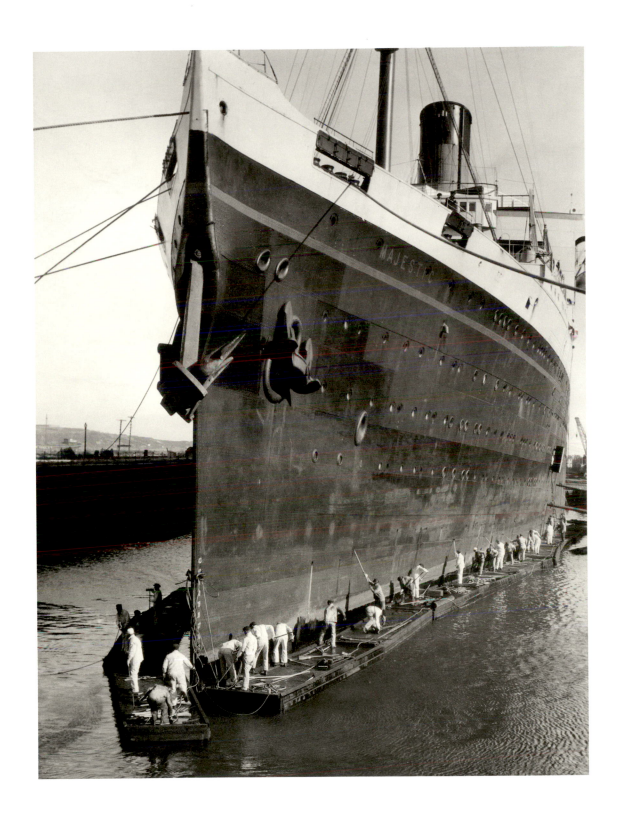

NORMANDIE ENTERING NEW YORK HARBOR

EDWIN LEVICK AND SONS active 1909–1940

———————————

What a grand and celebrated procession this is. The closest event we have today might be a Hollywood premiere, and if we imagine this watery view to show one, then the star making her grand entrance is the liner *Normandie,* coming in at about a thousand feet, and 83,000 tons deadweight. Her brilliant white upperdecks and three huge funnels are as much a piece of fashion as the newest *haute couture* dress. The smaller boats running alongside scurry about like paparazzi of the harbor angling for a precious look.

These great liners had their beginnings in the nineteenth century when Britain and America needed to communicate as rapidly as possible. Starting out as mail packets, the transatlantic steamships took more and more passengers and became increasingly luxurious, so that by World War I they boasted restaurants and wine lists to rival any on the mainland. Part of the attraction of the huge ships was their speed, and until the advent of air travel, a liner was the fastest means of bridging the ocean. Much of the drive toward better and bigger hulls, and more efficient powerplants, came from rivalry between the countries along the Atlantic shores as they competed for the "Blue Riband" that signified a record holder for the crossing. In 1850 the trip took about ten days. The *Normandie,* during her heyday in the thirties, held the record for a brief period until bumped out of first place by the new British liner *Queen Mary.* In 1952 the liner *United States* set the final record of three days and twelve hours traveling from England to the *Ambrose* lightship off New York.

All this money and effort and glamour had its dark side. The great circle route that crossed the Atlantic Ocean on the shortest path between England and America passed through the northern half of that ocean. This terrifying piece of water is home to icebergs for much of the year, and the intoxicating power of the great ships and the prestige associated with a speedy crossing led to astonishing lapses of judgment. Lacking radar, which would be developed years later, ships ran full tilt through known icepacks. The most renowned disaster was the *Titanic,* and her 1,500 needlessly lost lives. The era of the huge passenger liners also coincided with two world wars, during which the North Atlantic was home to a deadly new predator, the U-boat. The *Normandie* herself, taken out of her fine clothes, dressed in military drab, and rechristened the USS *Lafayette* as a gesture to our early French friend, was the victim of sabotage. She burned in a spectacular fire in New York Harbor in 1942 and rolled over at the pier, never to run the high seas again.

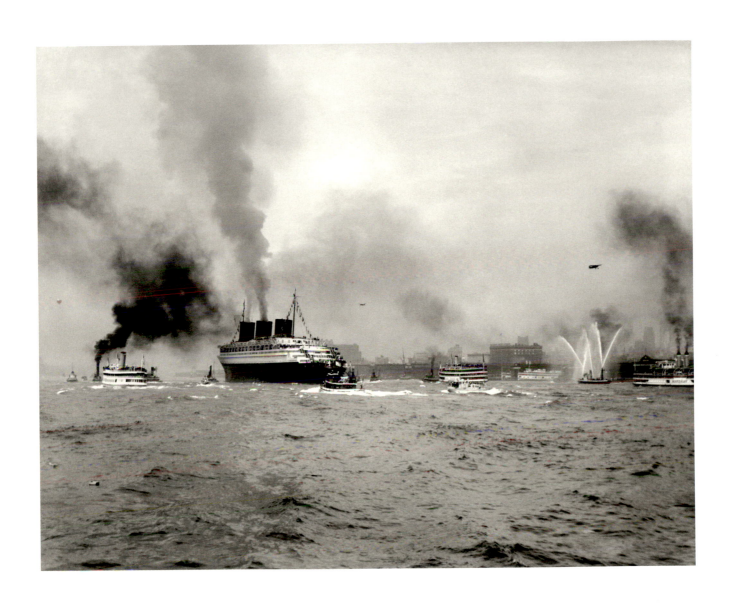

FRENCH DESTROYERS, VENICE, 1935

JOHN PHILLIPS CRENWELL

Venice once was one of the commercial wonders of the world, but today we chiefly recognize its esthetic value, as an extraordinary display of human culture expressed through the structure of a city. For centuries Venice has been the haunt of tourists: here we find gondoliers waiting for the day's customers and well-to-do folks standing on the stone plaza, with no work at hand but the contemplation of a sunny day in their elegant surroundings. The warships are five French destroyers that were mass produced, even to the extent of having progressive serial numbers painted on their bows, to define their membership in a rigidly designed class of ship. Soon after this picture was taken, the French and Italians were at war and the destroyers had left their uneasy berths to go into the Mediterranean and stake out the dividing line between the Allied and Axis theatres of control.

At first it seems inappropriate that beautiful Venice should have such signs of war crammed into her lagoon, but this great mercantile center was spawned by tooth-and-nail fighting through the centuries. The head of the Adriatic, where she is located, has received both the silt of rivers and the assault of invaders over the years. The deltas gave protection from attacks at the same time that they provided a base for fleets that could control the entire sea and its ports. The glorious buildings, plazas, and watery streets came from the riches that this domination engendered, and like so much great art, this city's wonders were only made possible by the most ruthless behavior of her patrons. It would do well for the young and inspired artists of today, wrapped up in the soothing ideals of our new age, to realize that the partnership of brutal wealth and refined esthetics is among the oldest of human relationships.

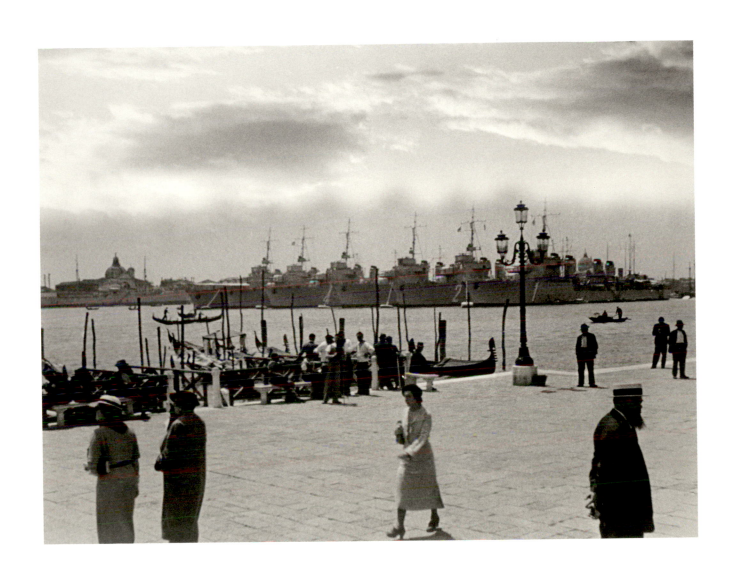

THE *HINDENBURG*, 1936

JOHN LOCHHEAD American 1909–1991

The streets of St. John are nearly empty, with a lone walker visible, and the roads and building facades are clean and empty like some backdrop for a theatre piece soon to be enacted. Unreality hangs above as well, where the *Hindenberg,* adorned with the swastika of her imperial owner, glides over this piece of coastal Canada. The old totalitarian monster came clothed in the techno-garb of the twentieth century, and it reached across the Atlantic to cast a shadow on the New as well as the Old World. With perfect hindsight we can see the ominous note which preceded the descent into madness that somehow occurred in our enlightened modern times. Now, decades later, our children cannot really believe what the photographs and history books describe, and so, with the old but naive wisdom bred of affluence, they build a new stage set for the twenty-first century's dramas.

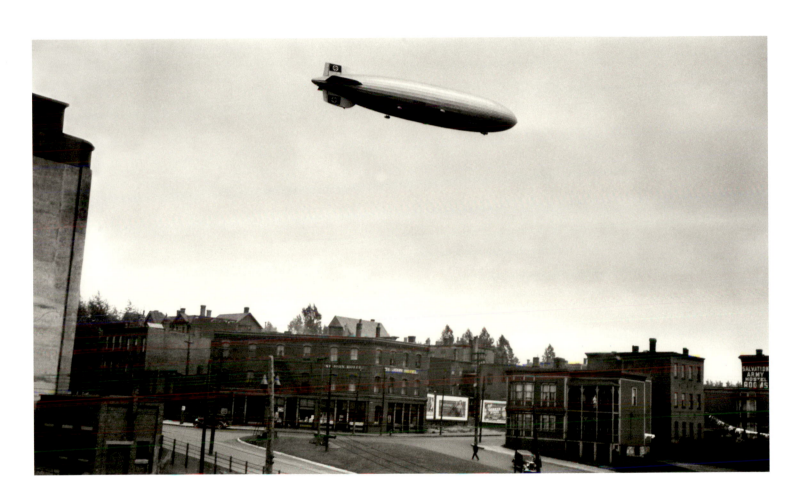

STERN FRAME AND RUDDER TRUNK

PHOTOGRAPHER UNKNOWN

This is a big piece of iron. The elegant homemade ruler marks out six feet, and so the rudder and propeller that live adjacent to this casting will be huge. What we see here is a more modern solution to the structural issues described in plate 41, which shows the running gear below the waterline at the stern of the USS *Trenton*. In that older ship the wooden hull holds plates, bolts, pins, and rivets that together create the stern works, while this newer monolithic casting will do the same job better by using a single part that is immensely rigid and tough.

Iron comes in many forms which give this fascinating material different characteristics. The pure element is never found in industry, but is always used as an alloy. The most important additive is carbon, and the classes of iron vary in both the way in which they are produced and the percentage of this vital ingredient. The three major types of iron are cast iron, wrought iron, and steel. Cast iron is brittle and crystalline and rigidly holds its shape. It is formed by being poured into molds, such as the one of sand which produced the stern frame we see here. A special sand, which can be dry yet hold its shape, is impressed with a wooden pattern which is then withdrawn, leaving a space into which the molten iron can be poured to create the casting. Wrought iron can be shaped and beaten into different forms because of its stringy toughness. Before the age of steel, iron ships were made of sheets of wrought iron because this material holds up remarkably well in salt water. The remains of some early iron ships are still around today. Wrought iron is the material favored by the village blacksmith; it can be heated to be softened for forging, can assume many shapes, and can be welded by hammer blows when red hot. Steel is high carbon iron, and it too is flexible and resilient. Because of its great versatility, steel changed the world when it became common. Steel can be tempered, a characteristic that allows it to be either hard or soft. Sharp blades and resilient springs all depend upon steel's ability to be tempered, and wire rope and thin sheets are possible because of its flexibility. Steel rusts rapidly but welds well, and its versatility has all but eliminated wrought iron from industry. In 1940, when this iron casting was made, the age of steel was approaching full stride. Today, exotic metals and different materials such as ceramics and plastics are attacking steel's role in manufacturing. For a wide range of manufactured products, the next century will most likely see this old friend left behind in the pursuit of tough, permanent lightness.

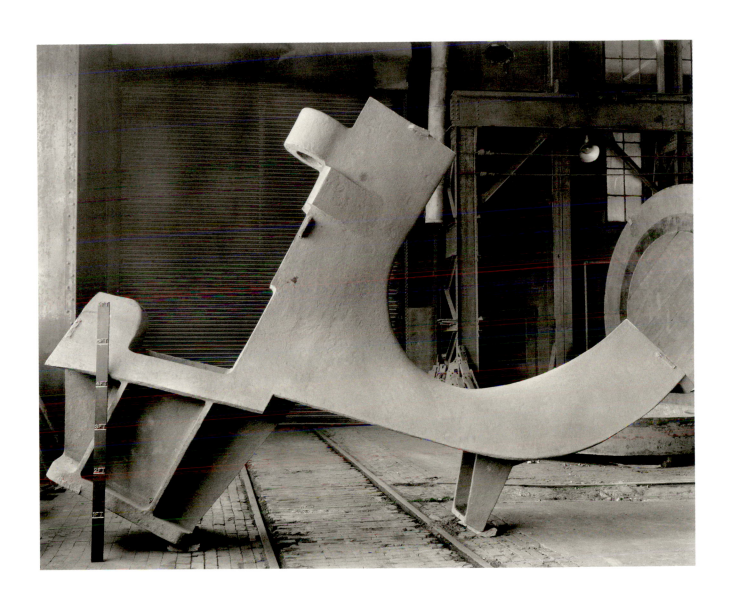

LIGHTSHIP *NORTHEAST*

EDWIN LEVICK British 1869–1929

Lightships and lighthouses perform the same function: they both hold an elevated beacon for ships to use as a navigational aid. This light needs to be as high as possible because the Earth is round, and consequently a distant object appears low on the horizon. At sea the curvature of the planet is unobstructed by the hills and valleys that cover it up ashore, and so the early marine explorers knew many hundreds of years ago that the Earth was not flat. When we first see an approaching sailing ship, only the sails appear, and then gradually she comes "hull up" as the topsides lift into visibility. A navigational light must be high enough that even from twenty miles away it will clear the horizon's obscuring curve.

Sailors not only need to avoid rocks, but also to learn where they are traveling; the fixed beacon of a lightship could tell a ship its location. The *Northeast*, also called the *Ambrose* lightship, was moored in deep water off the New Jersey coast, and she was the first piece of America that incoming liners and freighters saw at the end of their transatlantic trip.

This ship has the deep draft and steeply sheered, double-ended hull that can ride out any sea, and she had to be prepared to survive the worst winter storms or tropical visitors. Her anchor was a mushroom type, like the spare we can see low at her bow. These odd anchors worked by setting deep into a muddy bottom where the weight of the seabed helped to hold them down. A mushroom is a terrible anchor for frequent use, because it takes time to find its seating and requires patience and steady pressure to finally pull it out. The ship's lights are electric, modern replacements for the oil lamps first used, and there are two of them so that servicing or accidental failure wouldn't leave a coast unmarked. The small nominal smokestack lets us know that the engine wasn't large—but just sufficient to keep power up and allow the *Northeast* to move slowly into harbor when relieved of duty.

Most of the lightships, and many lighthouses, have disappeared. Some were replaced by long-legged towers developed for offshore oil drilling, but now even these are being abandoned as large illuminated buoys take over the jobs. When the coasts were dark it was extremely difficult to know where a ship was at night, and these warning lights made safe travel possible. Until the 1950s there was no way to be really sure where the sea ended and the land began if a day wasn't clear; even the largest military or passenger ships had no magical solution for approaching the shore safely. We are spoiled nowadays because radar and radio systems provide navigators with accurate and continually updated information. Now the tension associated with a landfall exists only as a memory in old-timers long since stuck on land.

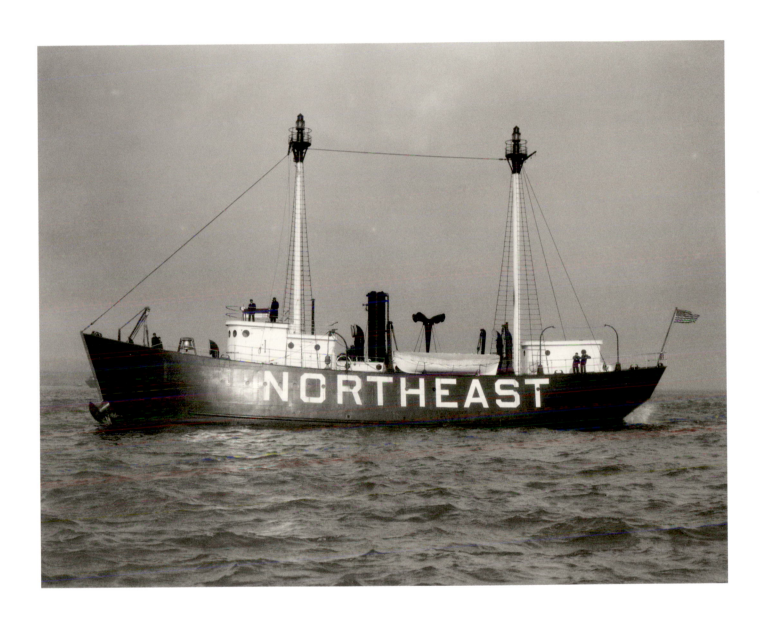

THE USS *WEST VIRGINIA* AT PEARL HARBOR
OFFICIAL UNITED STATES NAVY PHOTOGRAPH

The USS *West Virginia* and the USS *Tennessee* are already on the bottom, and the fire aboard them is sending black smoke far up into the clear Hawaiian sky. The water in Pearl Harbor was literally on fire on December 7, 1941, and this extraordinary photograph shows exactly that, as the oil from the ships' bunkers spreads over the surface and burns fiercely. In the foreground is a small wooden forty-foot Liberty boat, and if we look carefully we can see that a swimming seaman was being rescued as the picture was made. He is clinging to the boat's painter and is being pulled from the flames as the boat backs away from the conflagration. The streak of gray water through which he is being pulled shows just how close the rescuers had to come to the *West Virginia* to toss the swimmer a line. The heat must have been terrible, and the man at the bow must have suffered a blistered face and arms from his brave actions.

There have always been grumblings among historians that too many old but impressive ships were packed into Pearl Harbor, and that they created an almost irresistible target for the pent-up Japanese military ambition. The loss of life was great and the trauma to America deep, but the shock did galvanize the U.S. war effort in a way that no other entry into battle could have done. Whether these ships were sacrificed through a cynical plan or were simply at the wrong place in 1941 doesn't really matter; the fact is that the new and final generation of great battleships had begun to have their keels laid some months earlier.

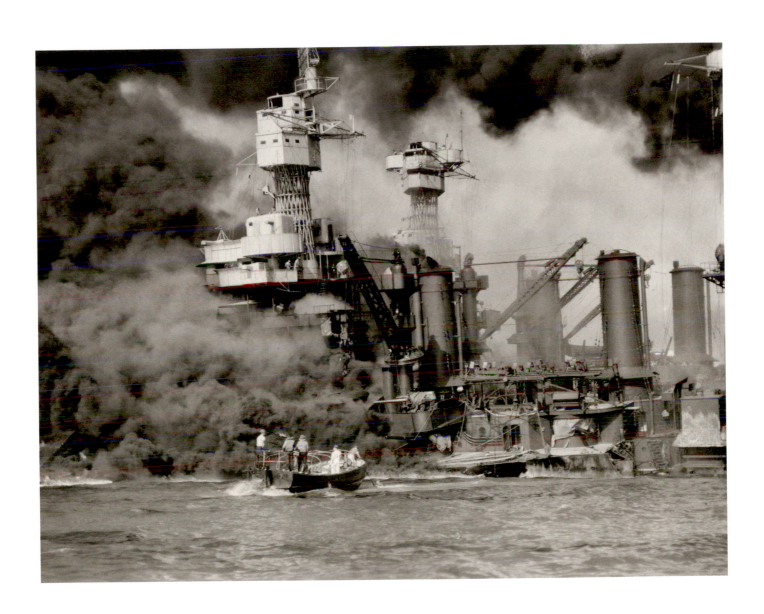

CONVOY AT SEA

OFFICIAL UNITED STATES NAVY PHOTOGRAPH

This is an aerial view of a convoy in the North Atlantic during the middle of World War II. The ships are lined up in careful rows, and they will travel the hundreds of miles of their trip together, at a speed low enough to accommodate the most plodding member of the group. To the right side is one slender ship out of formation. This is a naval destroyer, running at the heels of the pack like an Irish sheep dog keeping her charges in order. The forty freighters visible here were probably moving under the protection of two or three of these fighting ships, which could attack any submarine that tried to pick off a member of the group.

A loaded cargo vessel is a perfect target for an enemy warship. Under normal circumstances on the broad ocean, ships travel alone, and if a quick-moving attacker comes upon a heavily laden merchant ship there is little question about the outcome. Convoys changed the odds of this encounter. Grouping so many potential targets seems to increase the chances for loss, but together they could justify an accompanying protective force so each ship was no longer a solitary sitting duck. A destroyer could outrun a submarine, and a pair of them could stop any attack and perhaps even sink the enemy, using the depth charges we see in the next picture. If a group like the one we see here lost a ship or two in the crossing it was bad, but nothing like the wholesale slaughter that took place before the Atlantic convoys were instituted.

England is an island nation, and a small one at that, and the British Empire that spanned the globe was built entirely on the foundation of sea power. Every imaginable product or material moved in or out of its islands in the holds of the merchant marine, and the existence of this country as a world figure came about because the British Royal Navy had ruled the seas for so long. Hitler understood this and created Germany's powerful submarine force as a noose to stop the vital flow of goods for England, in a watery siege of the homeland of his strongest enemy. The convoy cut this tightening loop, and the ships we see here are literally keeping England alive with their massive cargos.

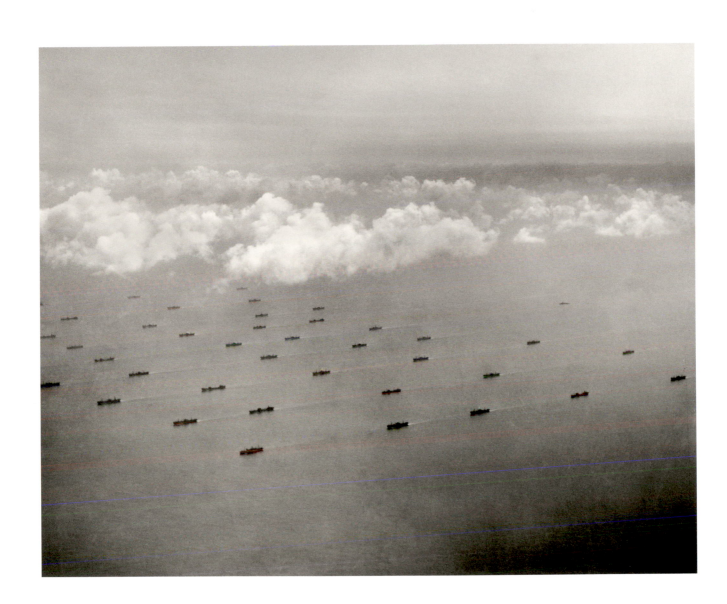

USCGC *SPENCER* SINKING SUBMARINE
OFFICIAL UNITED STATES COAST GUARD PHOTOGRAPH

The most dependable way to enhance the narrative of a photograph is with a juicy caption. This literary addendum was the true foundation of the picture magazines. While we thought we were witnessing life in photographs, we were often being steered to our impressions by a writer who stuck one- or two-liners beneath each picture. The back of this photograph looks somewhat like this:

FROM:
> PUBLIC RELATIONS DIVISION
> U.S. COAST GUARD
> WASHINGTON, D.C.

OFFICIAL COAST GUARD PHOTO

COAST GUARD CUTTER SINKS SUB

COAST GUARDSMEN ON THE DECK OF THE U.S. COAST GUARD CUTTER SPENCER WATCH THE EXPLOSION OF A DEPTH CHARGE WHICH BLASTED A NAZI U-BOAT'S HOPE OF BREAKING INTO THE CENTER OF A LARGE CONVOY. THE DEPTH CHARGE TOSSED FROM THE 327-FOOT CUTTER BLEW THE SUBMARINE TO THE SURFACE, WHERE IT WAS ENGAGED BY COAST GUARDSMEN. SHIPS OF THE CONVOY MAY BE SEEN IN THE BACK-GROUND.

* * *

We should be skeptical when the agency through which we have received the picture turns out to be the Public Relations Division. All celebrities, politicians, big businesses, and military organizations have these representatives nowadays, and their cleverly worded "disinformation" has cast permanent doubt on the relationship between truth and photography.

There is no doubt that, looking through the wonderful window-in-time of the still photograph, we witness a tremendous underwater explosion here. The men on deck face the eruption of water, the next charges wait in a rack for their deployment, and the distant ships hold back as the battle takes place. There is no submarine in sight, though; the sinking of the U-boat might just as well have been imagined, and the darkening sky—put there by intention in the darkroom—may cause us to question this picture as a relic of death and victory at sea.

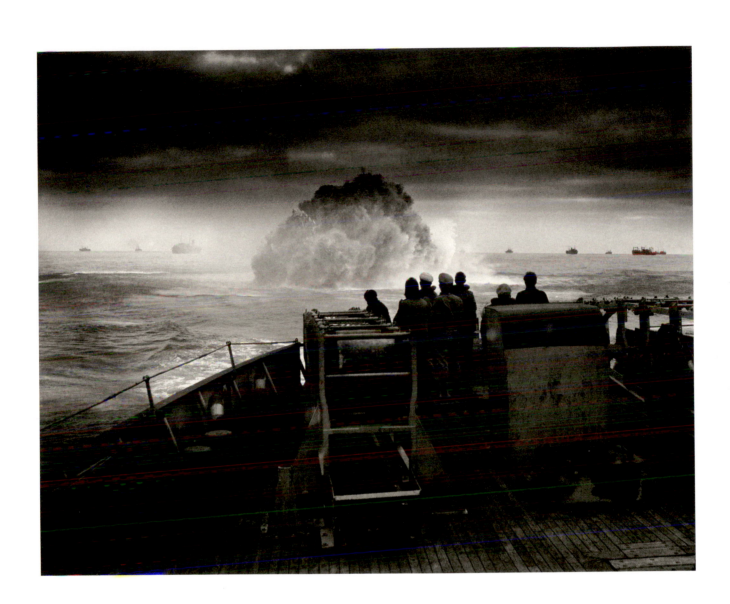

SEA SCOUTS OF *FLORENCE LOUISE*

A. AUBREY BODINE American 1906–1970

———————————————

Making a good photograph can be technically complicated. There are issues of focus, exposure, and framing, as well as darkroom considerations that can wreck good work done in the field. Beginners do well to read the little slip of paper that comes with each box of 35mm film. It gives sample exposures for different sorts of days, mentions the value of a high shutter speed to avoid jiggling, and makes it very clear that photographs look best when made with the sun behind the camera. Light is the drawing medium of photography, and the sharp description of surface and form that is revealed by direct sunlight striking the subject head-on shows the magic of these little pictures at their best. A. Aubrey Bodine, who made this photograph, was an old hand at this art, and he has three pictures in this book.

The boys shown here were born just late enough to have escaped World War II, and their lean bodies and exuberant leaps celebrate the endless summer of the young. Every one of them is so healthy, clean, and well-shorn that they must be the children of the solid middle class, at a summer camp on the water to teach them manners and get them out of the house for a while. No children of the poor or minorities allowed here, and these two omissions, along with the presence of the old Chesapeake Bay oyster boat, firmly date the picture. The hanging reef points in the sail are a reminder that not all days are so perfect. The large patch sewn into the sail tells of long hours of sailing, the stretched mainsail flapping against the rope lazyjacks that help to furl it when the boat is put away for the night.

The character of the boys is revealed by their jumps: at the far right is the exhibitionist, his back arched for the camera in a pose that could fit right into a Renaissance Last Judgment. Two over from him is the one who couldn't quite get himself off the rail; then comes the central group, simply leaping and yelling in their exuberant moment of release for the watching photographer. This captured moment is the sum of all those sunny days that can make childhood such a carefree dream.

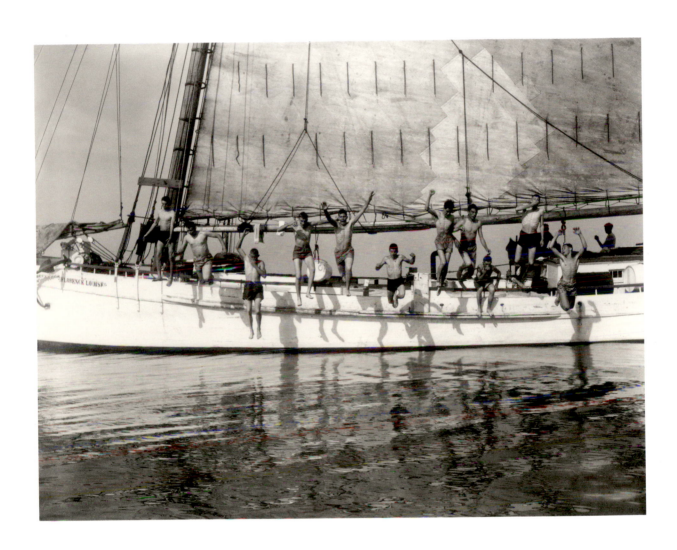

FISHING BOAT

EDWIN LEVICK British 1869–1929

A small fishing boat fights its way out of New York Harbor. A weather front has rolled through, and the whitecaps topping the short seas tell us that the wind is new and the harbor is confined; if we were further out, the waves would have a longer and deeper roll than is possible so near land. In the foreground is a bit of the white wake of the photographer's boat; he is working as well, trying to keep the camera steady and dry until the perfect moment for the picture arrives. The little boat has a smooth carvel-planked hull and enough rigging to support nets and steadying sails, but neither are in evidence in the picture. She is one of those boats made in a little yard, probably by an immigrant builder, with galvanized fastenings, wood that's not quite up to snuff, and a small, dependable flat-head gasoline engine that will run forever inside its rusty outer covering.

The boat sits small in the picture's frame, so we understand its scale out on the violent water. The enterprise it represents, of one or two people who work out of a small wooden boat, had its own scale as well. A good day's fishing could fill a local store's display cases and produce a few cartons of iced-down product to be brought to larger markets. The scale of the boat and its operation fitted perfectly with the lives of the fish as well, because even with a fleet of such craft the stocks of fish would not be depleted but could steadily supply enough catch to keep the fishermen solvent and the schools healthy.

A distressing things about technology is that it benefits from largeness; when we build bigger and increase the scale of any operation, then the technology becomes much more efficient. This little fishing boat is a minor player in the game of harvesting protein from the sea, because for many years there have been fleets of large ships that catch unbelievable amounts of fish with horrifying effectiveness. This has resulted in disappearing stocks and unpaid boat loans. It also has put the fishing industry in a terrible cycle of boom and bust as whole species are decimated by large trawlers, so there is nothing left to catch. The ups and downs of this trade demonstrate the human habit of always working for the short haul. Time and again we fail to see how we cut our own throats when we ravenously consume the natural wealth that the environment holds up for the taking. When the scale of things is kept small, and the coarse temptations of complex technology are resisted, then styles of living have a chance to grow old, and we all have better lives.

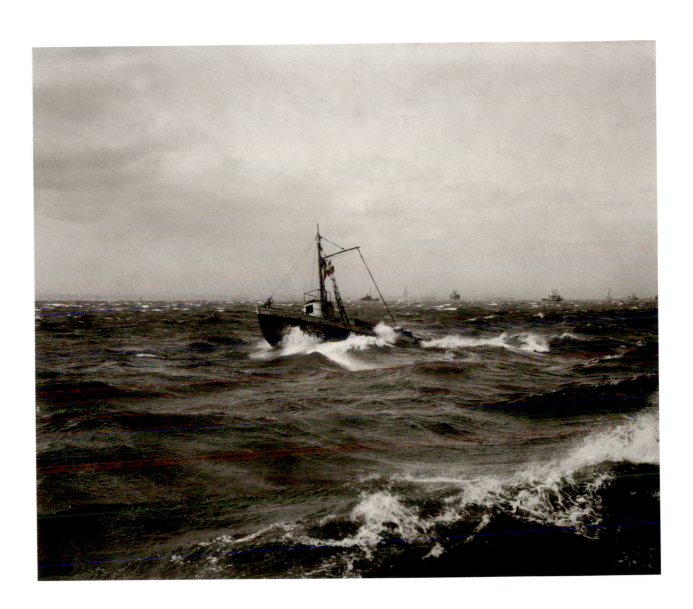

94

EIGHTEEN-FOOT FIESTA KIT BOAT

PHOTOGRAPHER UNKNOWN

Here we see the raw material for an advertisement for a Chris-Craft kit boat. This company manufactured the first successful leisure powerboat for the American masses, and produced thousands of them in fixed styles and models, in large editions. The Chris-Craft was disdained by traditional sailors, because these boats were built with an absolute disregard for the lessons of the sea; no moral-fiber building trials and labor here, but instead just a slightly damp version of the American dream. The truth is that these old-timers were dead wrong, and the harbors and rivers of the twentieth century have become one of the best pleasure grounds for a hard-working society.

There is no reason why the owners of these quite impractical pleasure boats should have had to worry about the dangers of the open sea. Today plastic has replaced wood, the versatile outboard has supplanted the gas inboard engine, and hundreds of thousands of these unseaworthy craft bring relief from heat and work to the affluent of our country. As the Chris-Craft tended to ignore the realities of the water, so too does this picture ignore the nature of visual reality in its pursuit of a directed meaning. Sitting on a cradle within the calm confines of a warehouse, the actors wave and smile to an unwitting public who will see the picture later, carefully printed on a watery background from a different photograph, taken on some warm and sunny day far removed from this boat and its promise of ideal times.

STEAM GENERATOR FOR THE USS *SAVANNAH*

PHOTOGRAPHER UNKNOWN

This is the steam generating unit from the nuclear ship *Savannah*. In atomic-powered vessels a nuclear reaction produces heat that is used to make steam, and this high-pressure vapor is then utilized in traditional turbines to drive the ship. That the nuclear age is a continuation of the steam age is often overlooked, and this omission has made the general public think that atomic power belongs to a completely new era. We are really just a primitive people who have found a substitute for fire to use in conjunction with our old machines. The traditional steam boiler was a dangerous thing, as we have seen in plate 32, and only by creating standards for boiler construction have these pressure vessels been made safe. When atomic energy was applied to steam generation, another frightfully dangerous ingredient was added to the complex structures we use to produce power.

The steam boiler can explode when a lack of containment releases the energy held within the pressurized hot water. The atomic pile exists under a similar containment; the fuel within it is capable of an uncontrolled reaction that is carefully held in check by physical structures within the reactor. Thus far there has been no known case of a reaction getting out of control and completely running amok except for the infamous accident at Chernobyl in 1986, where a melting reactor core was just barely contained within the safety shield built around it.

The first *Savannah* was built in 1819 as a demonstration ship for the new innovation of steam power. She acted as an ambassador for the future of travel on the sea, and the ship whose innards we see in this picture was similarly named because she was built for the same reason—but now to familiarize the public with commercial seagoing atomic power. The new *Savannah* wasn't even capable of carrying a cargo large enough to justify the cost of shipping it, but her gleaming white hull and sleek lines spoke of a new age for the maritime world. As it turned out, the dangers of the atom were too great for the competitively driven world of the merchant marine, and so the *Savannah's* work was unrewarded and she ended up a symbol of an imagined future that wasn't in the cards.

96

THE USS *FORRESTAL* UNDER CONSTRUCTION

NEWPORT NEWS SHIPBUILDING STAFF PHOTOGRAPHER

This picture shows the USS *Forrestal* under construction at the Newport News Shipbuilding and Dry Dock Company. This huge aircraft carrier is 1036 feet long and displaces 59,650 tons. The photograph makes clear that this monster is built of tiny pieces, by what appear to be tiny people. The scaffolding that forms her chrysalis, and the endless planks, plates, ropes, and blocks that cover and surround her all indicate the fine scale of the builders who can plan and construct in such a grand way. This construction was possible because the ship had already been carefully laid out in thousands of precise blueprints.

The blueprint came about because two things changed in the nineteenth century. The first was that our creations became too big and complex for any one individual to understand, and the second was that the manufacture of repeatable, identical parts became possible. These changes have literally created the modern world with the power and universality of their effect. We now purchase and use tools that are truly magical in their capabilities; we accept that some other group of people can understand them but that we, even without that comprehension, can use them. Whether it is a car that glides along at a mile per minute, or a thin disk of plastic that holds Mozart's genius, we accept the new age and its empowering gadgets without ever needing to know how they really work. The basis of all this magic is the interchangeable part—made by the identical thousands (like the machine screw), but capable of being used in endlessly different ways—and the blueprint, which records how all these versatile pieces should be shaped and assembled.

The *Forrestal* was designed right down to the final layer of paint and built over the course of a couple of years by thousands of people. She is CVA-59, and our next picture shows the USS *Constellation* CVA-64. The *Constellation* was made to a different set of plans, because technology and knowledge both grew in the interval between the two boats. While the parts used are universal, and the blueprints rigidly fixed on paper, the ever-changing state of our minds and crafts ensure that constructions built over time, like these, are each always unlike any other. This is probably the saving grace of the modern era: that the repeated small part, and the codified description of a plan, still cannot help but make a single new and unique object when the scale of construction becomes large and complex. The work of thousands then produces an item as interesting as the bark canoe of plate 3, because no two are alike, and each perfectly expresses the condition of its own time and purpose.

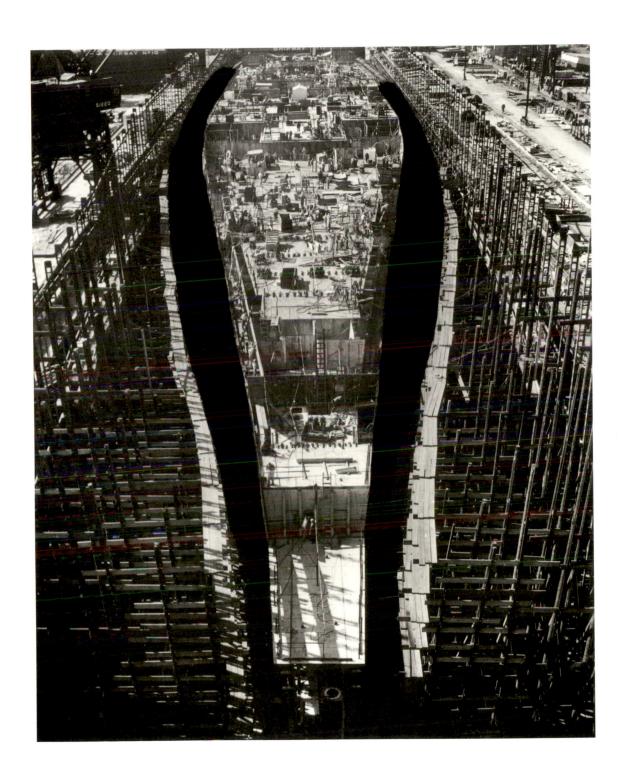

THE USS *CONSTELLATION* FROM THE AIR

P. D. TIFFANY

As we rise above the USS *Constellation* and look down on the pattern of her armament and the wind-smudged sea through which she moves, we must be aware that a new time has come. How can we be hanging so high in the air, where a thousand-foot construction of steel turns into some new creature with the delicate, feathered edges of its aircraft wings? We have this view because the labor of thousands is brought to focus by the photographer's lens, sent up high to make this picture for the satisfaction of the nation whose effort built the ship. The deadly sting of the jet aircraft is implied by their predatory white shapes, and the round disks of the two radar planes are eyes waiting to locate ready targets.

Humanity appears nowhere in the picture: the sailors who run the ship are hidden in the stunted and foreshortened conning tower barely visible on the flight deck's side. While individuals do not appear, their collective effort is the real subject of the picture. Only through tremendous cooperation and organization could this new creature of the sea have been built, and only as a part of this endeavor could such an unlikely picture have been extracted from a point so far above the water. As soon as fighting and travel at sea became valued for the changes they could produce, both stopped being individual efforts and became instead training grounds for the human talent for sharing labor and its rewards. Maybe the lesson of this great warship is that the future shows no people, but instead only what the social contract can create, and that the threads of our eccentric and cherished individual lives must find a way to survive and flourish while woven into the tight fabric of modern times.

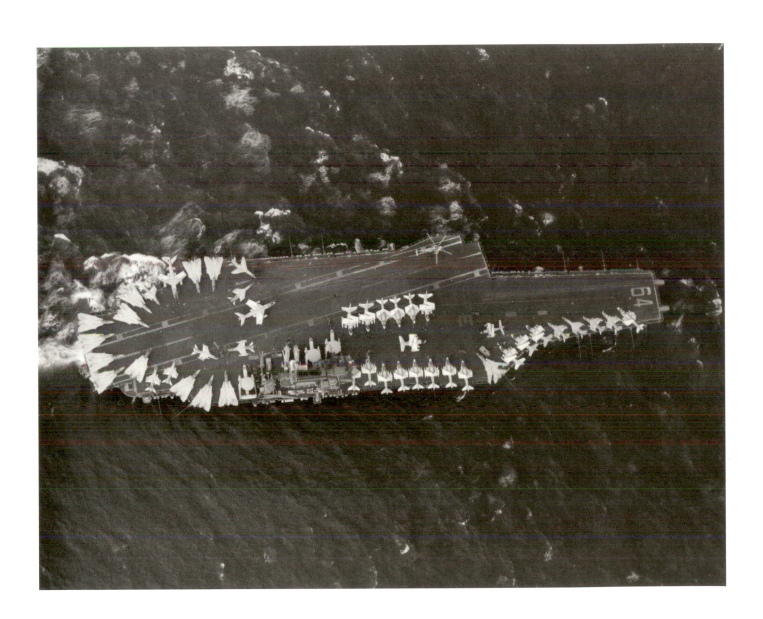

SAN DIEGO TRAINING CENTER
RICHARD STEINHEIMER

This photograph shows the parade grounds at the U.S. Naval Training Center at San Diego, California. The trainees are decked out in white, wearing the anachronistic leggings that were part of a recruit's uniform, and they march in step in their respective companies. This must be a graduation day, because at least twenty-three companies of over seventy men each are visible on the macadam "grinder" — close to the total number of new sailors that could be trained at one time.

The canvas leggings are not the only outdated item in this picture, though, because here we see sailors marching in formation, and for most of them the twelve weeks of boot training are the only time they will walk like this in their entire military careers. Marching sailors are a little like cadets going to sea in a square-rigged training ship: both are thoroughly outmoded activities, but are cherished for the principle and discipline involved. In this photograph, taken well after the war ended in 1945, we are also being shown evidence of another obsolete idea — that men are the fundamental unit of military strength.

Because we build things with such cleverness, the machinery of war developed early, and the continual fighting that has been going on has been supplemented by increasingly lethal tools. For thousands of years the foot soldier, like the sailors we see here, has carried a hand weapon, and this deadly and versatile combination of man and simple machine has been the backbone of warfare. This practice still seemed reasonable when our picture was made, but the recently ended battles had been carried out with huge and complex new machinery on land, air, and sea, and the day of the marching soldier, stacked up in broad ranks, was coming to an end.

In small wars such as those in Korea and Vietnam, the single arms-bearing soldier remained the active unit, but even there the complex machinery of war bombed and destroyed landscapes on a horrifying scale. In the war in the Persian Gulf we could see, for the first time, that a tiny number of well-equipped combatants, using their minds instead of their bodies, could devastate a country with impunity using the technology of the new electronic age. The twentieth century's massive machinery of destruction has changed all the rules, and battles of the mind are now replacing physical ones. Soldiers and sailors will always be around, however, because the unspoken truth about military life is that men love it, and, for many of those who have fought, the years spent doing so are the most vibrant and memorable of their lives.

VOLKSWAGENS ON DOCK

HANS MARX American, b. 1915

Here is the new invasion force, just poured out of the German freighter *Ravenstein* in March of 1956. Soldiers are no longer the tools of war, and death and destruction no longer the means; economic force is wielded instead, and the consumer's pockets have become the battleground. This photograph was made a scant eleven years after the surrender in Europe, and there had been a broad understanding that commerce and economic interaction needed to be re-established between victor and vanquished. Germany and Japan were both given aid and access to free markets that allowed their brilliant national structures to join battle again on the new economic field.

The Volkswagen, car of the people like the Ford Model T, was a great little vehicle. It was cheap, hardy, fuel efficient, and standardized to an unprecedented degree. Like the T, it also started out in limited models available only in black, but here on the docks variation is already present to accommodate American taste. Remarkably, the little VW started out as a basic military vehicle in World War II, but the old battle of guns and the new one of dollars were so similar that this very car could play an active role in both.

The repeated units of the car are a parallel to the ranks of sailors in our previous picture. Mass production, practiced by the living world for millions of years, has now been taken up by manufacturers, and the economic war of today can only be waged so efficiently because the more copies we make of one item, the cheaper each one gets. Many examples generated from a single design are only useful if they are needed by many people, and so the benefit of mass production is mass cooperation. The primitive understanding between opposing armies, which would agree to meet on a given field of battle, has been replaced by the new cooperation of countries and businesses that agree to meet instead on the competitive field of consumer choice. It is hard to believe that this is not a great improvement over the old ways.

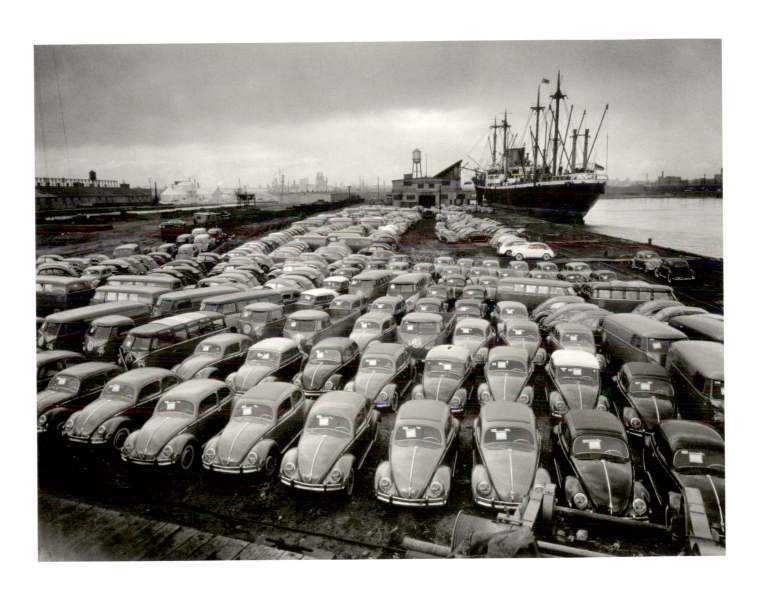

DEADRISE BOAT UNDER CONSTRUCTION

HERMAN C. HOLLERWITH, JR. American, active 1910–1940

———————————————

The man bending over is probably the father, and the other two are probably sons; perhaps there is a pair of daughters between them, to explain the age difference. All three wear identical clothes, and they work together at the ancient art of building a boat by hand among the trees, grasses, and moist earth of a shoreline field. If photography were a thousand years old, then we could have pictures from that entire span of time that looked just like this, from every society and culture near the water. In some the planks would be cut by hand, not neatly sawn like those we see here, and in others the fastenings would be ties of tough fiber rather than the nails and screws that most likely hold this boat together.

Something even more ancient than boatbuilding is going on here, however. This is the process of learning by doing, the handing down of craft and understanding from parent to child. Many animals teach their offspring—this isn't unique to humanity—but only in our species does an artifact such as this growing boat act as a repository of wisdom. The boat has become better through its many versions over the years, and the example that is being built under the father's direction is giving to his children lessons that earlier generations have refined and developed for their descendants. The lessons of all the prior boats reside in the physical form of this new one, and they span the generations with a longevity that no living creature can possess.

Today, sixty years after this picture was made, we have shifted much of education over to books and verbal lessons, passed on more and more frequently to the young by teachers instead of practitioners. There is a terrible loss in this modern practice, because it puts too much emphasis on the part of our being that thinks with words, and relishes knowledge separated from its generative physical roots, out of which all real activity and understanding grows. As our educational systems mature, and we learn to roundly educate billions of human beings, the grounded knowledge found in physical experience must be recognized as the true realm of learning.

The youngest man here, proudly wearing a hat like his father's, takes a short break to beam at the photographer who records the growing miracle of their boat. With every glance the boy will make along the unfinished deck, through this day and those to come, an infinite series of pictures will be impressed on his fresh mind of how the frames and planks should look, and what the intrinsic nature of a wooden boat truly is. This complex understanding will later guide him to make a new version, perhaps in a seaside field such as this one, for his unborn child to see some distant day in the future.

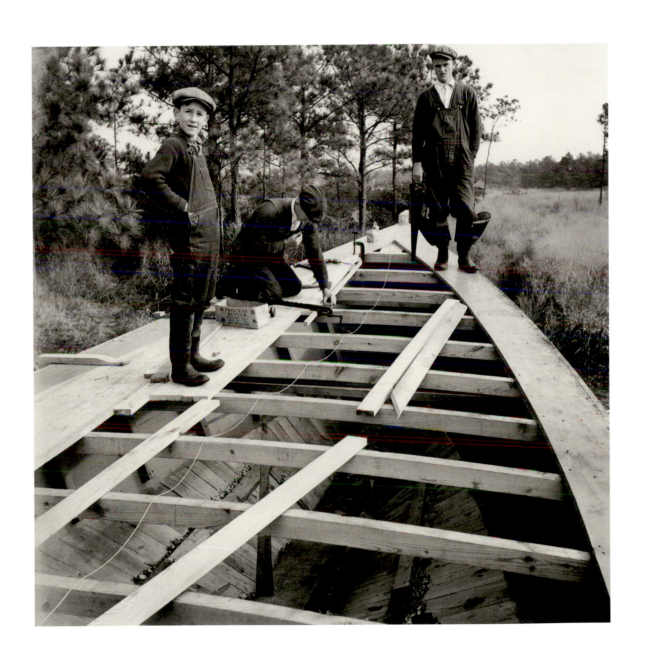

CHECKLIST AND SUPPLEMENTARY NOTES
ON THE PHOTOGRAPHS

Presented below is a checklist of the exhibition including inscriptions, from which many of the titles derive. Much judgment has been exercised in copying inscriptions from the backs of the photographs; every manner of scrawl appears on them, and we have only transcribed portions of this archival material. For most of the photographs I cannot resist adding further information that could be of interest to some readers. — *RB*

1

John Lochhead (American, 1909–1991)

HULKS ON THE NORTH LANDING RIVER

Gelatin-silver print 6.5 x 9.5

Museum Collection PR 250

INSCRIPTION: *Cutoff in the North Landing River, North Landing, Virginia, December 4, 1952*

One of the grandest marine junkyards still exists on the Kill van Kull, in Staten Island, New York. When seen from a plane approaching New York City, this mass of burned and rotting ships covers acre after acre, and it is an archaeological treasure trove for the marine world. Called "Witte's Shipyard," this remarkable place has ships piled three and four deep, and looking at any given stack of hulls is like seeing a roadcut on the highway that reveals the history of its creation in cross section. The wrecks at Witte's span the entire era of steam and diesel, but to the best of my knowledge the age of sail is not represented there. Perhaps I just haven't looked deep enough.

2

Photographer unknown

FISHING CRAFT ON THE NILE

Albumen print 6.25 x 8

Museum Collection PI 160

INSCRIPTION: *Fishing craft, probably on the Nile River*

3

Photographer unknown

ALGONQUIN CANOE

Printing-out paper 7.5 x 9.75

Gift of E.T. Adney PI 574

INSCRIPTION: *Algonquin Indian canoe, Edwin Adney Collection*

Adney did not just collect information about canoes, but also kept detailed notebooks on the techniques used in their building. He went so far as to make half- and quarter-sized models of the different types. These remain at The Mariners' Museum today, a fascinating testimony to the craft and dedication of both Adney and the original builders.

4

Photographer unknown

OUTRIGGER CANOE, YARUTO ISLANDS

Platinum print 6.25 X 4 5

Museum Collection A-PI-V.1-60

INSCRIPTION: *Outrigger Canoe, Yaruto (Jaluit) Island Marshall Group*

This little picture comes from a traveler's album, full of small prints made in the Pacific Islands. There are a number of photographs of this proa there, but the one we have reproduced best shows the boat at work. The mast clearly pivots in the center of the hull, so reversing direction is easy, and the crew of three sit so their weight perfectly balances the force of the sail, keeping the hull level in the fore and aft direction. Just ahead of the sail, in the background, is a fixed marker, indicating a channel or the location of a reef.

5

Photographer unknown

THE *JOSEPH CONRAD*

Gelatin-silver print 16.25 x 20

Gift of S. Otis Bland PK 6925

INSCRIPTION: *Joseph Conrad (ship), Copenhagen, Denmark, formerly Georg Stage*

The *Conrad's* hull is high out of the water because she is not a cargo ship. We easily forget that sailing ships were built to carry huge loads, and they sat very low in the water, achieving stability because of their great waterborne mass held in the stable press of the wind. A ship's hull isn't meant to stick up out of the water, and this unnatural attitude adds to the unsettling quality of the photograph.

6

John Justice

USRC *BEAR* ANCHORED TO AN ICE FLOE

Printing-out paper 6.25 x 8.25

Museum Collection PN 6220

INSCRIPTION: *USRC Bear anchored to an ice floe. Circa 1895.*

Unlike the South Pole in Antarctica, the North Pole has no land mass at its center. Instead, it is located in an ocean ringed by countless islands. In this sea swirls a huge mass of semi-permanent ice; this floating pack is always present but continually recycles itself, with fresh ice forming and old ice breaking off the edges. As seasons change, the countless bays and passages among the surrounding islands freeze and thaw, but never in quite the same order, nor to exactly the same degree each year. This unpredictability of the ice has made exploration here immensely difficult, and if the brief Arctic summer came a bit late to an ice-bound ship, then an entire additional winter's stay could be incurred with only a hope that freedom would come the following year. For centuries this wild and changing place has been home to a native population that apparently came into the Arctic from Asia. One of the ironies of explo-

ration here was that an adapted people had already come to terms with the demands of life at the top of the world, and had achieved an enduring culture that spread through much of the North.

7
Marian Smith (American, active 1901)
SPERM WHALE ON *CALIFORNIA*
Gelatin-silver print 7.375 x 9.25
Museum Collection PW 10
INSCRIPTION: *Cutting in a sperm whale aboard Brig California. The "junk" on deck.*

This huge piece of the whale's head has been lifted up onto the whaler's deck, and the lines we see in the lower right corner, going into the mass of flesh, must turn around a piece of bone hidden below the blubber. Our romanticized image of the whaling era leaves out the reality of these great mammals being boiled down to their constituent parts, which created a dreadful smell that could tell of a whaler's presence long before she was visible over the horizon.

8
Photographer unknown
WHALEMEN, NEW BEDFORD
Cyanotype 9.5 x 7.5
Gift of A.W. Barnes PW 184
INSCRIPTION: *Arctic whalemen, in skin suits, New Bedford, 1882*

This picture, like plate 19, is an eight by ten inch blueprint, or "cyanotype," as the curatorial folks would like us to call them. These prints were very cheap and easy to produce but had the bad habit of being intensely blue, which imposes an artificiality on the picture; this can interfere with a photograph's ability to convince us that we are viewing the unblemished record of the world.

9
Photographer unknown
COMMODORE MORRIS, WHALER
Albumen print 8 x 9.75
Gift of Mr. William F. Crosby PK 327
INSCRIPTION: *Commodore Morris (bark) New Bedford, Mass.*

10
John Justice
USRC *BEAR* WITH CARIBOU
Gelatin-silver print 4.75 x 7.75
Museum Collection PN 6221
INSCRIPTION: *Reindeer, likely released into Alaska during 1895 Eskimo relief mission. USRC Bear in background.*

11

Photographer unknown

MINOT'S LEDGE LIGHT

Gelatin-silver print 9.25 x 6.25

Museum Collection PL 32

INSCRIPTION: *Minot's Ledge Lighthouse, Wednesday August 3, 1859*

The original Minot's light was a spider-like iron tower supported by nine legs set into the stone of the ledge. Lit in January 1850, this early open framework was completely destroyed by a storm in April of the following year.

12

Photographer unknown

WRECK OF THE *ADLER*

Albumen print 7 x 9.5

Museum Collection PH 773

INSCRIPTION: *Wreck of German warship "Adler." Hurricane in bay of Apia, Samoa Islands. March 16, 1889.*

It is difficult to know just when the cannon turned into the gun. If we look carefully we can see a large piece of ordnance on the deck of the *Adler* close to the stern, and I think we can say with some confidence that it is a cannon. Going ahead to plate 67, there is another firearm visible on the deck of the USS *Shaw*, just aft of the remains of her forward house. This machine looks very like the one on the *Adler*, but may actually be a gun. Perhaps the one on the *Shaw* has a rifled barrel, a feature that signals that the cannon has been left behind, as the weapon no longer fires a round ball but instead a spun, aero-dynamically efficient bullet.

13

Photographer unknown

THE USS *CONSTITUTION* ON THE WAYS

Albumen print 9.5 x 13

Museum Collection PN 8341

INSCRIPTION: *Frigate Constitution hauled out on the sectional dock at Philadelphia. 1874*

The USS *Constitution* and the USS *Arizona* (plate 60) both have rounded hulls, and the stern poppets for both have had to be lashed together to support them on the marine railway. I mention this in the text for the *Arizona*, and here we can see the relatively light chain used for this purpose on this much smaller sailing ship.

14

Photographer unknown

RIGGING OF THE USS *CONSTITUTION*

Gelatin-silver print 9.5 x 7.75

Museum Collection PN 454815

INSCRIPTION: *Constitution, by Sumner Besse, 1932*

15

Albert Sands Southworth (American, 1811–1894) and Josiah Johnson Hawes (American, 1808–1901)

DONALD MACKAY

Daguerreotype 8.5 x 6.25

Museum Collection PP 137A

INSCRIPTION: *Donald MacKay 1810–1880. Shipbuilder, born in Shelburne Co., Nova Scotia.*

My parents knew MacKay's grandniece, Helen Hunt, who raised Cairn terriers in Washington, Connecticut. The driveway of her farm had garnets in amongst the pebbles, and I always looked forward to our annual visits there when I could pick these jewels up off the ground. Only gradually did I realize that the paintings over the mantels and on the walls of the house showed the parade of great clippers built a hundred years before by her famous uncle.

16

Photographer unknown

THOMAS W. LAWSON

Gelatin-silver print 16.25 x 20.35

Gift of R.L. Hague PK 413

INSCRIPTION: *Thomas W. Lawson (schooner) Boston Mass.*

17

Clifton Guthrie

JUAN SEBASTIAN DE ELCANO

Gelatin-silver print 7.5 x 9.5

Gift of George Tucker PF 566

INSCRIPTION: *Juan Sebastian de Elcano (training ship)*

The stiff white bar that counteracts the immense pull of the stays on the bowsprit is solid for an additional reason (beyond issues of corrosion discussed in the text): the bar can be made of iron, and therefore have much less stretch and springiness than a similarly sized piece of cable. This rigidity is important in setting up the rig properly.

18

Photographer unknown

HIGGINS AND GIFFORD BOATYARD, GLOUCESTER, MASSACHUSETTS

Albumen print 7.25 x 9.25

Gift of the Smithsonian Institution PS 321

INSCRIPTION: *Higgins and Gifford Boat Shop. Gloucester, Mass.*

There is a pretty little lapstraked double-ender sitting on the dock, with a small house with a single porthole. She is a type of small craft that evolved all over the world for general fishing use. Her dorylike shape continues deep into the water (unlike the true dory, which has a flat bottom), and when ballasted with beach stone her fine hull could ride out any sea that might exist. The lifeboats carried on the davits of modern passenger liners have this same traditional shape.

19

Photographer unknown

IRISH CLAM DIGGERS

Cyanotype 7.5 x 9.5

Gift of the Smithsonian Institution PP 740

INSCRIPTION: *Irish clam diggers, Boston Mass, 1882*

20

J. Jay Hirz (active 1930s)

FISHING BOATS, BOSTON

Gelatin-silver print 7.5 x 9.5

Museum Collection 154082

INSCRIPTION: *Hundreds of Italian fishermen rush in from the fishing grounds to celebrate Masquerade Day at home.*

21

Edwin Levick and Sons (active 1909–1940)

MAN HOLDING HALIBUT

Gelatin-silver print 6.5 x 4.5

Museum Collection 151985

INSCRIPTION: *Fishing trawler near Boston. A big one.*

The halibut and the large flounder differ in the construction of the end of their flat body just before it runs into the tail, and in our picture this part of the fish is covered by the dark board running across the bottom of the photograph. However, we have confirmed that the fish is, indeed, a halibut.

22

Edwin Levick (British, 1869–1929)

UNLOADING THE SEINE

Gelatin-silver print 5.5 x 9.5

Museum Collection 58460

INSCRIPTION: *Unloading the seine*

The double-ended net boats in the photograph have descended in a direct line from the beautiful white boats visible in plate 18. If we came upon a pogie boat today, then these narrow working craft would be built of aluminum, with slightly clumsy lines because the flat plates of metal never want to bend into the compound curves we see in these well-worn wooden examples.

23

Edwin Levick (British, 1869–1929)

LIFTING POUND NET

Gelatin-silver print 7.5 x 9.75

Museum Collection 154909

INSCRIPTION: *Lifting pound net*

24

A. Aubrey Bodine (American, 1906–1970)

CLEANING FISH

Gelatin-silver print 7.5 x 9.5

Gift of A. Aubrey Bodine P-654

INSCRIPTION: *Cleaning fish—river herring. Havre de Grace, Md. May 6, 1943.*

25

H.C. Mann (American, 1866–1926)

SOUTH MILLS, DISMAL SWAMP CANAL

Gelatin-silver print 4.5 x 5.5

Museum Collection PR 259

INSCRIPTION: *Dismal Swamp Canal. Bridge at South Mills. ca 1910.*

The little bridge is a marvel, and the system used to hold the roadway—simple diagonal cables from the main tower—is becoming popular today in highway construction. One of the most impressive of these runs across the harbor mouth at Tampa, Florida, alongside older traditional steel bridges. The idea of diagonal cables has its most famous expression in the Brooklyn Bridge, where Washington Roebling put in a set to act as a redundant support to the main catenary cables that hold the trussed roadbed.

26

H.C. Mann (American, 1866–1926)

ENOLA, DISMAL SWAMP CANAL

Gelatin-silver print 6.75 x 9.5

Museum Collection PR 265

INSCRIPTION: *Dismal Swamp Canal, ca 1910. Enola (sloop)*

The log boat on the left is almost surely a Chesapeake Bay bugeye, an extinct form of oyster boat. These ketches had no gaff, and this difference of rig is visible in our photograph when we compare the foreground boat to the schooner ahead of her.

27

A. Aubrey Bodine (American, 1906–1970)

LOG RAFT

Gelatin-silver print 10 x 13

Gift of A. Aubrey Bodine PJ 96

INSCRIPTION: *Log raft, Honga River, Maryland c.1930. Photo by A. Aubrey Bodine.*

28
Photographer unknown
MANNING THE YARDS
Gelatin-silver print 8.875 x 7.25
Museum Collection U-PN 43
INSCRIPTION: *Manning the yards in honor of Queen Kapioliah of the Sandwich Islands. Brooklyn N.Y., May, 1887.*

29
Handy Photo
EARLY SCREW PROPELLERS
Gelatin-silver print 7.75 x 9.75
Gift of J.W. Jenkins PC 72
INSCRIPTION: *Screw propellers, John Stevens (1749–1838)*

John Stevens was the first vessel to use the screw propeller for navigation. Like the engines for the *Joseph Henry* in plate 34, these two propellers are counter-rotating, made to turn in opposite directions to eliminate the torquing force of a single wheel.

30
James F. Gibson (Scottish, b. 1828)
CREW OF THE *MONITOR*
Albumen print 3.75 x 4.5
Gift of S.C. Snow PN 514
INSCRIPTION: *Monitor (ironclad) U.S. Navy. Deck scene, crew of Monitor awaiting mess call as the cook prepares the meal.*
There were many monitors, and it is easy to confuse others with the original *Monitor*, which became famous for its battle with the confederate ship *Virginia*. This is a picture of the legendary vessel, which gave her name to a class of iron warship.

31
Photographer unknown
BOILER FOR THE *J.D. ROCKEFELLER*
Gelatin-silver print 7.75 x 9.75
Gift of Newport News Shipbuilding PC 356
INSCRIPTION: *John D. Rockefeller (tanker) Bayonne, N.J.*

It was hard to resist the character in the bowler, or the rough and ready sawhorse in the foreground. I don't know why the boiler is out on the pier, but it doesn't look like a new one, just being installed. Maybe there was a serious repair that couldn't be done when this huge machine was crammed into the boiler room. The round tube running up the side of the shell looks very like a pneumatic line, which could have driven a caulking hammer that could beat a seam in the shell back into its proper state. The

rough, ladder-like structure at the extreme left most likely held one end of a horizontal plank on which a worker could stand while cleaning the profusion of boiler tubes hidden behind the flat clean-out doors.

The pressure in a boiler such as this, often over 200 pounds per square inch, was high because the efficiency of any engine is intimately connected to the temperature range through which its working medium passes. The temperature of saturated steam is in turn directly connected to its pressure; the fundamental problem faced by engineers was to attain high pressures without the frightful explosions that could occur when a boiler failed. The outer shell of a fire-tube boiler was under incredible stress, and so it was always made in a perfectly cylindrical form—the shape sought out by the cross section of any pressurized container. Running along the side of this shell is the riveted butt plate, with six rows of fastenings holding the seam together at this weakest point in the machine.

32
Photographer unknown
WRECKED BOILER FOR THE TUG MORFORD
Gelatin-silver print 4.5 x 6.5
Museum Collection PC 184
INSCRIPTION: *Wrecked boiler for the tug Morford*

This shows the remains of a locomotive type boiler, not so named because it was ever in a locomotive, but because it had the form that evolved for that use. The weakest part of one of these boilers was the crown sheet, which bent over the top of the fire and which took the direct heat of the flames and gases, yet was covered by only a shallow layer of water. If the water level went low due to inattention or a bad sight glass, then the crown sheet could become overheated and fail. At first glance I was sure that this had happened here, but a close look makes it quite certain that instead we see the remains of a boiler on which the outer cylindrical shell underwent a catastrophic failure.

33
Photographer unknown
WHEEL FOR THE TASHMOO
Gelatin-silver print 7.25 x 9.5
Museum Collection PC 62
INSCRIPTION: *Tashmoo (SS) Detroit, Mich.*

When we look at old photographs taken on the water it is always fun to check the foreground and see what kind of a wake was made by the boat that carried the photographer. At the beginning of this project I was sure I would find a paddle wheel wake somewhere in the book, but, alas, there is not a single one. Unlike the central propeller, hidden below the surface, the paddle wheel leaves a pair of foamy corrugations in the water as the ship passes, and this telltale mark identifies many pictures made from the sterns of fancy coastal passenger vessels.

34
Photographer unknown
ENGINES FOR THE *JOSEPH HENRY*
Gelatin-silver print 9 x 7.375
Gift of Newport News Shipbuilding PC 357
INSCRIPTION: *Joseph Henry (cable layer) U.S. Army Engineers*

It can be tricky to understand the difference between a right-handed and left-handed object. In the case of a glove we can turn one inside out and so create the other. When objects are built of smaller pieces, then these parts can be assembled to make a right and a left version; for example, two identical piles of brick could each generate a house of either handedness. It is a bit more complex for our engines, because any piece that does not possess a symmetry along one orientation must be cast from a new and different pattern to shift from one hand to the other. Many smaller pieces, such as the grooved valve chest covers on these engines, can be bolted on as they are, and add a bit of the "wrong" handedness to a pair of mirror-image machines.

These are compound reciprocating marine steam engines. Compound means that they each drop the high-pressure steam down the thermal ladder in two steps, through two cylinders, in order to extract the heat of the vapor efficiently. Reciprocating simply means that the steam is handled in cylinders, with their up-and-down motion, instead of by the more modern system of a smoothly rotating turbine wheel. Many people are unaware that the age of steam never stopped, but merely changed into a more technologically complex era when the turbine, with its higher efficiency, was developed. Today these new high-speed machines drive all the world's large ships, including those fueled with atomic energy, and turbo-generators create most of the electricity that we use. The turbine, unlike these piston engines, must be precisely engineered and manufactured, at great expense. For this reason steam has ceased to be around us at the human scale we see in this picture, where the young man had a hand in making and being proud of his clearly understood machine. The best reciprocating steam engines could convert the heat of a coal fire to useful work with an efficiency of about 15 percent at full load, and this was a good enough ratio to keep this sort of engine working through World War II, when internal combustion finally put them out of existence.

35
Photographer unknown
STEAM WINCH
Gelatin-silver print 7.5 x 9.75
Gift of Newport News Shipbuilding PC 360
INSCRIPTION: *Steam winch*

This is a confusing picture because there are a couple of geared axles lying around that don't have much to do with the winch as it is currently set up. In the left foreground is a shaft that obviously is meant to connect to the steam engine, but which is just sitting on blocks (and in one bearing to the left) in its approximate working location. To the right is another, balanced on a worm gear, which appears to be completely unrelated to the winch. These both might have run some sort of power take-offs which could be driven by the same engine as the winch head.

36

Photographer unknown

MODEL-BUILDING SHOP

Gelatin-silver print 13.125 x 10.125

Museum Collection PNA 225

INSCRIPTION: *Model-building shop*

At the picture's left side just above the large counterweight, the pantograph has a delicate spoked wheel that will run up and down along the pattern's surface. As it does, a rapidly rotating saw blade, seen above the small round counterweight, will make cuts that duplicate the movement of the spoked wheel. These will gradually create the model's hull out of the glued blank sitting on the top shelf of the machine.

The pattern, made of its twisted and bent strips, can thus produce as many identically shaped copies as needed. If we look carefully at this wooden guide obscured by the pantograph's weights and levers, we can barely see delicate rows of nails running up the hull at the photograph's left side. These hold the strips of wood to their frames, and those invisible forms can just be seen protruding from the bottom of the pattern's smooth, linear covering. While the frames are separated from each other by a foot or two, the tendency of the bent wood that will cover them to hold its shape means that the final hull surface will lay smoothly from frame to frame to form a perfect overall shape. This represents a nice use of materials; the designer need only determine a few points along the model's length, and the nature of wood will intelligently connect these points.

37

Photographer unknown

ARGONAUT

Gelatin-silver print 4.375 x 5.75

Museum Collection PN 3722

INSCRIPTION: *Argonaut (Submarine) (old) Built at Baltimore, a submarine with three wheels to draw the boat along the water bed. Designed by Simon Lake.*

In fairness, it should be noted that Simon Lake was one of the pioneers in successful submarine design and construction. His company also built the *Nautilus*, shown in plate 70.

38

Photographer unknown

REMOVING ICE FROM THE ST. MARY'S LOCK

Gelatin-silver print 7.625 x 9.5

Museum Collection PR 23

INSCRIPTION: *St. Mary's Canal. Removing ice from the Poe lock. April 11, 1907.*

39

Underwood & Underwood

ROOSEVELT IN A PANAMA STEAM SHOVEL

Gelatin-silver print 7.25 x 9.25

Museum Collection PP 231

INSCRIPTION: *Roosevelt in a steam crane*

40

Photographer unknown

THE PANAMA CANAL

Gelatin-silver print 8 x 35.25

Museum Collection PR 434

INSCRIPTION: *Panama Canal*

This is a panoramic photograph made with a "cirkut" camera. These clever devices used film on a roll, which was passed behind a slit upon which the lens focused. The camera rotated as the film was moved, and so pictures could be taken that encompassed a far greater angle than any single conventional photograph could capture.

41

Photographer unknown

RUDDER OF THE USS *TRENTON*

Gelatin-silver print 8.875 x 7

Museum Collection U-PH 20

INSCRIPTION: *USS Trenton, rudder of, Samoa hurricane, March 15–17, 1889*

42

George Prince

LAUNCH OF THE USS *ILLINOIS*

Gelatin-silver print 12.75 x 16.375

Gift of John E. Ware PN 4578

INSCRIPTION: *Launching the Illinois*

There is a nice point to be pondered here: Does the ship start moving when the bottle breaks, or is it the other way around? In most cases the sponsor does not break the bottle until the hull starts moving, so the difficulty of timing the end of the cut is avoided. If the bottle's break was a signal to the torch operator, then there would always be an embarrassing pause between flying champagne and moving ship.

43

Prince Foto

CHRISTENING OF THE USS *ARKANSAS*

Gelatin-silver print 10.875 x 16.25

Gift of Missouri Historical Society PN 3234

The champagne bottle that is broken for a christening can be quite dangerous, and so these have been traditionally wrapped in a net-like wire sheath that will hold the pieces of glass once the bottle has burst. In our picture the wine bottle has been swung inward to strike the bow, and this also gets the flying shards away from dignitaries on the platform. When we would launch boats in my neighborhood, the wife of the couple who owned her would strike the stem with a quart of beer tightly wrapped in an orange onion bag. The party that followed was at least as good as those that accompanied grander launchings.

44

Photographer unknown

THE USS *OLYMPIA* AT MANILA HARBOR

Gelatin-silver print 14.5 x 19.25

Gift of the United States Navy PN 1323

Deception and quality can go hand in hand in the world of photography. This is disturbing but absolutely true, and the notion that photographs are carriers of unblemished fact is held only by those who have never made one of these sorts of pictures. We must accept that the victorious general landing on a beachhead in the Pacific, coming to liberate the conquered, probably has been carefully posed for the picture, wading ashore long after the messy and imperfect battle was over. This deception of the photograph is no different than the straightening of a sagging profile, or embellishment of ermine robes that has always characterized painted portraits — it is just that we still think photographs are made by a machine handling the undistorted light of the world, and so they must show us the way things really were. This is not the case.

The *Olympia* is still afloat, in Philadelphia, and she is the only one of these early U.S. naval cruisers left from the era of the Spanish-American War.

45

O.W. Waterman

THE GREAT WHITE FLEET

Gelatin-silver print 11.25 x 19.375

Gift of N.P. Cooke PN 263

INSCRIPTION: *The Great White Fleet*

46

Edwin Levick (British, 1869–1929)

GROUNDED SCHOONER *BESSIE A. WHITE*

Gelatin-silver print 9.5 x 7.5

Museum Collection 154915

INSCRIPTION: *The four masted schooner Bessie A. White. Stranded off Smith Point, Fire Island, and abandoned.*

When a ship breaks her back it is fatal because she must be literally disassembled in order to repair the damage. If the photographer had walked down the beach and photographed the *Bessie A. White* head-on, then perhaps the resulting picture would have shown that the four tall masts no longer lay in one plane but instead were slightly out of alignment in relation to each other, betraying the mortal twist that condemned her.

47

Photographer unknown

CAPTAIN ORVIS MURRAY GRAY AND HIS SON

Gelatin-silver print 6.25 x 9.375

Museum Collection PP 431

INSCRIPTION: *Capt. Orvis Murray Gray and son Murray Laurence Gray on unidentified schooner*

48

Photographer unknown

HORSE-DRAWN LIFEBOAT

Gelatin-silver print 6.25 x 9.25

Museum Collection PI 610

The wagon is reminiscent of the ceremonial wagons that carry the coffin in military funerals, when the hollow load puts little demand on its conveyance. There is a small museum of farming technology in Kinzers, Pennsylvania, called the Rough and Tumble Engineer's Historical Association. There, in a shed, is a perfectly preserved Conestoga wagon. This machine reeks of medieval times, and every piece of it, whether wood or iron, reveals its long developmental history in a perfect union of form and function. The Rough and Tumble has many treasures, but this wagon is worth the trip all by itself.

49

Photographer unknown

BARK *GARTHSNAID*

Gelatin-silver print 10.5 x 13.375

Gift of R.D. Williams PK 2886

It could be that the *Garthsnaid* has her mainsail furled, and instead only flies reefed sails high up, where they are in steady air. The photographer is without question in a very dangerous spot, and has risked his life for this blurry but dramatic view.

50

Photographer unknown

LETTERS SALVAGED FROM THE *EMPRESS OF IRELAND*

Gelatin-silver print 4.7 x 6.5

Gift of R.G. Skerrett PO 5052

INSCRIPTION: *Empress of Ireland. Sank in St. Lawrence.*

In May of 1914 this 550-foot liner was hit at night by a heavily laden collier and sank in fourteen minutes with the loss of 1,027 lives.

51

Photographer unknown

GREAT LAKES FREIGHTER

Gelatin-silver print 7.75 x 9.5

Museum Collection PR 97

This picture might be a record of the ice, and of life on the Great Lakes in winter, but it also could have been made to show the results of a collision. There appears to be a rip in the hull toward the bow, and the voyage she has just completed could have skirted that sort of danger as well as fierce weather.

52

Photographer unknown

THE COLLIER *NEPTUNE*

Gelatin-silver print 7.75 x 9.5

Gift of Newport News Shipbuilding PN 2757

Here we can find steam winches, riveted girders, steel cable and manila line, dogged-down hatches, and endless blocks and rigging. The *Neptune* is a twentieth-century iron ship with rigging more complex than an eighteenth-century sailing ship of the line. At the photograph's bottom edge we can even see wooden casks, probably holding lubrication oil to make this whole affair run smoothly. The age of oil must have come as a great relief to a host of marine architects.

53

Keville Glennan

ELY'S FIRST FLIGHT

Printing-out paper 3.5 x 4

Gift of Virginia Ferguson PN 6399

Taking off and landing on a runway short enough to fit a ship both pose special problems. To become airborne, the pilot must achieve high air speed across the wings, so enough lift is generated to make the plane overcome its falling weight. One way to do this is to accelerate as fast as possible, and here we see a starting ramp that slopes down so gravity will help the engine and propeller. Ely's plane needs even more help, however, and he uses the standard pilot's technique of dipping down the nose to accelerate the plane's fall, which increases lift and so will permit it finally to pull up. Another picture made a second or two later would have shown us just how close to the water he had to come to achieve the required speed. Landing is a whole different procedure. Then, the nose must lift to diminish the efficiency of the airfoil so the plane will slow and settle down on its wheels. On the short flight deck of any aircraft carrier, whether it be an improvised wooden runway like this or a modern 1,000-foot landing strip like that of the USS *Constellation* in plate 96, the plane must be mechanically stopped as well. The first landing in January 1911 used hooks to catch the undercarriage of the machine, and every airplane flight at sea has been arrested by a similar device since then.

54

Young, Lord & Rhoades

CANADIAN LOCK ACCIDENT

Gelatin-silver print 7.75 x 9.5

Museum Collection PR 35

INSCRIPTION: *Improving St. Mary's River, Michigan. Canadian Lock accident. Upper end of lock, looking west, just after accident, showing recesses of upper gates, June 6, 1909.*

The recesses in the sides of the lock which held the now-missing gates cause a turbulence in the flow. The large standing wave results from an invisible step in the bottom of the lock, against which the base of the gates rested when closed.

55

Photographer unknown

NORDENFELT II, TURKISH SUBMARINE

Gelatin-silver print 6.5 x 8.875

Museum Collection PF 499

INSCRIPTION: *Nordenfelt II (submarine) Turkish Navy. Designed by Nordenfelt, a Swedish gun expert.*

To make matters worse, there are two engines in here. One is the primary drive engine that turned the screw, while the other, visible to the left, ran the vacuum pump that allowed this steam plant to operate on a closed condensing cycle. Only by so doing could the submarine contain her exhaust steam, and be self-sufficient in regard to feedwater.

56

Photographer unknown

BIG TIMBER

Gelatin-silver print 7.75 x 9.55

Museum Collection PR 60

INSCRIPTION: *Improving St. Mary's River, Michigan, new lock and canal. 3rd lock gates. 20 inch by 46 inch by 47 foot timber for upper guard gates. January 6, 1914.*

It is not quite clear just where the center of the tree was; it could have been located in the geometric center of this timber, or it could have been located along a line drawn down the center of the long side that faces us. If the latter is the case, then the tree could have produced two such massive pieces of wood, but these would have been less stable than a single one cut out of the center.

57

Photographer unknown

PROPELLER ADVERTISEMENT

Gelatin-silver print 9.75 x 6.625

Museum Collection PC 540

INSCRIPTION: *Propellers*

There is something not quite right about the photograph, because there is a distinct foreground in front of the patterns but none for the man. The earth there could be simply overexposed, and consequently washed out, but it is also possible that the man, at a slightly reduced size, has been added to the picture later.

58
Photographer unknown
DIVER WITH DIVING SUIT
Gelatin-silver print 9.75 x 7
Gift of R.G Skerrett P 1767
INSCRIPTION: *Diver. A type of submarine armor designed for deep sea work.*

59
Photographer unknown
RAISING OF *LORD DUFFERIN*
Gelatin-silver print 4.75 x 6.5
Museum Collection PB 31927
INSCRIPTION: *Damaged plating of ship sunk in New York harbor after stern was cut by collision. Lord Dufferin.*

60
Photographer unknown
THE STERN OF THE USS *ARIZONA*
Gelatin-silver print 7.625 x 9.625
Gift of Robert Stacker PN 2805
INSCRIPTION: *Arizona (battleship). Photo 8 x 10, launching*

Of all the battleships sunk at Pearl Harbor, only the *Arizona* remained on the bottom at war's end. The *West Virginia* and the *Tennessee*, seen in plate 89, were both raised and returned to active service. The *Arizona* remained as a memorial to the "day of infamy."

61
Photographer unknown
LAUNCH OF THE USS *MISSISSIPPI*
Gelatin-silver postcard 3.25 x 5.125
Museum Collection PN 5717
INSCRIPTION: *USS Mississippi, 1917*

62

Photographer unknown

CREW OF THE USS TEXAS

Gelatin-silver print 11.25 x 18.125

Museum Collection PN 4461

INSCRIPTION: *USS Texas*

In our photograph the *Texas* has an open work tower that extends up from her superstructure to hold a high observation platform. This sort of tower is visible on the USS *Connecticut* (plate 63) and also on the USS *Tennessee* and the USS *West Virginia* (plate 89). When the *Texas* was rebuilt prior to World War II, she received a more modern tubular tower, and this makes her current appearance much closer to that of the giant battleships built for the Second World War.

63

Photographer unknown

SOUND MUFFLING TRUNK

Gelatin-silver print 7.785 x 9.75

Gift of S.C. Snow PC 210

INSCRIPTION: *View of sound muffling trunk at mouth of left 12" gun, forward turret, on the USS Connecticut, Dec 21, 1916*

If pressed to guess just what was going on here, I would say that research was being done for the development of a device to be used in the radio room of the battleship.

64

Photographer unknown

FIRST WING PANEL MADE BY GIRLS

Gelatin-silver print 7.375 x 9.375

Museum Collection U-PA 81

INSCRIPTION: *First wing panel made by girls. Naval Aircraft factory, Phila. Pa, 1918.*

65

Photographer unknown

CHANGING PILOT OF OBSERVATION BALLOON

Gelatin-silver print 9.75 x 7.125

Museum Collection U-PA 105

INSCRIPTION: *Changing pilot of observation balloon*

Sailors were pulled aloft in the bosun's chair. This conveyance might have been a simple sling or even a board seat, used to haul a youngster up into the sky to spread grease from the galley onto the wooden parts of a sailing ship's rig. There was another type of suspended seat, called the "breeches buoy." Hung from a horizontal cable this device could carry people from a wreck to the shore, lifting them over the surf that would otherwise have been impassable.

66

H.C. Mann (American, 1866–1926)
FIRE ROOM CREW, USS *NORTH DAKOTA*
Gelatin-silver print 7.625 x 9.375
Museum Collection PP 712
INSCRIPTION: *Fireroom crew, USS North Dakota*

Standing in the background, wearing his hat, is the enlisted chief petty officer, who ran the crew under the direction of the young ensign. There has always been a strange relationship between these old-timers, who have come up through the enlisted ranks by hard work and high brain power, and young and educated officers who have little practical knowledge.

67

Photographer unknown
THE USS *SHAW* AFTER COLLISION
Gelatin-silver print 8.625 x 7.875
Museum Collection U-PN 820
INSCRIPTION: *USS Shaw after collision.*

It is interesting how good tools and machines persist in the face of changing technology. In the lower left of this photograph is a small oar-driven work boat—a basic craft that has been around for so long that it could perfectly easily turn up in identical form in a Dutch painting of some 300 years earlier.

68

David Barry (American, 1854–1934)
SHIPYARD WORKERS, SUPERIOR, WISCONSIN
Printing-out paper 7.625 x 9.375
Museum Collection PP 2586
INSCRIPTION: *Unidentified shipyard workers, probably at Superior Shipbuilding Company, Superior, Wisconsin, c. 1918*

69

Edwin Levick (British, 1869–1929)
THE USS *GEORGE WASHINGTON*
Gelatin-silver print 7.375 x 9.625
Museum Collection 47453
INSCRIPTION: *The George Washington with the President passing the Statue of Liberty*

70

W.R. Bomberger
THE LAST FAREWELL
Gelatin-silver print 8 x 10
Gift of W.R. Bomberger PN 355
INSCRIPTION: *Sir Hubert Wilkins submarine "Nautilus." Taken from the USS Pontchartrain 1200 miles at sea. 1931.*

71

Major Keith Hamilton Maxwell

PORT OF NEW YORK

Gelatin-silver print 16.375 x 23.25

Gift of Mrs. I.G. Redpath PH 833

INSCRIPTION: *New York from the air*

72

Edwin Levick (British, 1869–1929)

RUNABOUT *RASCAL*

Gelatin-silver print 7.375 x 9.375

Museum Collection 154922

INSCRIPTION: *Runabout Rascal*

73

Photographer unknown

BOMBING OF THE USS *ALABAMA*

Gelatin-silver print 13.875 x 16.875

Gift of R.L. Hague PN 627

INSCRIPTION: *Bombing of the Alabama*

The Norden bomb sight got all the glory, but I have been told that the one built by Sperry was even better. Apparently there was a bit of political infighting to get the Norden installed as the standard, and this company's public relations effort was more efficient than that of its rivals. I believe Sperry invented this remarkable gadget, which saved countless lives by ensuring that military targets could be singled out of a confusing landscape rushing by below the aircraft.

74

Edwin Levick (British, 1869–1929)

SHAMROCK AND RESOLUTE

Gelatin-silver print 9.5 x 7.25

Museum Collection 51745

INSCRIPTION: *Shamrock and Resolute*

Shamrock IV actually won two of the races, but still lost the overall match to the Herresoff-designed *Resolute*, sailed by Charles Francis Adams, descendant of two American presidents and a member of one of this country's most distinguished families. For the next challenge, Lipton built *Shamrock V*, and on this new boat the older gaff rig, which we see here, was given up and the more modern Marconi sail was used. Over the years marine architects have gradually come to understand that the leading edge of the sail—that running up along the mast—does most of the work when sailing at an angle to the wind, and so rigs have become taller and narrower to increase the size of this cotton airfoil that drives the boat. In 1988 the Lipton Tea Company donated *Shamrock V* to the Museum of Yachting in Newport, Rhode

Island. Today she is still there, occasionally match-racing against *Endeavour*, another sloop that has become her stablemate at the International Yacht Restoration School based in this old and beautiful seaport town.

75
Edwin Levick and Sons (active 1909–1940)
VADIM MAKAROFF AT THE WHEEL OF *VAMARIE*
Gelatin-silver print 7.75 x 9.625
Museum Collection 118469
INSCRIPTION: *Vadim S. Makaroff. Vamarie 1933.*

76
Photographer unknown
NINETEEN-FOOT CHRIS-CRAFT RACER
Gelatin-silver print 4.625 x 6.75
Gift of Chris-Craft Industries PI 3459
INSCRIPTION: *1937 19 ft*

77
William T. Radcliffe (American, 1913–1997)
BOSUN EARL WARREN MAKING A FENDER
Gelatin-silver print 7.875 x 9.5
Museum Collection P 1818
INSCRIPTION: *Rope fender under manufacture for Chesapeake and Ohio, Bosun Earl Warren. Starting with a core made of chain and old rope, the fender is built up with the single-strand whisker rope.*

The thin and short single fibers of the line are a microcosm of the individual human life in the complex and interwoven society of modern culture. The line extends through space over a greater distance than can its parts, as does the life of the culture through time, when compared to the individuals that comprise it. The strong rope can carry out tasks impossible for the tiny strands of which it is made, in the same way that the united effort of many individual people laboring side by side can achieve astonishing wonders.

78
Edwin Levick (British, 1869–1929)
UNLOADING SULPHUR
Gelatin-silver print 9.625 x 7.5
Museum Collection 60026
INSCRIPTION: *Unloading sulfur*

79

Edwin Levick and Sons (active 1909–1940)

BARGE IN HIGH WIND

Gelatin-silver print

7.625 x 9.375

Museum Collection 60244

INSCRIPTION: *Amy G. McKean (schooner) Halifax N.S.*

The barge is ill-suited for any chop at all, but the coaster is able to handle quite a rough offshore sea. To the extreme right we see the silhouette of a fine traditional ship's stern, with its deep rudder post and gentle rise to a shallow counter. This form could handle any sea that the world's oceans could throw at it.

80

Photographer unknown

ROMA DISASTER

Gelatin-silver print 4.75 x 6.75

Gift of Mrs. Myron F. Hill PA 22

INSCRIPTION: *Roma (airship) built in Italy. 1,200,000 c.f. gas capacity. 410 L, 82 D.*

The story of the *Italia's* fateful trip is told in the book *Airship over the Pole* by Garry Hogg. Roald Amundsen, one of the greatest polar explorers, was lost while flying over the northern ice pack searching for the *Italia's* survivors.

81

William T. Radcliffe (American, 1913–1997)

COLEMAN'S TATTOO PARLOR

Gelatin-silver print 7.625 x 9.5

Museum Collection P 873

INSCRIPTION: *Tattoo Place, 1936, Norfolk, Va.*

82

Edwin Levick (British, 1869–1929)

TUGS WORKING IN ICE

Gelatin-silver print 7.375 x 9.625

Museum Collection 43075

This picture gives a clear look at the manner in which a towing bit is mounted in a tugboat. We might expect this anchor point to be right at the stern of the boat, but if this was the case it would not be possible to change direction while straining at a load. In fact, the bit is always close to the rudder post, so a change of the rudder's position can let the boat pivot on the tensioned point of the bit.

83
Edwin Levick (British, 1869–1929)
CLEANING THE *MAJESTIC*
Gelatin-silver print 9.75 x 7.5
Museum Collection 65117
INSCRIPTION: *"Majestic"—largest vessel in the world being scraped, cleaned, and repaired in Boston.*

Appearance counted for a lot in the fashionable world of the liner, and so a ship such as this was kept scrupulously clean. Sailors are afflicted with a need for absolute cleanliness, and I have always thought this was because the sea has the last word. Its nature is rampant disorder and lack of planning, so the ships confront this insecure life by being as tightly run as possible. When vessels are built of steel (as opposed to the more enduring iron of the *Majestic*) then the problem becomes much worse because only a few days at sea triggers flowing rivers of rust throughout the topsides. Perpetual chipping and painting is the only way a modern steel ship can be kept looking good.

84
Edwin Levick and Sons (active 1909–1940)
NORMANDIE ENTERING NEW YORK HARBOR
Gelatin-silver print 7.625 x 9.5
Museum Collection PB 22995
INSCRIPTION: *Normandie*

85
John Phillips Crenwell
FRENCH DESTROYERS, VENICE, 1935
Gelatin silver print 10 x 13.375
Gift of John Phillips Crenwell PF 42
INSCRIPTION: *Venice, Italy. French Destroyer Flotilla. June 2, 1935.*

86
John Lochhead (American, 1909–1991)
THE *HINDENBURG*, 1936
Gelatin-silver print 5.625 x 9.5
Museum Collection PA 48
INSCRIPTION: *Hindenberg (dirigible) German. View of dirigible passing over Saint John, N.B. 1936.*

87
Photographer unknown
STERN FRAME AND RUDDER TRUNK
Gelatin-silver print 7.375 x 9.25
Gift of Charles D. Mills PC 176
INSCRIPTION: *Stern Frame and Rudder Trunk. Erie Forge Co.*

88

Edwin Levick (British, 1869–1929)

LIGHTSHIP *NORTHEAST*

Gelatin-silver print 7.375 x 9.5

Museum Collection 12128

INSCRIPTION: *Northeast (lightship) Northeast End, N.J. Built 1926, at Bath Maine, by Bath Iron Works. 775 T. 109.6 x 30 x 16 Renamed Ambrose (lightship). Lightship No. 111.*

89

Official United States Navy photograph

THE USS *WEST VIRGINIA* AT PEARL HARBOR

Gelatin-silver print 7.5 x 9.75

Museum Collection PN 2490

INSCRIPTION: *USS West Virginia (H 211) Crew rescuing men on sunken West Virginia after Japanese raid. USS Tennessee in background.*

My old Navy Chief, Frank Fletcher, who spent the war years in the Pacific, told me that in 1941 everyone knew war with Japan was going to happen, and by 1942 everyone also knew we would eventually win it. He said that on clear and perfect evenings at sea, up out of the engine room of the old four-stacker he was on, this certain knowledge carried absolutely no assurance that he or his companions would live through the war.

90

Official United States Navy photograph

CONVOY AT SEA

Gelatin-silver print 7.625 x 9.50

Museum Collection PN 5691

INSCRIPTION: *Convoy at sea, 1943.*

91

Official United States Coast Guard photograph

USCGC *SPENCER* SINKING SUBMARINE

Gelatin-silver print 7.625 x 9.5

Museum Collection PN 5688

INSCRIPTION: *Spencer (cutter)* [The official text for this picture is quoted opposite the picture in the plate section of the book].

92

A. Aubrey Bodine (American, 1906–1970)

SEA SCOUTS OF *FLORENCE LOUISE*

Gelatin-silver print 3.75 x 4.75

Gift of A. Aubrey Bodine PY 1179

INSCRIPTION: *Sea scouts on Florence Louise 6/12/46*

93
Edwin Levick (British, 1869–1929)
FISHING BOAT
Gelatin-silver print 5.75 x 6.75
Museum Collection 152054
INSCRIPTION: *Windy day on New York Bay. Fishing boat en route to sea.*

94
Photographer unknown
EIGHTEEN-FOOT FIESTA KIT BOAT
Gelatin-silver print 9.5 x 5.75
Gift of Chris-Craft Industries A 2653-4
INSCRIPTION: *1954 18' Fiesta Kit boat*

95
Photographer unknown
STEAM GENERATOR FOR THE USS *SAVANNAH*
Gelatin-silver print 7.625 x 9.625
Gift of Babcock & Wilcox PC 489
INSCRIPTION: *Savannah (nuclear ship). Steam generator assembly in shop. Heat exchanger and drum fit-up. Located deep amidships, the secondary shielding and containment vessel houses the pressurized water reactor and all other primary components that will be radioactive. In the center is the reactor and its primary shield tank. The spider-like units are the heat exchangers (bottom) and the steam drums (top). The bullet shaped unit at the right is the pressurizer, which maintains the primary system at a constant pressure of 1750 psi. The primary piping, manufactured by The Babcock & Wilcox Co, is shown between the reactor, pumps and boilers. The entire containment vessel shown here is covered with a six-inch layer of lead and a six-inch layer of polyethylene.*

I'm sure glad I didn't have to figure this one out based on the caption. There has always been some talk that while the ostensible role of the *Savannah* was to tour all the major harbors of the United States to show off nuclear peacetime power, her real mission was to establish the precedent of nuclear ships entering these heavily populated locations.

96
Newport News Shipbuilding staff photographer
THE USS *FORRESTAL* UNDER CONSTRUCTION
Gelatin-silver print 9.5 x 7.625
Museum Collection PN 2283
INSCRIPTION: *Forrestal (aircraft Carrier) U.S. Navy*

When this photograph was made, the *Forrestal* didn't show up in the picture the way the photographer intended, as her chaotic decks looked just the same as the scaffolding around her. Someone decided this would not do, and so the print was airbrushed to make a black swath around the ship and separate her from the noisy surround. This print was then copied, yielding the second-generation print we reproduce here.

97
P.D. Tiffany
THE USS CONSTELLATION FROM THE AIR
Gelatin-silver print 7.5 x 9.5
Museum Collection PN 5129
INSCRIPTION: *Pacific Ocean....an overhead aerial view of the aircraft carrier USS Constellation, CV-64, underway.*

98
Richard Steinheimer
SAN DIEGO TRAINING CENTER
Gelatin-silver print 10.25 x 13.5
Museum Collection PN 3781
INSCRIPTION: *US Naval Training Center, San Diego, Cal. Preble Field.*

In the water just beyond the marching sailors are three twenty-six-foot motor whaleboats on a training exercise. These versatile little double-enders had the same shape as the pretty lapstraked boat on the pier in front of the Higgins and Gifford Boat Shop in plate 18, and they are another example of how a tried and true form will crop up in new versions. These boats were traditionally made of wood, and they ferried sailors in all the ports of the world. My brother owned a late one, beautifully built of fiberglass, and used it in Newport Harbor. Many whaleboats became civilian pleasure boats, but usually they were top heavy from the addition of a comfortable but ill-designed house built forward.

99
Hans Marx (American, b. 1915)
VOLKSWAGENS ON DOCK
Gelatin-silver print 10.375 x 13.75
Museum Collection PH 3782
INSCRIPTION: *First complete shipload of the cars being unloaded at Pier 11, Canton, Baltimore, from the German ship "Ravenstein". March 1–2–3, 1956.*

My mother drove a small black Volkswagen "beetle," and when it was finally worn out and we were ready to junk it I noticed that the builder's plate was in Japanese. Our new German invader came to conquer in the form of a Japanese car!

100
Herman C. Hollerwith, Jr. (American, active 1910–1940)
DEADRISE BOAT UNDER CONSTRUCTION
Gelatin-silver print 7.875 x 7.75
Museum Collection PI 591
INSCRIPTION: *Deadrise Boat, Chesapeake Bay. Power Boat. Guinea Neck, ca 1937.*

The boat has two remarkable characteristics: it lasts through time, even outliving its makers, and it is the product of human cooperation. Humanity builds this way, and every brilliant achievement of an

individual which we love to celebrate so, only has meaning from its lasting impact on our cooperative lives. From the start, life on the sea has required that people work together, and the struggles there have dictated that tightly knit groups of individuals live together in functional hierarchies like ships, which are themselves far too complex to have been created by single individuals. The power of these long-lived productions, whether they be social structures (such as the complement of a ship), tools like our wooden boat, or even educators like the old pictures in this book, is so great that they demonstrate that things we make will probably someday be recognized as being more meaningful than their makers. We are such builders that our productions transcend ourselves.